Painting with
watercolor,
Pen & Ink

Claudia Nice

NORTH LIGHT BOOKS
CINCINNATI, OH
www.artistsnetwork.com

ABOUT THE AUTHOR

Claudia Nice is a native of the Pacific Northwest and a self-taught artist who developed her realistic art style by sketching from nature. She is a multimedia artist, but prefers pens, ink and watercolor when working in the field. Claudia has been art consultant for Koh-I-Noor Rapidograph and Grumbacher. She travels across North America conducting workshops, seminars and demonstrations at schools, clubs, shops and trade shows. Claudia has recently opened her own teaching studio, Brightwood Studio (www.brightwoodstudio.com), in the beautiful Cascade wilderness near Mt. Hood, Oregon. Her oils, watercolors and ink drawings have won numerous awards and can be found in private collections across the continent.

Claudia has authored fifteen successful art instruction books, including *Sketching Your Favorite Subjects in Pen and Ink*, *Creating Textures in Pen and Ink with Watercolor*, and *Painting Weathered Buildings in Pen, Ink & Watercolor*, all of which were featured in the North Light Book Club.

When not involved in her art career, Claudia enjoys hiking and horseback riding in the wilderness behind her home on Mt. Hood. Using her artistic eye to spot details, Claudia has developed skills as a man-tracker and is involved, along with her husband Jim, as a search-and-rescue volunteer.

Compilation edited by Michael Berger
Cover design by Brian Roeth
Compilation production coordinated by Mark Griffin

...to my father who passed to me his creativity, and taught me to love nature from the business end of a fishing pole.

...to my mother, who read to me and instilled in my mind the love of good books, and a colorful imagination with which to create my own.

...to my husband, Jim, for his patience, encouragement and support.

...to my naturalist friend, Winnie, who taught me wilderness wisdom, and to my adventurous friends Becky, Jan and Nellie, who taught me the meaning of kindred spirits.

...and above all, to the Father of all creation, who blessed the earth with so much beauty and diversity.

TABLE OF CONTENTS

Introduction 6

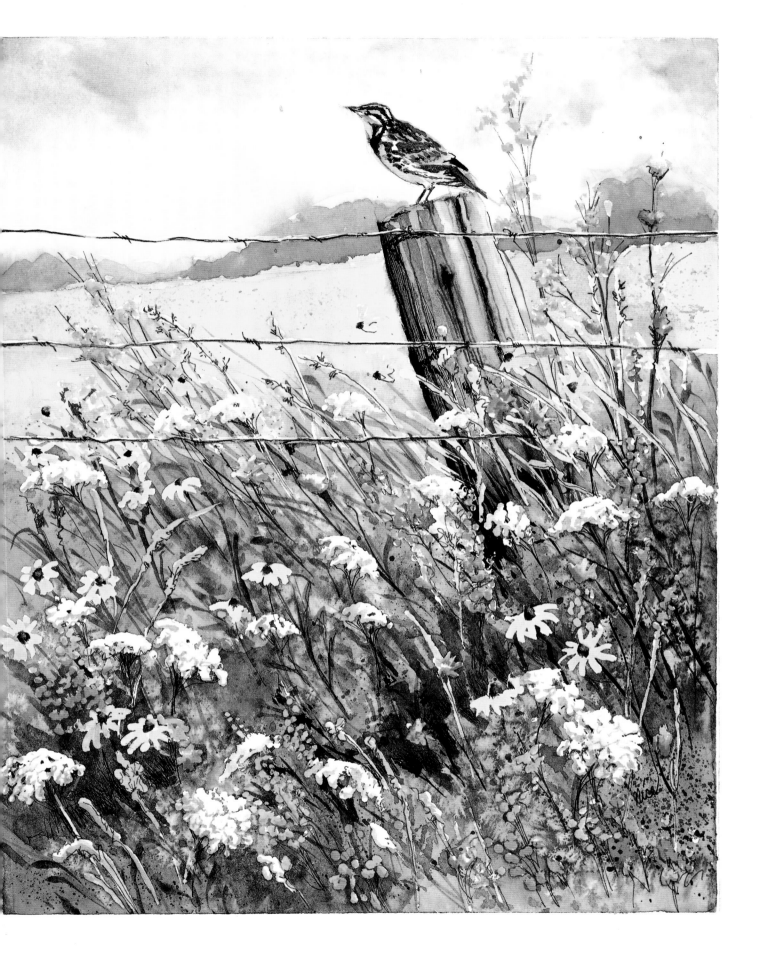

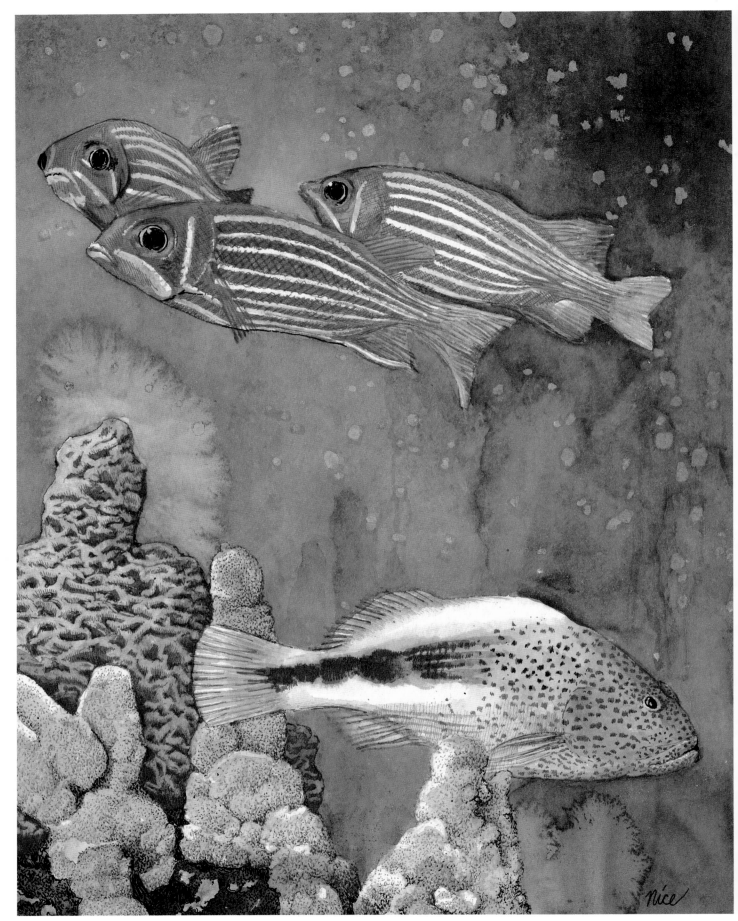

REEF FISH, 9½″×7″, Watercolor textured with colored pen work.

INTRODUCTION

I first learned to appreciate texture as a pen-and-ink artist. Value contrasts and texture are the heart of an ink drawing. I discovered that stippled dots could become gritty sand or a velvety horse muzzle. Thick tangled foliage, flowing water, soft rabbit fur, weathered wood and the leathery folds of elephant skin could all be depicted with the stroke of a pen. I was hooked, but I missed the colorful vibrance of paint. A dew-dappled flower petal or the misty arch of a rainbow needed color to be at its glorious best. The solution was to combine the best of both mediums. The result: some really fun and exciting mixed media techniques. A lot of them were old standards. Salt techniques have been around almost as long as watercolor. However, it took a lucky accident to reveal to me what happens when rock salt falls into water and bounces into a wet wash—a lacy sea anemone is born. Ink stippling over a bump-shaped, washed area becomes coral with personality. A bit of alcohol spatter tucked between layers of sea-green watercolor brings an otherwise dull background to life. I now have a colorful reef scene with texture, as you can see on the facing page!

The knowledge of many watercolorists, months of experimentation, and dozens of accidents, both good and bad, have combined to become the techniques I share with you in this book. I have only touched the surface. There are vast combinations of mixed media textures waiting to be tried and appreciated. Armed with a pen, brush and the spirit of adventure, the next "textural discovery" could be yours.

Happy Texturing.

Claudia Nice

GATHERING RUST, 9¾″ × 7¾″, Watercolor, pen & ink, pen & ArtistColor.

MATERIALS

THE TECHNICAL PEN

The technical pen is an advanced drawing instrument consisting of a hollow nib, a self-contained ink supply and a plastic holder. Within the hollow nib is a delicate wire (which should not be removed from the nib); and a weight, which shifts back and forth during use, brings the ink supply forward. An ideal pen has a steady, leakfree flow and a precise nib that can be stroked in all directions.

With proper use and maintenance, the technical pen is the answer to the "perfect art pen." I find I am most comfortable using a Koh-I-Noor Rapidograph. It is dependable and the refillable cartridge allows me to choose my own ink or colored medium.

Technical pens come in various nib sizes, ranging from very fine to extra broad. The line width chart at right shows both the Rapidograph nib sizes and their equivalent metric line widths. For a first pen, I recommend nib size 3×0/ .25mm. Most of the detail work shown in the illustrations in this book were created using a 3×0 sized pen. I have indicated the sizes of the Rapidograph pens I used on many of the projects by placing the numbers in parentheses beside the sketches.

PEN USE AND MAINTENANCE

Hold the pen as you would a pencil, keeping the angle rather upright. Use a steady, light pressure, maintaining good contact with the drawing surface.

Do not shake the technical pen! Shaking tends to flood the air channel with ink, creating a vacuum that prevents ink flow. If ink flow stops suddenly, try tapping the end of the pen holder (nib pointing skyward) against the table.

Keep the pen cap on when not in use. Wipe the nib often using a lint-free cloth when working over watercolor paint. Clean the pen thoroughly, following the manufacturer's instructions, at least once a month, or when changing inks or colored mediums.

For a more complete reference on using the Rapidograph pen—maintenance, textural stroking, and various styles and techniques—refer to *Sketching Your Favorite Subjects in Pen & Ink*, by Claudia Nice (North Light Books, 1993).

THE CROW QUILL

The crow quill dip pen consists of a wooden or plastic holder and a removable steel nib. With Hunt nibs no. 102 (medium) and no. 104 (fine), the crow quill will provide a good ink line. The tool cleans up easily and is inexpensive. It's useful for applying colored mediums when you desire many color changes or wish to add a finishing touch without filling a Rapidograph. Final touches of liquid acrylic were applied to *Gathering Rust* (page 2) and *Along the Trail* (page 72). However, crow quills are limited in stroke direction, with a tendency to drip and splatter, and the redipping process interrupts the stroking rhythm.

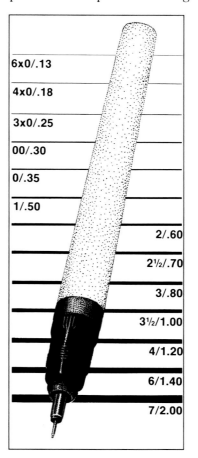

6x0/.13
4x0/.18
3x0/.25
00/.30
0/.35
1/.50
2/.60
2½/.70
3/.80
3½/1.00
4/1.20
6/1.40
7/2.00

TECHNICAL PEN

INK

India Inks are composed of water, carbon black particles for rich, dark color and shellac or latex for a binder. Different blends of these ingredients determine the ink's opacity, surface drying time, adhesion and permanence. India Ink labeled "permanent" should hold up under high humidity situations, adhering well to the drawing surface when touched with a damp finger. However, even "waterproof" inks may smear or lose pigment when brushed over with washes of watercolor, diluted ink or acrylic. Test the ink on scratch paper before applying any type of wash to your sketch.

My favorite ink is Koh-I-Noor's Universal Black India (3080), a versatile, high-opacity black ink that is free flowing, fast drying, and withstands vigorous brushing with colored washes.

COLORED INKS

Dye-based colored inks flow nicely in the technical pen, but some have a tendency to fade over a period of time. Many are not permanent, let alone brushproof. Check the labels for lightfast ratings, and run your own test for permanence before using it as part of a mixed media art piece.

Note: The ArtistColor liquid acrylics mentioned alongside some of the illustrations in this book is no longer available. I am presently using Koh-I-Noor Drawing Ink 9065, for all of my colored ink work. This too is subject to change according to product availability.

WATERCOLOR

The watercolor techniques discussed in this book require a quality watercolor paint in order to work effectively. Look for a watercolor paint that has rich, intense color for a good tinting strength. It should be finely ground and well processed so that the washes appear clean, with no particulate residue. The majority of the mixed media art pieces in this book were created using Grumbacher Finest Watercolor. Whatever your brand choice, remember that it is better to have a limited palette of quality paints than a kaleidoscope of poor substitutes. Your choice of paints will be reflected in your work.

THE COLOR WHEEL

The color wheel chart shows a simple palette of six basic colors: Cadmium Yellow Medium (warm yellow), Cadmium Yellow Lemon (cool yellow), Ultramarine Blue (warm blue), Thalo Blue (cool blue), Grumbacher Red (warm red), and Thio Violet or Quinacridone Red (cool red). From these six colors, the three primary colors (yellow, red and blue) can be mixed (a theory that goes against Art Class 101, but works great!). The usual basic mixing palette of pure red, blue and yellow is valid, but each primary color must be "hue perfect" (almost impossible to find in manufactured color) in order to produce vibrant secondary mixtures.

Using a basic palette of six warm and cool "primary" colors will produce a full spectrum of intense, accurate secondary and intermediate colors (greens, browns and oranges.) Earthy browns and shadow colors can be mixed by combining complementary colors (colors opposite each other on the color wheel). Four of the six basic colors (excluding the two yellows) will mix together to produce varied blacks and warm or cool grays.

The use of ready-mixed tube colors, other than the basic six shown on the color wheel, are a matter of budget and convenience, not a necessity.

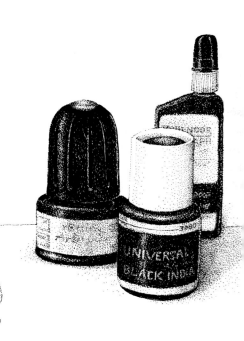

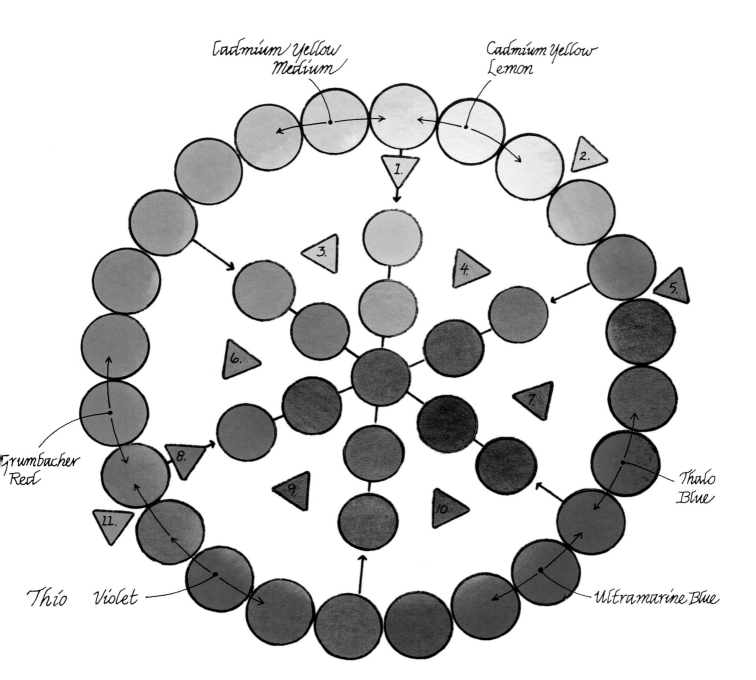

The color chart above shows a simple palette of six basic colors, consisting of a warm and cool red, yellow and blue. These intense mixing colors will produce vibrant, accurate secondary colors (oranges, greens and violets). Red, yellow and blue can be obtained by combining the related warm and cool base colors together. Shading colors, browns and neutrals can be mixed by combining complementary colors (colors opposite each other on the color wheel).

The triangular-shaped hues represent a few of my favorite premixed tube colors. Having them on hand is convenient, but optional.

1. Gamboge
2. Thalo Yellow Green
3. Yellow Ochre
4. Sap Green
5. Thalo Green
6. Burnt Sienna
7. Sepia
8. Brown Madder
9. Burnt Umber
10. Payne's Gray
11. Thalo Red (hard to duplicate by mixing)

LIQUID ACRYLICS

For colored pen work, I prefer using Rotring's ArtistColor (transparent), referred to in this book as *liquid acrylic*. It is a finely pigmented, transparent, permanent acrylic that is made especially for air brushes and technical pens as well as brush application. It is quick drying and, once dry, completely brushproof. Being transparent, it is very compatible with the "watercolor look," and works well layered over or under watercolor washes. At my work station, I keep a 3 × 0 pen filled with ArtistColor Payne's Gray for shading cool watercolor washes, and a pen filled with ArtistColor Brown to accent warm colors. Unless one has an abundance of technical pens, other liquid acrylic hues can be mixed and placed in the pen as needed.

Caution: White and Black ArtistColor have a heavier pigment concentration and are not recommended for the medium- and fine-nibbed Rapidographs. The other transparent colors are treated like inks and should be maintained in the pen as such.

BRUSHES

The best brushes to use with watercolors are sable hair. Soft, absorbent sable brushes are capable of holding large amounts of fluid color, yet retain a sharp point or edge. They respond to the hand with a resilient snap. The big drawback is that sable is expensive. An alternative choice is a quality blend of natural and synthetic sable hairs. The illustrations in this book were painted using both sable and blended brushes (Grumbacher Sables and Sable Essence in various sized flats, rounds and fan shapes.) Also useful is an old, frayed, synthetic flat brush for stippling, scrubbing and general misuse.

WATERCOLOR PAPER

When working in mixed media you must choose a surface that is compatible with both pen work and the application of wet washes. The pen should be able to glide over its surface without snagging, picking up lint, or clogging. The paper must be absorbent enough to avoid buckling into molehills when wet-on-wet techniques are used. To ensure the longevity of your work, the paper should have a high rag content and be pH neutral.

A good quality, cold-pressed watercolor paper of 125- to 140-lbs. seems to be a good compromise. Taping the edges of the paper to a moveable backing such as a drawing board will help the surface retain its shape, but still allow the paper to be rotated for pen work.

MISCELLANEOUS

Liquid frisket is used to mask out areas of a painting while washes are applied. Use a synthetic-hair brush for application, dipped first in liquid soap to aid in cleanup. Remove the liquid frisket from the work surface with an eraser.

Table salt and rock salt are used for the salt techniques in this book. Don't be afraid to experiment with sea salt, marguerita salt, kosher salt, etc. Rock salt needs to be dipped into water as it's applied, to cause the saline solution to flow. In high humidity areas, microwave the salt to dry it, and keep it in a sealed container.

Isopropyl rubbing alcohol, plastic wrap, spray mist bottles, paper towels and paper tissues are all handy items to have on hand. They can be used to alter the pigment flow, creating spontaneous, fun, textured effects. You can see how to create many of these effects on pages 14-21.

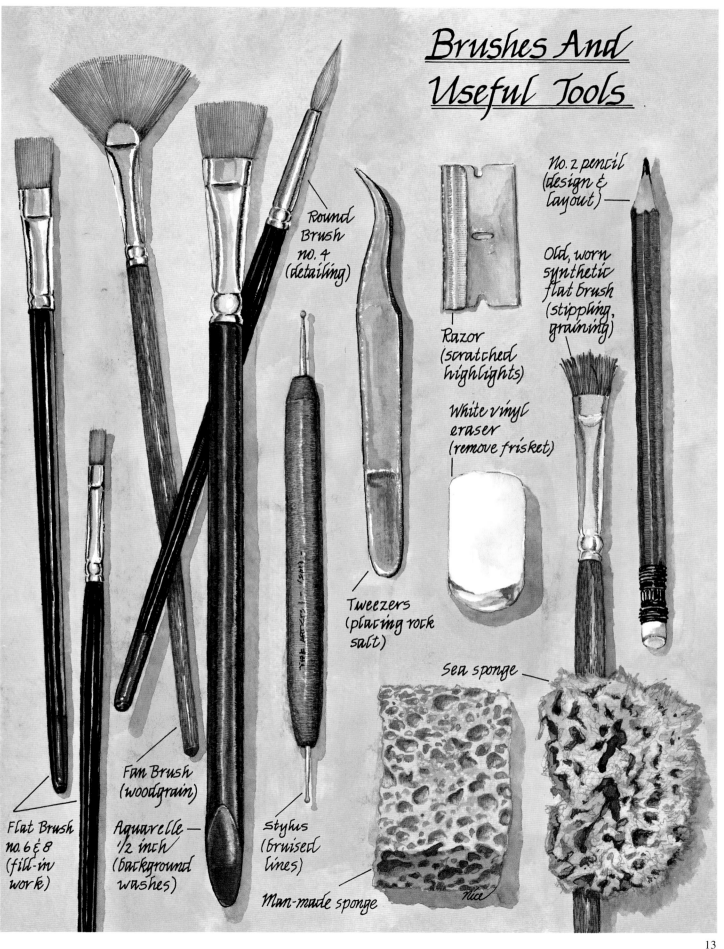

Brushes And Useful Tools

Round Brush no. 4 (detailing)

No. 2 pencil (design & layout)

Old, worn synthetic flat brush (stippling, graining)

Razor (scratched highlights)

White vinyl eraser (remove frisket)

Tweezers (placing rock salt)

Sea sponge

Fan Brush (woodgrain)

Flat Brush no. 6 & 8 (fill-in work)

Aquarelle — ½ inch (background washes)

Stylus (bruised lines)

Man-made sponge

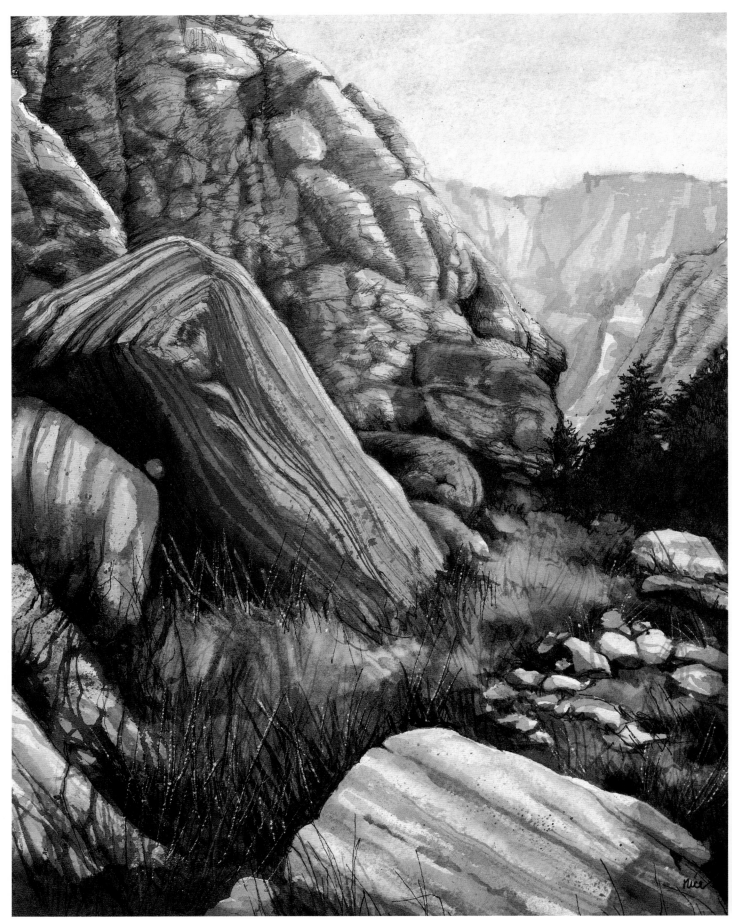

CANYON WALLS, 9½″ × 7″, Pen work overlaid with watercolor.

BASIC TEXTURING TECHNIQUES

Pen and ink is my favorite texturing medium. Dots and lines can be varied in size, volume, arrangement and form to create the appearance of texture. There are seven distinct texturing techniques: contour lines, parallel lines, crosshatching, dots or stippling, scribble lines, wavy grain lines and criss-cross lines. Each technique may be used separately or combined to produce countless effects. When the texture of pen work is desired, but India Ink lines are too prominent, earth tone mixtures of liquid acrylic may be substituted in the pen.

Watercolor is subtle in its display of texture. However, the softer look of brush-produced strokes and "water flow" textures are greatly enhanced by the impact of color. Dynamic choice of hue can "wake up" a tenuous texture to produce striking realism. Watercolor texturing depends greatly on the reactions of pigmented washes to dry, damp, and wet paper surfaces. The wetter the surface, the softer and more free flowing the applied paint will become. The use of various brushes and tools to apply (or remove) the paint is equally important to the creation of textural effects. Application techniques include stroking, scraping, spattering, stamping and blotting. Salt, liquid frisket, alcohol, plastic wrap and plain water can be used to alter the distribution of the pigment, producing even more visual variants.

By combining the boldness of pen and ink, the subtle qualities of watercolor and the visual impact of color, the creation of texture is only as limited as your imagination.

Pen And Ink Techniques

Contour Lines ~

(smoothly flowing, form fitting strokes)

- smooth, curved objects
- polished surfaces
- fluid motion
- glass, metal

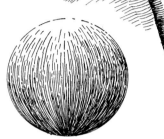

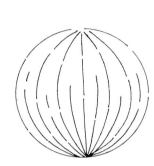

The seven basic texturing strokes can be layered or combined to produce countless effects.

Crosshatching ~

(two or more intersecting lines)

- deepen tonal values, heavy shadows
- roughened texture varying in degrees according to angle, precision and nib size

Parallel Lines ~

(straight, free hand lines, stroked in the same direction)

- smooth, flat objects
- faded, hazy, misty or distant look

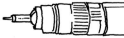

16

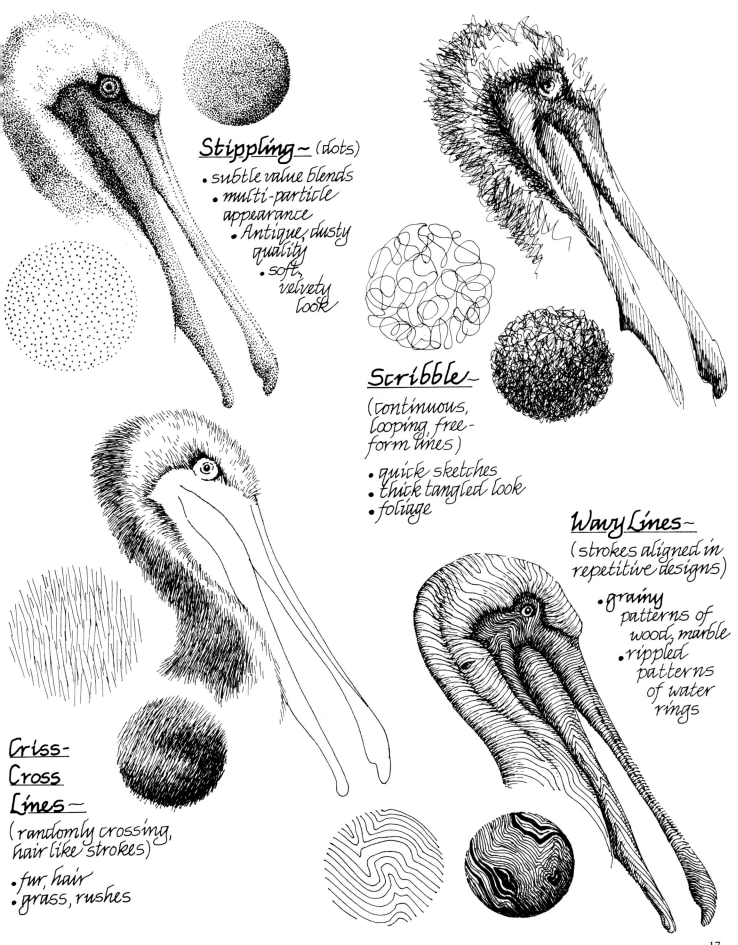

Stippling ~ (dots)
- subtle value blends
- multi-particle appearance
- Antique, dusty quality
- soft, velvety look

Scribble ~
(continuous, looping, free-form lines)
- quick sketches
- thick tangled look
- foliage

Wavy Lines ~
(strokes aligned in repetitive designs)
- grainy patterns of wood, marble
- rippled patterns of water rings

Criss-Cross Lines ~
(randomly crossing, hair like strokes)
- fur, hair
- grass, rushes

Value is the degree of lightness or darkness in a color. India Ink work has a palette ranging from white, through the various gray tones to black. The more marks added to the paper surface, the greater the degree of darkness.

Value deepened by stroking lines closer together

Value deepened by layering sets of pen strokes

Value deepened by combining different texture layers

Subtle blending of values

Stippling provides the most delicate means of blending value using pen and ink techniques.

Placing dark objects against lighter backgrounds and vice versa provides a natural edge where the two values meet. The greater the contrast between the two values, the more distinct the form of the object will become.

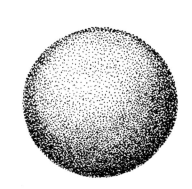

Contrast is the key to a well-defined art piece.

Below: Shapes defined by contrast of value

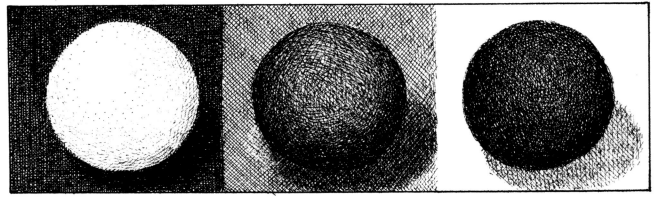

Techniques for developing contrast and definition ~

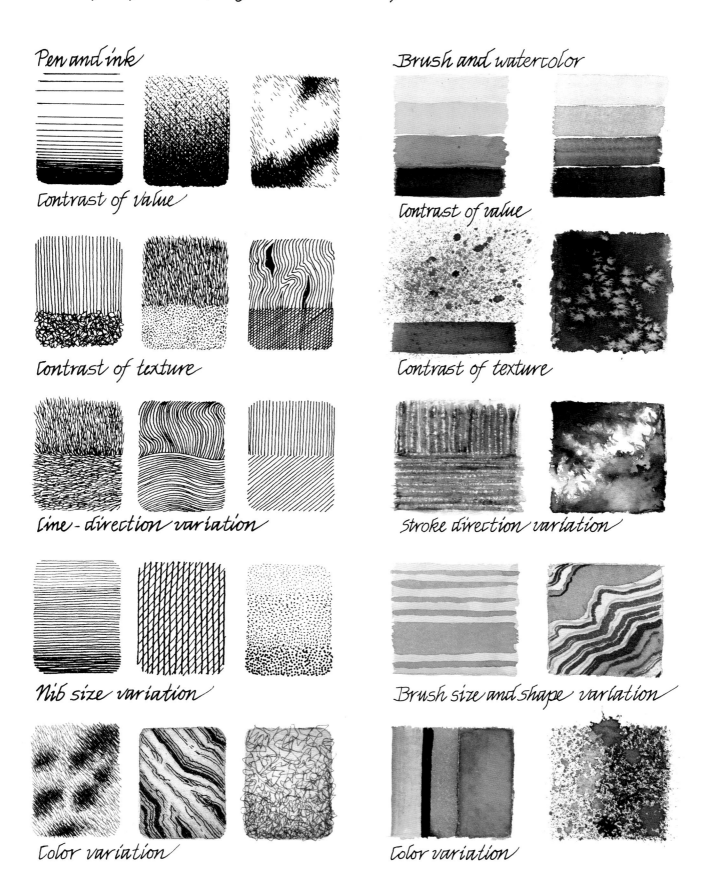

Pen and ink

Contrast of value

Contrast of texture

Line - direction variation

Nib size variation

Color variation

Brush and watercolor

Contrast of value

Contrast of texture

Stroke direction variation

Brush size and shape variation

Color variation

Dry Surface Techniques

Drybrushing-(moist paint applied to a dry surface) produces crisp-edged lines and paper induced textures as the brush dries out.

Round detail brush stroked over dry paper.

Round detail brush stroked over a dry wash.

Flat brushes stroked over dry paper surface.

As moisture leaves flat brush, paper texturing occurs.

Flat brush stroked over dry wash.

Edge of flat brush stippled over dry, mottled wash.

Fan brush stroked over a dry wash.

Lines scratched into a dry wash with a razor blade.

Damp Surface Techniques

Pigment spreads easily when stroked over a moist (not shiny) surface, producing softened edges and smooth blends.

Round and flat brush strokes on a damp paper surface.

Varied washes on a damp surface. Note smooth blending of hues.

Stroking the edge of a damp wash with a clean, moist brush produces a gradated blend.

Bruising the paper with a stylus causes the pigment in a damp surface wash to gather into dark lines.

Scraping through a near-dry wash with a blunt tool creates lightly pigmented designs.

White area protected from damp surface wash with masking tape.

White design area, masked with liquid frisket.

Liquid frisket applied over a dry wash, followed with a darker, damp surface wash.

Wet-On-Wet Techniques

Moist paint applied to a shiny wet surface will flow freely, creating soft, feathery designs.

Spontaneous design resulting from wet-on-wet application.

Flat and round brushes stroked over a wet surface.

Spontaneous mixture of varied hues applied to a wet surface.

Directional flow from tilted paper.

Pigment-filled round brush touched to wet surface.

Edge of wet-on-wet wash sprayed with spray mister.

Puddling occurs when additional liquid is applied to a wet-on-wet wash.

A water-filled round brush touched to a wet, varied wash.

Absorbent materials pressed into a damp-to-wet wash will lift the pigment, creating negative designs.

Pigment lifted from a moist wash with a damp, flat brush.

A near-dry wash, worked with a damp, flat brush and lifted with a tissue.

Moist washes blotted with a crumpled paper tissue.

Damp surface wash, blotted with a paper towel.

Varied, wet-on-wet wash, blotted with a paper towel.

Dry, multi-layered wash, worked with a damp brush and lifted with a tissue.

Impressed Textures

Foreign materials laid into a moist wash and left to dry completely, will draw and hold the pigment, creating dark print-like designs.

Crumpled wax paper - weighted down.

Crumpled plastic wrap - weighted down with a book.

Crumpled tin foil

Sewing thread

Fine hairs from a Chow dog's inner coat. (Pat into place with a brush.)

Spring leaves

Tooth picks

Coarse sand

Horse tail hairs

Salt And Alcohol Techniques

Introducing rubbing alcohol or salt into a very damp to wet wash will displace the pigment, creating pale designs.

Rubbing alcohol applied with the tip of a round detail brush.

Large drops of alcohol, dripped into a moist wash from the tip of a brush.

Fine drops of alcohol, spattered into a moist wash.

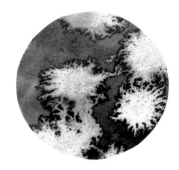 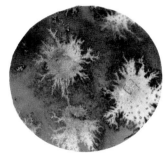

Wet pieces of rock salt, laid into a moist wash and left until dry.

Table salt sprinked into a moist wash and left until dry.

Under humid conditions, salt must be dried in an oven or microwave before use.

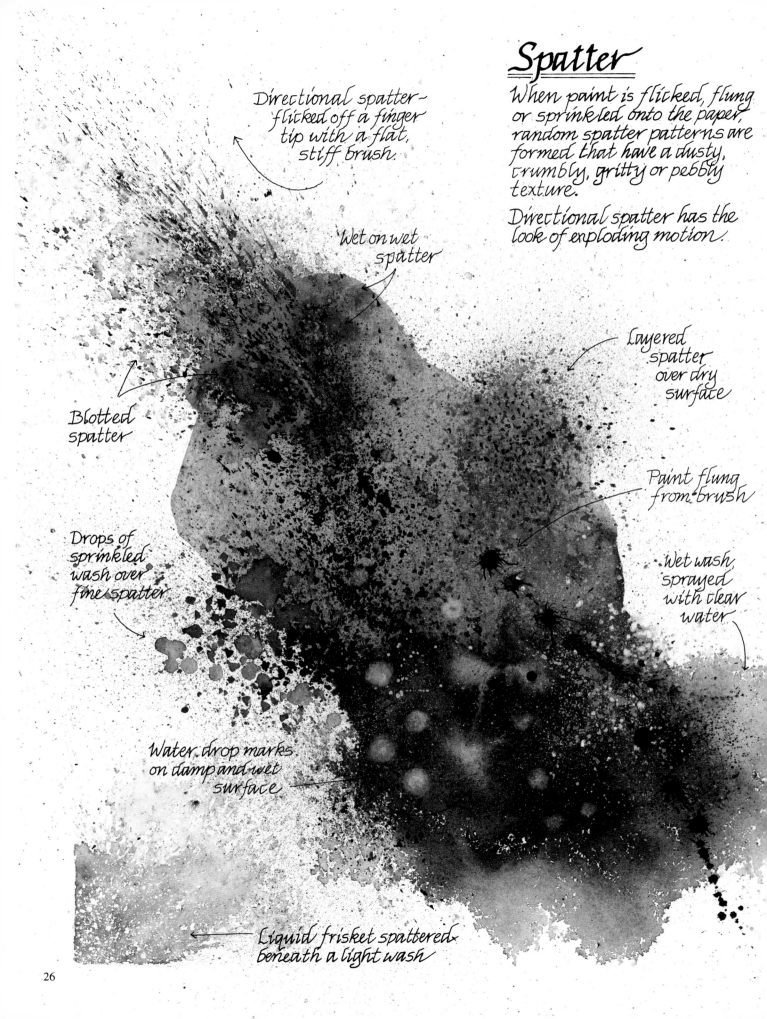

Spatter

When paint is flicked, flung or sprinkled onto the paper, random spatter patterns are formed that have a dusty, crumbly, gritty or pebbly texture.

Directional spatter has the look of exploding motion.

Directional spatter - flicked off a finger tip with a flat, stiff brush.

Wet on wet spatter

Layered spatter over dry surface

Blotted spatter

Paint flung from brush

Drops of sprinkled wash over fine spatter

Wet wash sprayed with clear water

Water drop marks on damp and wet surface

Liquid frisket spattered beneath a light wash

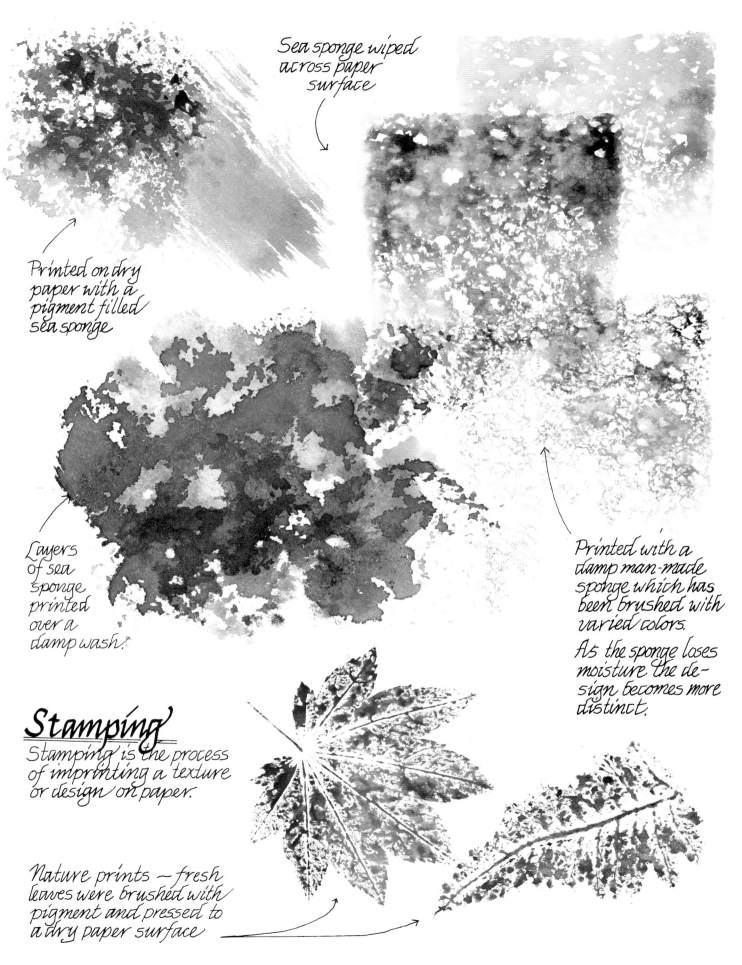

Sea sponge wiped
across paper
surface

Printed on dry
paper with a
pigment filled
sea sponge

Layers
of sea
sponge
printed
over a
damp wash.

Printed with a
damp man-made
sponge which has
been brushed with
varied colors.

As the sponge loses
moisture the de-
sign becomes more
distinct.

Stamping

Stamping is the process
of imprinting a texture
or design on paper.

Nature prints — fresh
leaves were brushed with
pigment and pressed to
a dry paper surface

Combining Pen, Ink And Watercolor

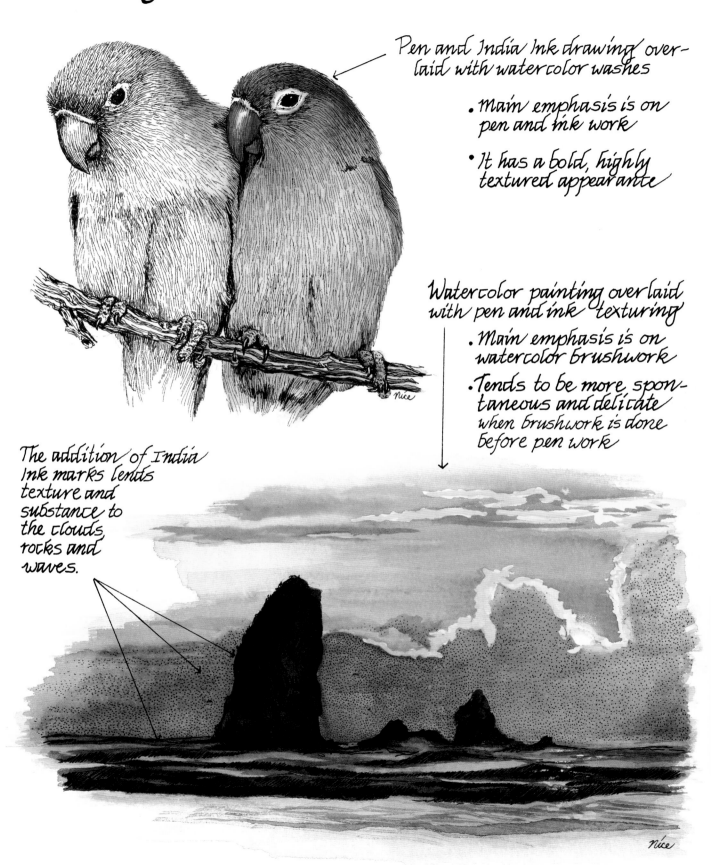

Pen and India Ink drawing over-
laid with watercolor washes

- Main emphasis is on
 pen and ink work

- It has a bold, highly
 textured appearance

Watercolor painting over laid
with pen and ink texturing

- Main emphasis is on
 watercolor brushwork
- Tends to be more spon-
 taneous and delicate
 when brushwork is done
 before pen work

The addition of India
Ink marks lends
texture and
substance to
the clouds,
rocks and
waves.

Nice

Nice

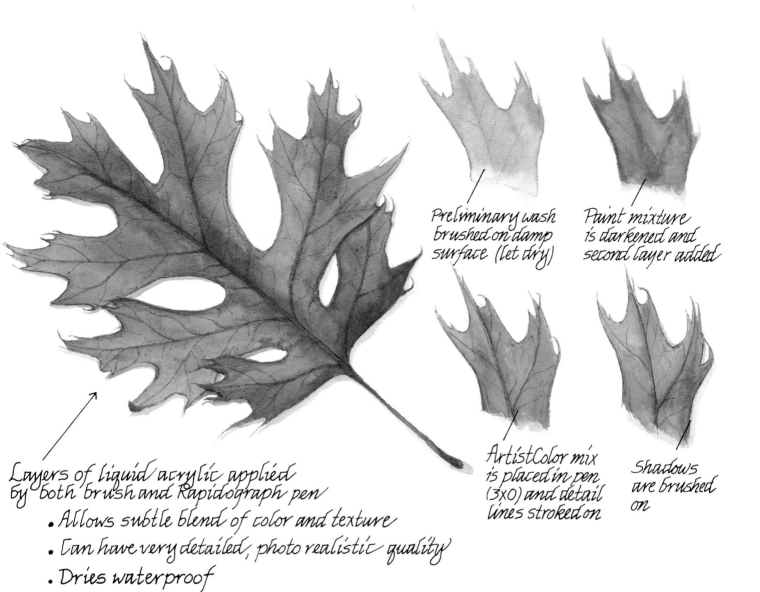

Preliminary wash brushed on damp surface (let dry)

Paint mixture is darkened and second layer added

ArtistColor mix is placed in pen (3x0) and detail lines stroked on

Shadows are brushed on

Layers of liquid acrylic applied by both brush and Rapidograph pen

• Allows subtle blend of color and texture

• Can have very detailed, photo realistic quality

• Dries waterproof

Intermixed layers of India Ink, liquid acrylic and watercolor, utilizing various techniques and applications

• Unlimited variety of color, textures and techniques

• Opacity can vary

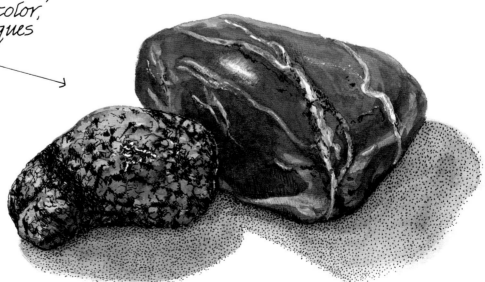

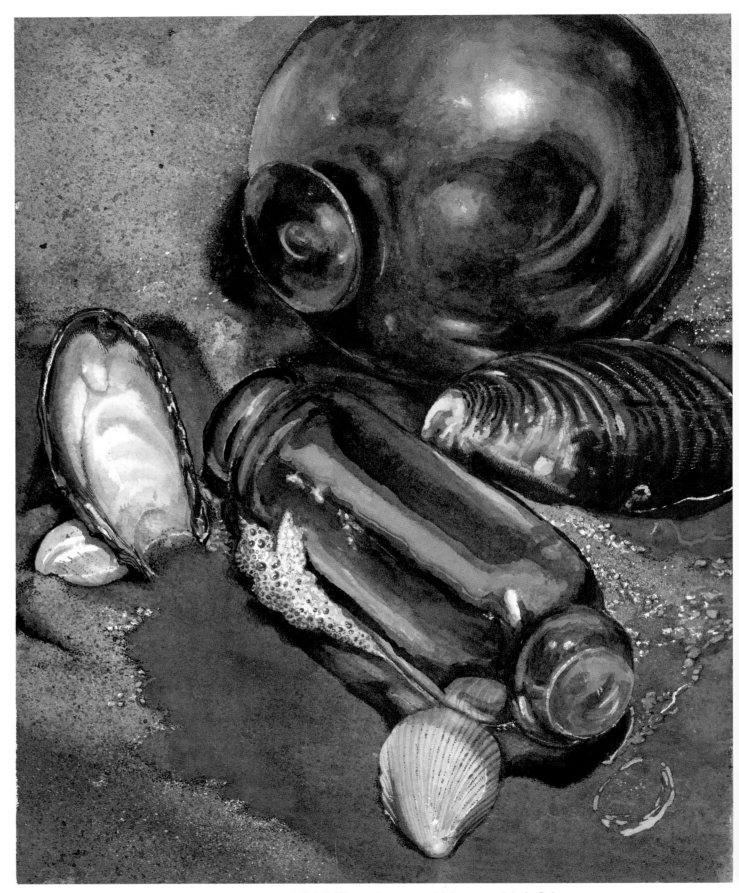

WASHED ASHORE, 10″×8″, Watercolor, pen and ink, pen and ArtistColor.

THE LOOK OF TRANSPARENCY

Transparency, because of its elusive, delicate nature, can be a challenge to depict. Indeed, the surface of a clear, pristine pool of water or a newly washed window can be almost invisible to the eye if it were not for the glint of reflected light. It's perhaps easiest to consider a transparent object in three aspects—the surface, the inside and the back side.

While the surface contours of untinted transparent objects are often evasive, the highlights and reflective colors are quite visible. Concentrate on this "light play" and the surface contours will be depicted in a natural manner.

The inside of the transparent object is the next area of consideration. Interior shadows will help define the inner shape. Objects within the transparent subject will add interest, but keep in mind that their shape and texture may appear distorted. Colors within a transparent object, especially liquids, are intensified and, depending on the whims of illumination, may appear darker or lighter than the surrounding outside area.

Last of all, the back side is considered, and more important, any background objects seen through the transparent surfaces. The farther away they are, the more faint and distorted they will appear.

Although transparent objects can be depicted adequately in pen and ink using contour lines, watercolor lends itself especially well to this work. Therefore, I often begin with a watercolor painting and carefully add touches of pen and ink, or the more subtle tones of liquid acrylic, to deepen shadows and enhance definition.

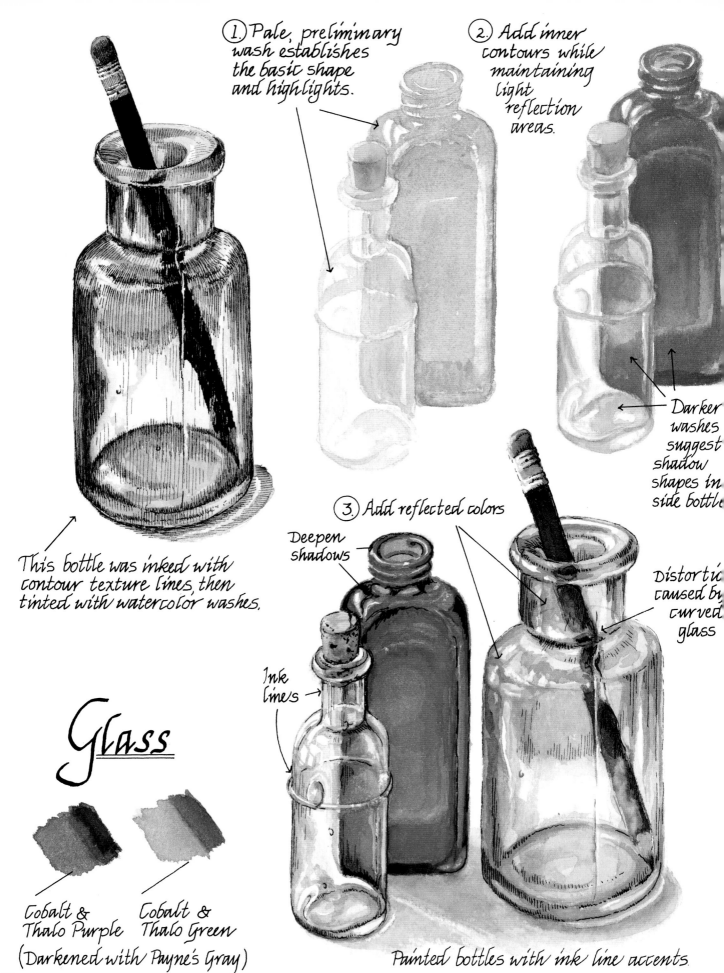

① Pale, preliminary wash establishes the basic shape and highlights.

② Add inner contours while maintaining light reflection areas.

Darker washes suggest shadow shapes in side bottle

This bottle was inked with contour texture lines, then tinted with watercolor washes.

③ Add reflected colors

Deepen shadows

Ink lines

Distortion caused by curved glass

Glass

Cobalt & Thalo Purple

Cobalt & Thalo Green

(Darkened with Payne's Gray)

Painted bottles with ink line accents.

Contour ink lines for definition

liquid frisket was used
to protect white highlights
during paint application.

highlights reflected
from flame

Objects behind glass
often appear distorted

stippled ink texturing

reflected color

amber colored lamp
oil

Lighter colors represent
the illumination of
light filtering through
the lamp.

As clear, antique glass
ages it often takes on
an amethyst tint.

Rose Madder &
Payne's Gray

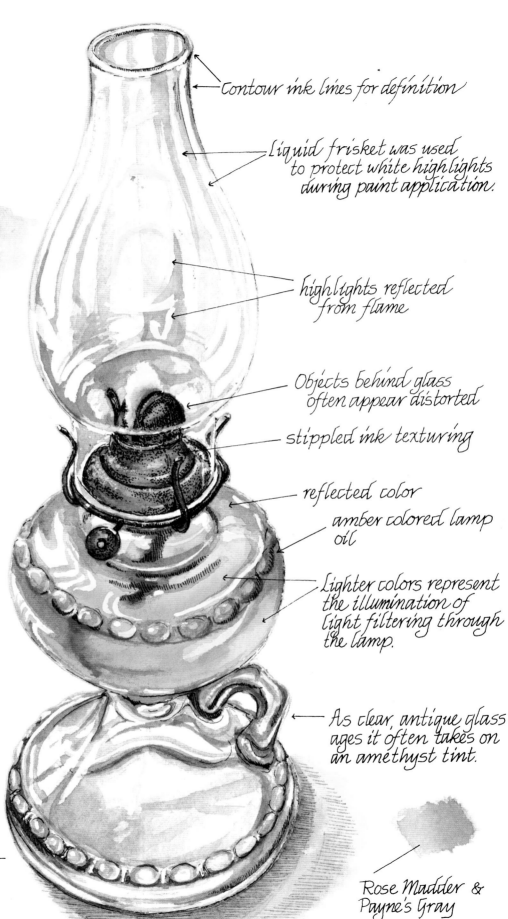

ut crystal~
 Faceted surfaces reflect
multiple highlights, shadows
and reflected color. Simplify
his "light play" where
possible and maintain
plenty of sparkling white
highlights.
The pepper in the shaker
was textured with ink
scribble marks and dots.)

This antique lamp was
painted with layers of
watercolor washes, then
a few well placed ink
texturing strokes were
added.

When pen and ink detail work is used to accent only the rough surfaced objects within the composition, contrast of texture is greatly increased.

Compare the rough texture of the inked and painted rope to the smooth look of the glass to which no pen work was added.

Note how the objects seen through glass are distorted both in coloration and shape.

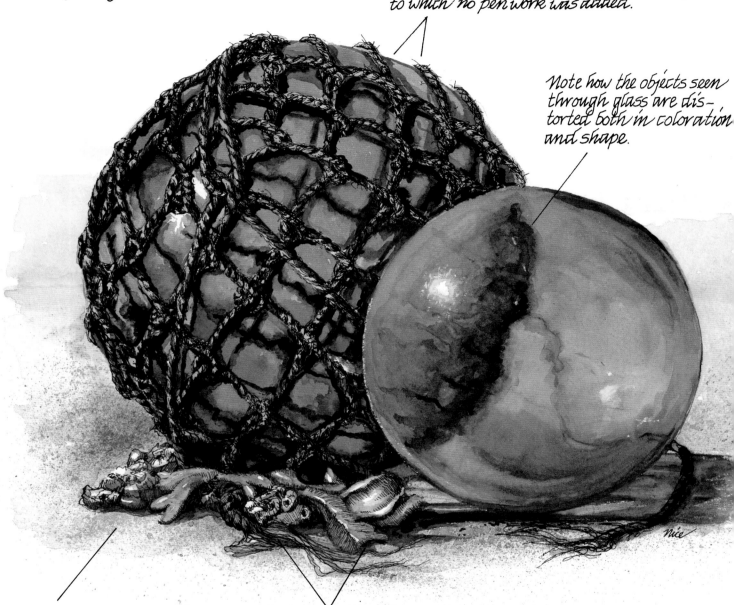

Nice

The sand was the first area of the composition to be painted, using a light wash overlaid with spatter.

The adjoining areas were protected with liquid frisket.

The rope and entangled sea life were detailed with pen and ink, then tinted with watercolor.

The Japanese floats were painted with layered washes of watercolor, blended one into another using damp surface and wet-on-wet techniques.

Begin with the light green washes, working towards the deeper shadow tones.

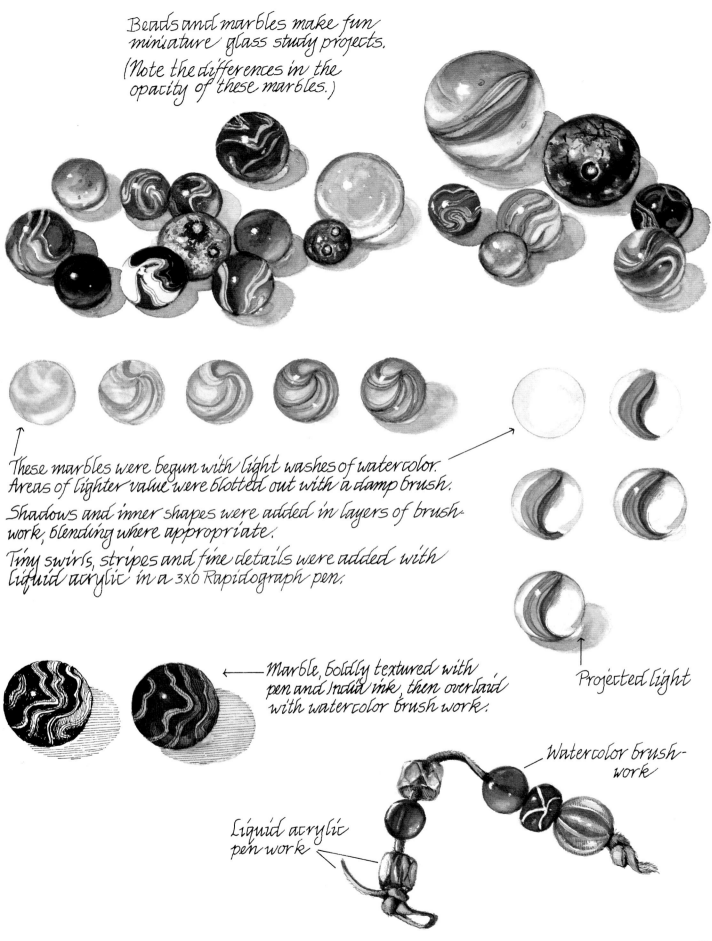

Beads and marbles make fun miniature glass study projects.

(Note the differences in the opacity of these marbles.)

These marbles were begun with light washes of watercolor. Areas of lighter value were blotted out with a damp brush.

Shadows and inner shapes were added in layers of brush-work, blending where appropriate.

Tiny swirls, stripes and fine details were added with liquid acrylic in a 3x0 Rapidograph pen.

Projected light

Marble, boldly textured with pen and India ink, then overlaid with watercolor brush work.

Watercolor brush-work

Liquid acrylic pen work

Dots, crosshatching and contour ink strokes combined suggest depth and mystery

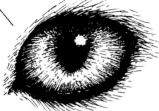

Contour lines emphasize the smooth, fluid transparency of the eye.

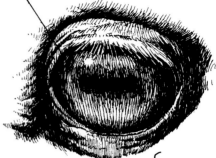

cat eye

pen and ink work overlaid with watercolor washes

horse eye – (note capsule shaped pupil)

Eyes

Where the light first strikes the transparent eye orb, highlights are reflected in small dots or shapes. The light then passes through the eye, spreading out and causing illumination. This is represented by a crescent of lighter value.

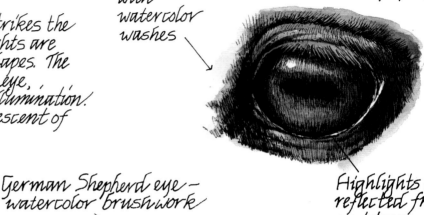

Highlights are reflected from moisture gathered along lower eye lid.

German Shepherd eye – watercolor brushwork

Highlights maintained with liquid frisket

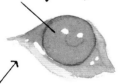

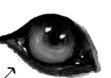

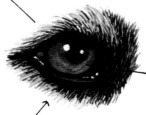

Base wash of Burnt Sienna

While still damp, a second layer of Burnt Umber was blended over base.

Using a no. 4 round detail brush, values are deepened and hair layered on.

Natural flow and puddling adds vein like texture to brown iris.

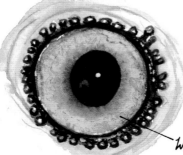

Parrot eye – watercolor brushwork with pen and ink detailing.

Wet on wet technique

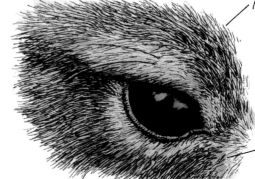

Rabbit eye – (eyes in deep shadow have no white highlight dots)

Ink criss-cross lines

36

Pen and India ink
(3x0)

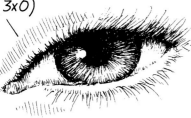

Pen and ink over laid with watercolor washes

Basic flesh tone is a mixture of Brown Madder, Burnt Sienna and Thalo Green watercolor.

Deepen skin color by adding Thalo Green and Thio Violet.

Add texture with similar mixes of liquid acrylic in a 3x0 pen.

Watercolor brush work, over laid with pen and India ink, and pen and liquid acrylic texture strokes.

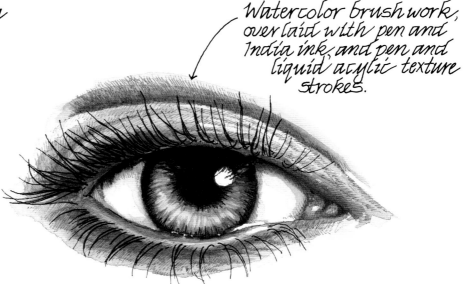

1.

2.

3.

Watercolor, textured with pen work

1. Lay a basic wash over a light pencil sketch, maintaining highlights
2. While still slightly damp, shade and deepen value, leaving an illumination crescent
3. Add pen and ink accent strokes

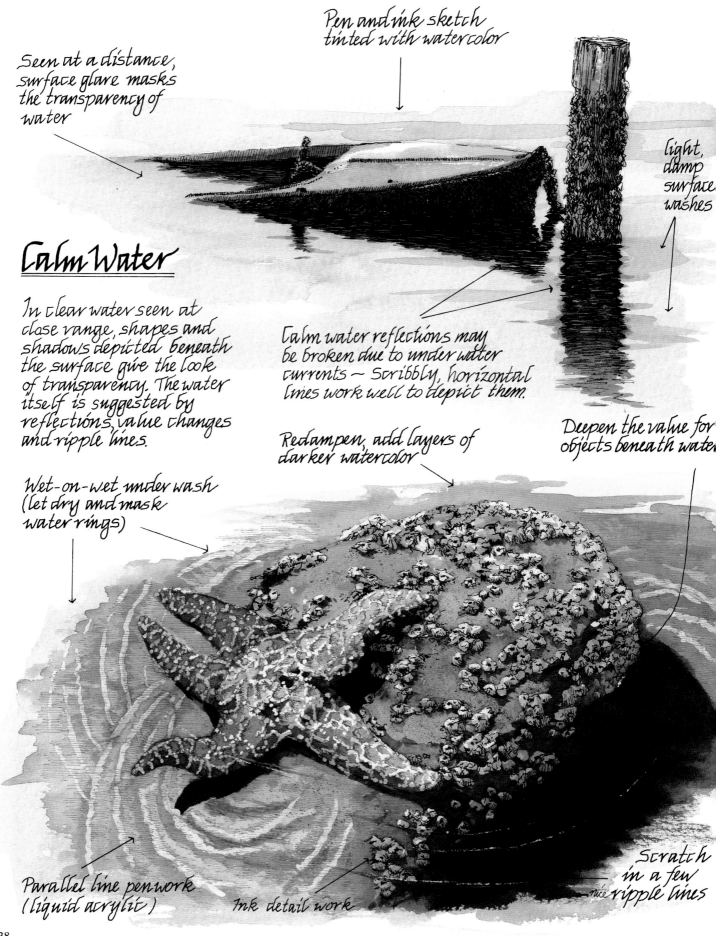

Pen and ink sketch tinted with watercolor

Seen at a distance, surface glare masks the transparency of water

light, damp surface washes

Calm Water

In clear water seen at close range, shapes and shadows depicted beneath the surface give the look of transparency. The water itself is suggested by reflections, value changes and ripple lines.

Calm water reflections may be broken due to under water currents — Scribbly, horizontal lines work well to depict them.

Deepen the value for objects beneath water

Wet-on-wet under wash (let dry and mask water rings)

Redampen, add layers of darker watercolor

Parallel line penwork (liquid acrylic)

Ink detail work

Scratch in a few nice ripple lines

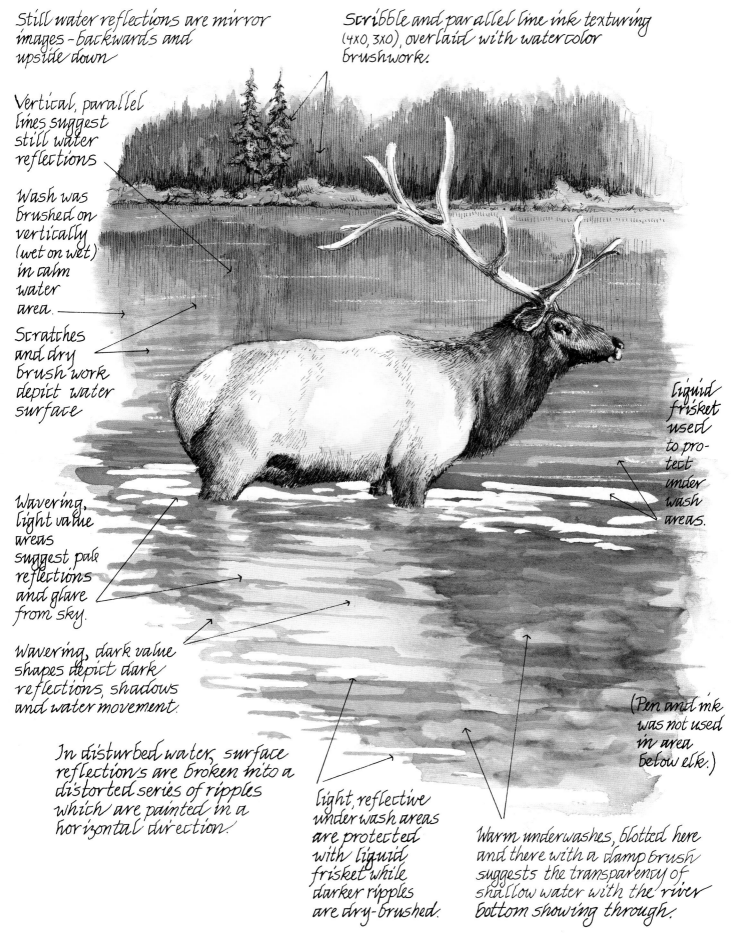

Still water reflections are mirror images – backwards and upside down

Scribble and parallel line ink texturing (4x0, 3x0), overlaid with watercolor brushwork.

Vertical, parallel lines suggest still water reflections

Wash was brushed on vertically (wet on wet) in calm water area.

Scratches and dry brush work depict water surface

Liquid frisket used to protect under wash areas.

Wavering, light value areas suggest pale reflections and glare from sky.

Wavering, dark value shapes depict dark reflections, shadows and water movement.

In disturbed water, surface reflections are broken into a distorted series of ripples which are painted in a horizontal direction.

Light, reflective under wash areas are protected with liquid frisket while darker ripples are dry-brushed.

(Pen and ink was not used in area below elk.)

Warm underwashes, blotted here and there with a damp brush suggests the transparency of shallow water with the river bottom showing through.

Preliminary watercolor washes–damp surface and wet on wet techniques

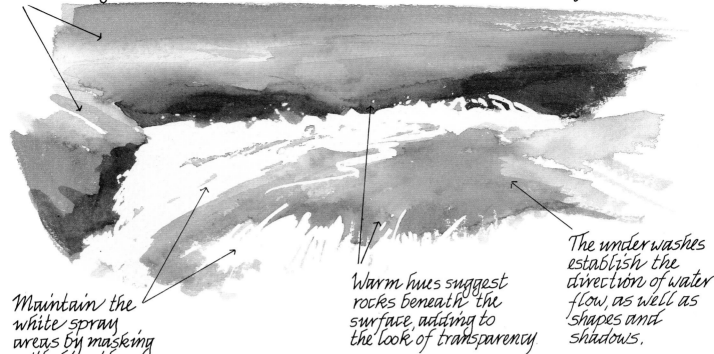

Maintain the white spray areas by masking with liquid frisket

Warm hues suggest rocks beneath the surface, adding to the look of transparency

The under washes establish the direction of water flow, as well as shapes and shadows.

<u>Whitewater</u>

Contour ink detail lines are added, further suggesting the direction of water flow.

The water behind the rocks is darkened with damp and dry-brush work.

Scraped lines add sparkle

The above-water rock is textured with both pen and brushwork providing contrast against the smoothness of the water

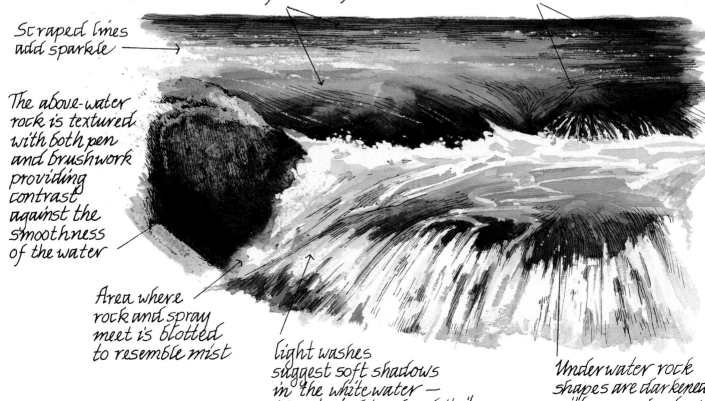

Area where rock and spray meet is blotted to resemble mist

light washes suggest soft shadows in the white water — Maintain lots of "white".

Under water rock shapes are darkened with warm shadow colors and ink lines.

Waterfalls

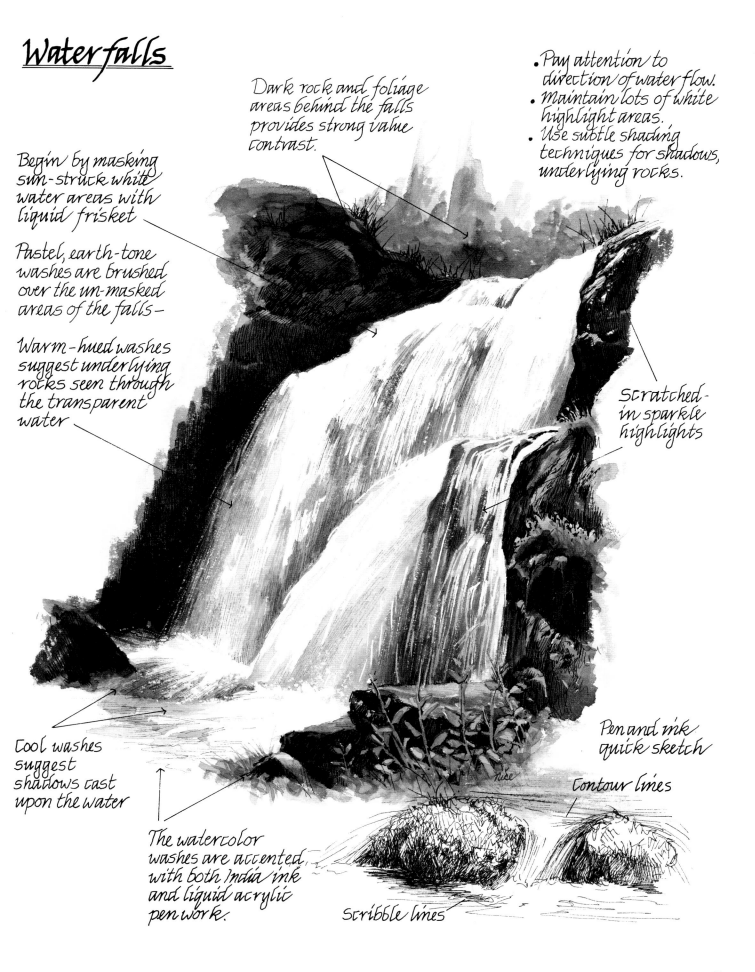

Dark rock and foliage areas behind the falls provides strong value contrast.

- Pay attention to direction of water flow.
- Maintain lots of white highlight areas.
- Use subtle shading techniques for shadows, underlying rocks.

Begin by masking sun-struck white water areas with liquid frisket

Pastel, earth-tone washes are brushed over the un-masked areas of the falls—

Warm-hued washes suggest underlying rocks seen through the transparent water

Scratched-in sparkle highlights

Cool washes suggest shadows cast upon the water

The watercolor washes are accented with both India ink and liquid acrylic pen work.

Pen and ink quick sketch

nice

Contour lines

Scribble lines

White spray areas are protected with liquid frisket.

Preliminary washes are brushed on a damp surface.

Spatter frisket at edges

Wave crests are illuminated with backlighting

Spray shadow area is painted, then blotted with a paper tissue

Stroke waves and breakers in the direction of water flow.

Soften white spray areas with shadows (cool washes)

Scratch in broken spray sparkles

Blend in additional washes to deepen value and create dimension

Waves are shaped using dry-brush work

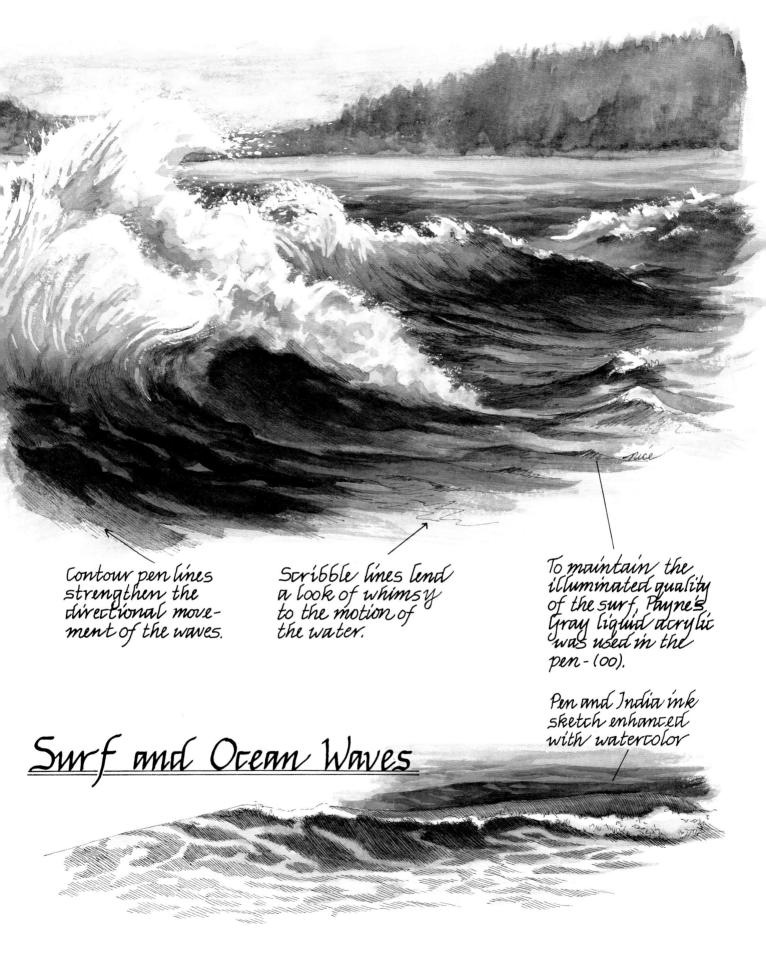

Contour pen lines strengthen the directional movement of the waves.

Scribble lines lend a look of whimsy to the motion of the water.

To maintain the illuminated quality of the surf, Payne's Gray liquid acrylic was used in the pen - (00).

Pen and India ink sketch enhanced with watercolor

Surf and Ocean Waves

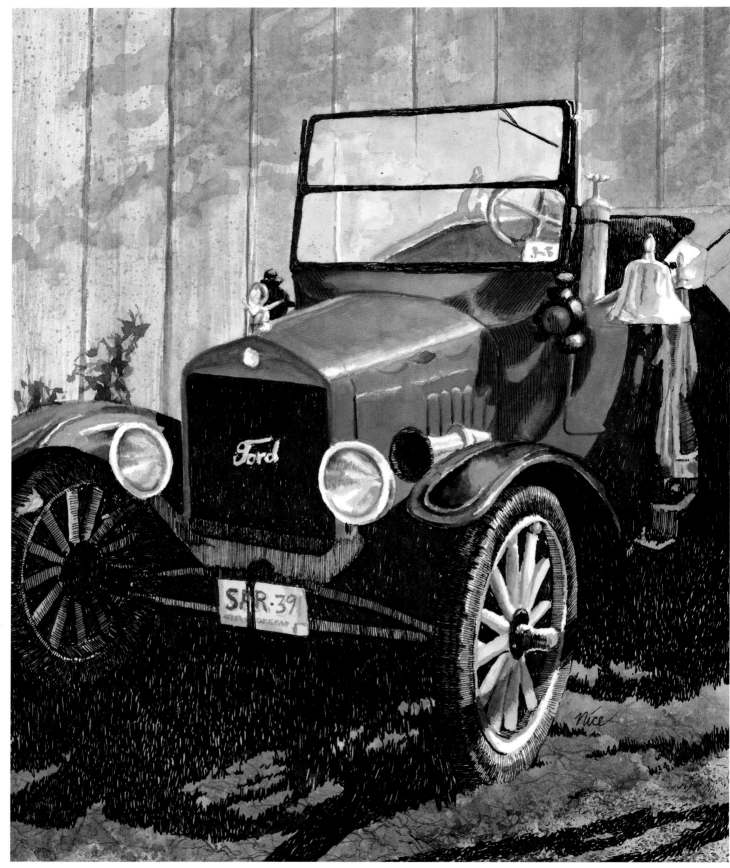

OLD TIMER, 8½″×7″, Pen and India Ink drawing, overlaid with watercolor.

METALLIC IMPRESSIONS

"Smooth" can be a tricky texture, especially when the smooth surface is in the form of polished metal. Understanding what makes a surface look shiny can help turn a metallic problem into a fun project. To begin with, a polished surface has an abundance of white highlights. It is strong in reflective color as well as local color, with quite a wide range of hues. Color and value changes are often abrupt, representing glare, sparkle and mirror-like reflections.

Contrasting a shiny surface with a highly textured background or foreground can make the surface look even more reflective by comparison. In the painting at left, the foreground area was heavily textured with scribble lines, splatter and dog hair techniques.

Dull, tarnished metals are strong in local color, but pick up little reflected color. The local color consists of a limited palette—usually a base mixture and several tints and shades derived from it. Tarnished metals have a blended look, with color and value changes flowing softly, one shade into the next. Oxidation causes the metal to lose its luster, resulting in a subdued glow that can be represented with a few small, off-white highlights.

Rusty, aged metals can range from fairly smooth to a virtual kaleidoscope of texture in their most corroded stages. Inked scribble lines, dots and cross-hatching, combined with an imaginative use of watercolor techniques, can produce rust so real it seems to flake from the page. Rust has so many "faces" that it's hard not to depict it well. In fact, if your polished metal doesn't shine and your tarnished·surface doesn't glow, dip your brush in a warm sienna mixture and corrode your metal into a rusty relic.

Polished Silver

Silver is very pale in local color with strong highlights and a profuse display of reflected hues.

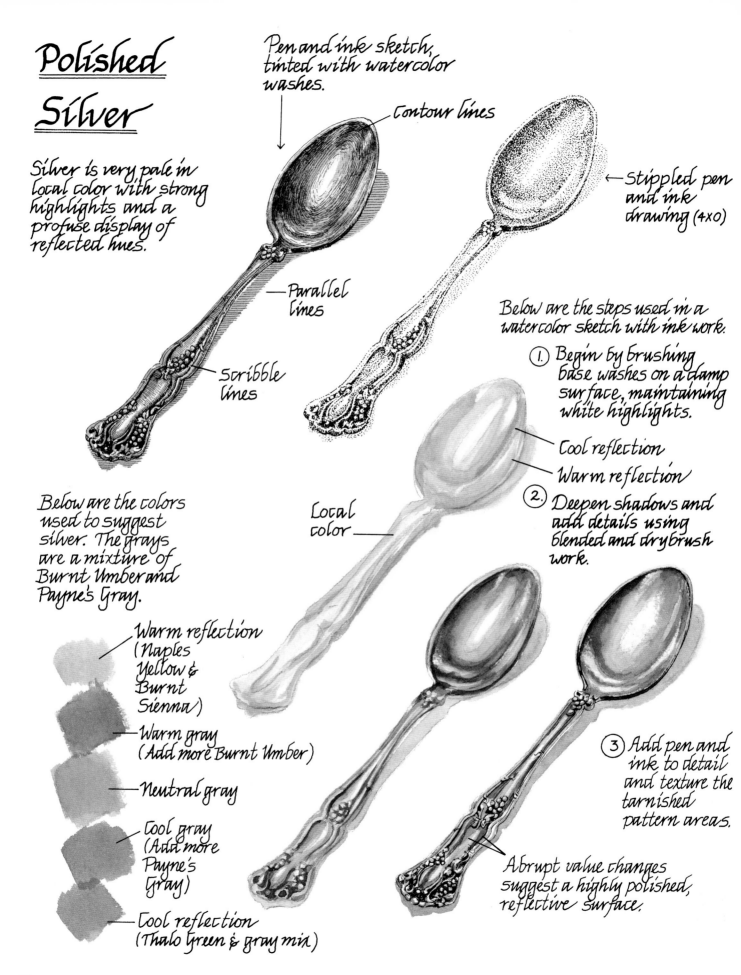

Pen and ink sketch, tinted with watercolor washes.

Contour lines

Parallel lines

Scribble lines

← Stippled pen and ink drawing (4×0)

Below are the steps used in a watercolor sketch with ink work.

① Begin by brushing base washes on a damp surface, maintaining white highlights.

Cool reflection

Warm reflection

② Deepen shadows and add details using blended and drybrush work.

Local color

Below are the colors used to suggest silver. The grays are a mixture of Burnt Umber and Payne's Gray.

Warm reflection (Naples Yellow & Burnt Sienna)

Warm gray (Add more Burnt Umber)

Neutral gray

Cool gray (Add more Payne's Gray)

Cool reflection (Thalo Green & gray mix)

③ Add pen and ink to detail and texture the tarnished pattern areas.

Abrupt value changes suggest a highly polished, reflective surface.

Raw Sienna makes a good base color for brass, which consists of copper and zinc.

Bronze, made up of copper and tin can be represented with Raw Sienna/Burnt Sienna mixes.

Gold base mixture— Yellow Ochre and Raw Sienna

Add Ultramarine Blue to deepen gold mixture.

For a dark, contrasting shadow add Thio Violet

Contour pen and ink lines

Abrupt value changes to depict a highly polished surface

Light areas of local color add a warm glow

Leave white-paper highlight areas for polished shine.

Brass, Gold, Copper And Bronze

These warm-hued metals are strong in local color. The light sienna tones are contrasted with dark, unblended streaks of rich brown, suggesting a reflective, shiny surface.

Copper base mixture— Burnt Sienna with a touch of Cadmium Yellow, Cadmium Orange and Alizarin Crimson added.

Add Violet and Alizarin Crimson to deepen mixture

Cast-iron And Tarnished Metal

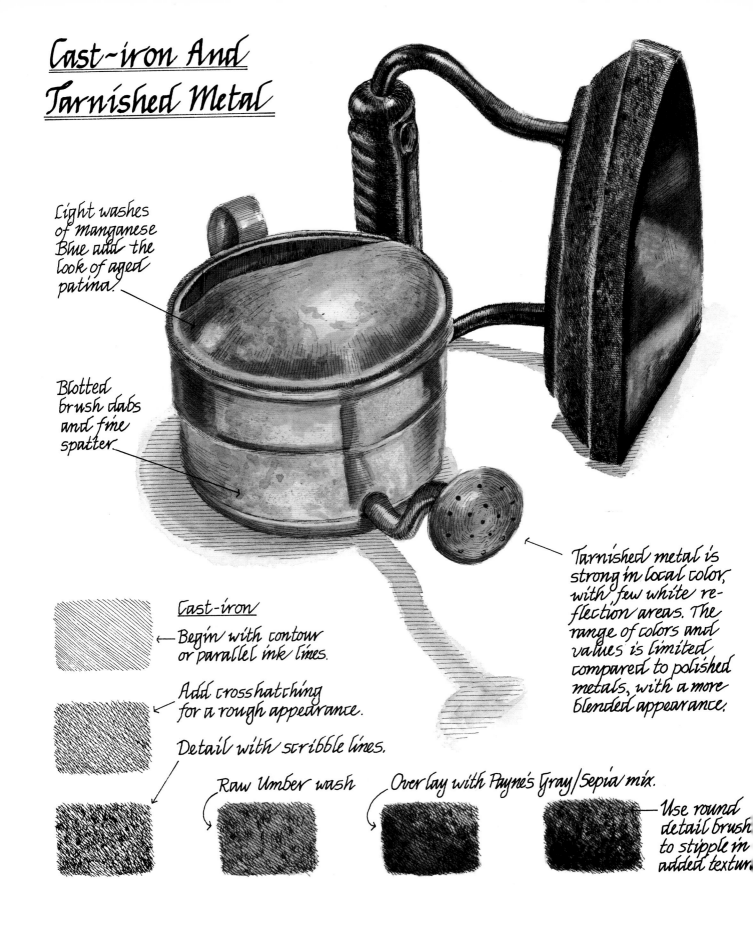

Light washes of manganese Blue add the look of aged patina.

Blotted brush dabs and fine spatter

Tarnished metal is strong in local color, with few white reflection areas. The range of colors and values is limited compared to polished metals, with a more blended appearance.

Cast-iron
← Begin with contour or parallel ink lines.

Add crosshatching for a rough appearance.

Detail with scribble lines.

Raw Umber wash

Overlay with Payne's Gray/Sepia mix.

→ Use round detail brush to stipple in added texture.

① Damp surface wash – (Indigo and Cobalt)

Brush on streaks of liquid frisket to form pattern

Chipped area is darkened with pen and ink work, then overlaid with watercolor washes.

Center of chipped area is a mixture of Indigo and Raw Sienna.

② Brush on a second, darker layer of the Indigo/Cobalt mixture. Let dry and remove frisket.

Lighten areas by blotting

Deepen shadows with both pen and brushwork

Burnt Sienna rust spot

③ Use a clean, damp flat brush to blend and soften streaked pattern into the darker hue surrounding it.

Flaws, chipped areas and spots of rust add character

White highlights suggest a shiny surface

The streaked design in patterned enamelware should conform to the contours of the object.

Enamelware

Preliminary damp surface wash -
(Mixture of Ultramarine Blue
and Burnt Umber)

Blotted
lightly with a
crumpled tissue

Using wet-on-wet, free flow
techniques, daub on warm
rust colors -

- Yellow Ochre
- Raw Sienna
- Indian Red
- Burnt Sienna
- Burnt Sienna
 mixed with
 Cadmium
 Orange, Indigo,
 Ultramarine
 Blue or Alizarin
 Crimson.

Heavy rust
requires lots of
texturing. Spatter,
dry brush, natural
sponge stamping
and a spray
mister were
all used to
achieve
this.

Rust

Under the influence of time,
weather and corrosion,
common metal objects can
become interesting sketching
subjects. The heavier
the rust, the more
textured and
colorful they
become.

This rusted
potato peeler was
found in a mole hill
in the author's garden.
The heavy rust was thickly
layered and crumbly.

India ink and brown
liquid acrylic were stippled
on with a 3x0 Rapidograph,
representing rust particles.

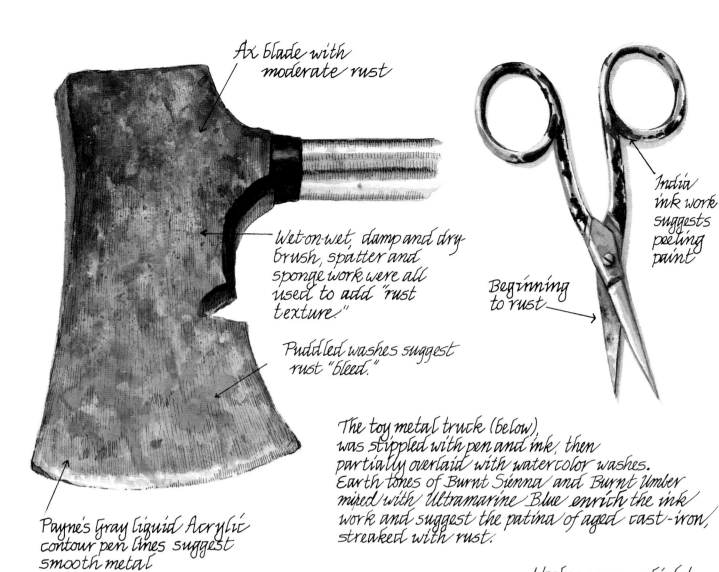

Ax blade with moderate rust

Wet-on-wet, damp and dry brush, spatter and sponge work were all used to add "rust texture."

Puddled washes suggest rust "bleed."

Payne's Gray liquid Acrylic contour pen lines suggest smooth metal texture.

India ink work suggests peeling paint

Beginning to rust

The toy metal truck (below), was stippled with pen and ink, then partially overlaid with watercolor washes. Earth tones of Burnt Sienna and Burnt Umber mixed with Ultramarine Blue enrich the ink work and suggest the patina of aged cast-iron, streaked with rust.

Washes were applied to a damp surface.

GASOLINE

Touches of red paint suggest the original color of the truck.

Damp surface bruising used to suggest tree branches.

Old machinery has a nostalgic appeal that makes it a good choice for subject matter. Old paint, dust, rust and corrosion all add to the interest.

Contour ink lines, layered damp surface washes and drybrush work provides the illusion of aged, rusty metal, seen at a distance.

Weathered metal has a dull sheen — keep highlights muted!

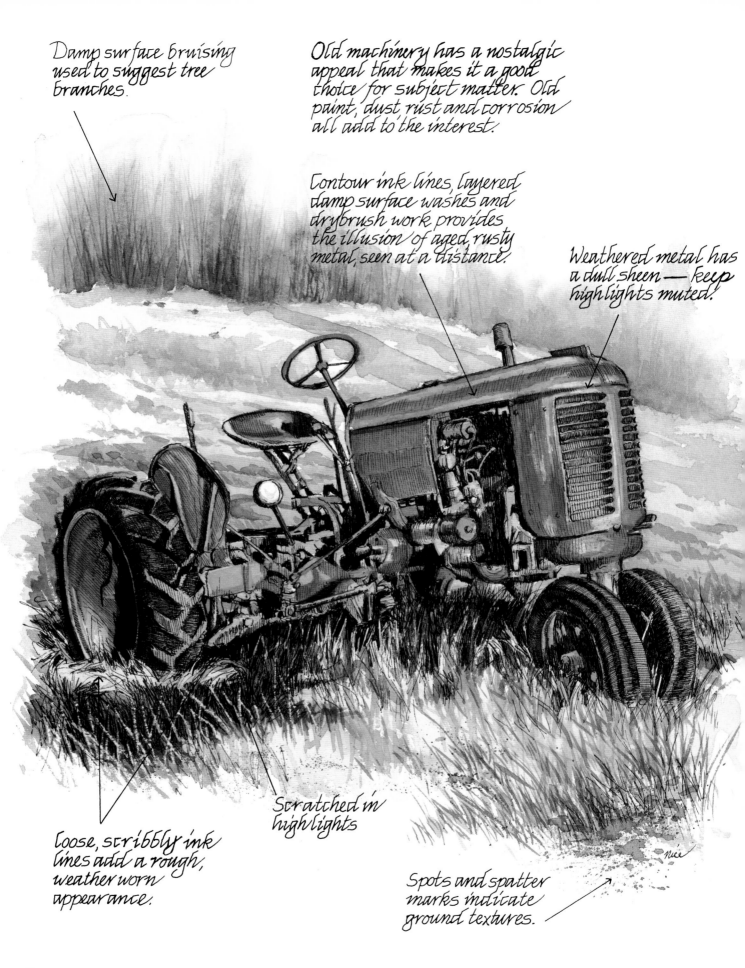

Scratched in highlights

Loose, scribbly ink lines add a rough, weather worn appearance.

Spots and spatter marks indicate ground textures.

Base wash – (damp surface)
- Burnt Sienna
- Cadmium Orange
- plus a touch of
 Ultramarine Blue

Overlay mixture
- Burnt Sienna
- Cadmium Orange
- Ultramarine Blue

Shadow mixture – (drybrush)
- Burnt Sienna
- Alizarin Crimson
- Violet
- muted with Indigo
 or Payne's Gray.

The barn sketch (below) is a pen and ink drawing enhanced with watercolor.

Rusty metal seen at a great distance is muted in color, with little apparent texture.

Corrugated metal roof suggested by parallel ink lines.

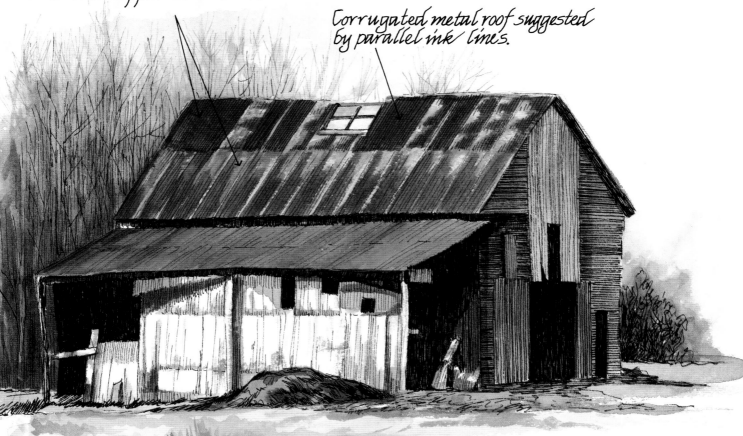

For color balance, the Sienna-earth tone mixtures are re-used in the foreground.

53

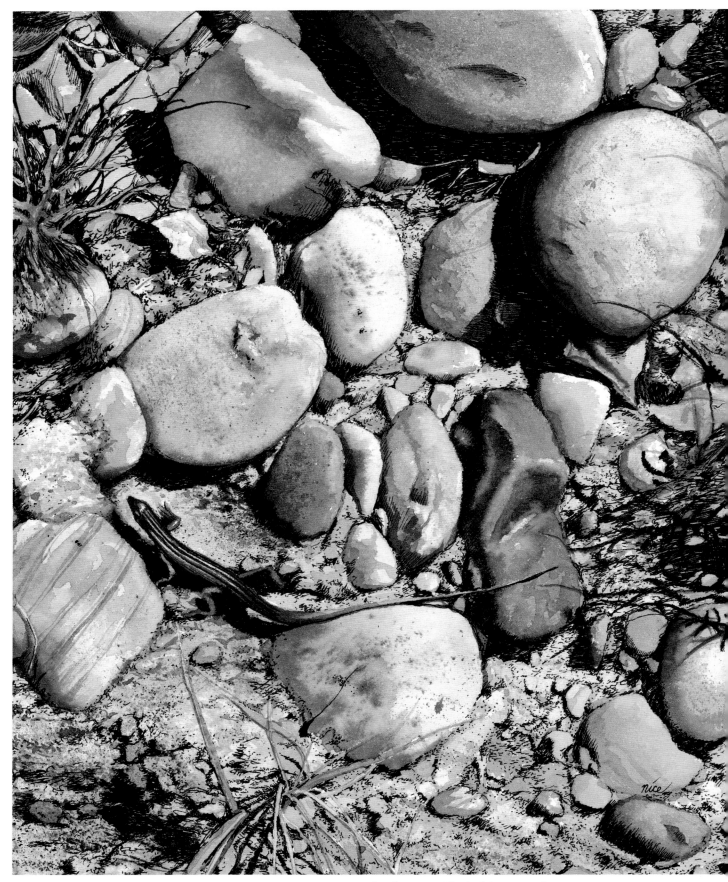

LIZARD ON ROCKY GROUND, 8½″ × 7″, Pen and India Ink, watercolor.

EARTH AND STONE TEXTURES

In your search for exciting textures, don't overlook the earth beneath your feet. Soil, sand and rocks are rich in texture, ranging from smooth to gritty, craggy and crumbly. Stippling and brush spatter techniques work well to suggest grittiness. Combinations of crosshatching, scribble lines and dotted ink work, intermixed with creative watercolor textures can produce an endless array of rough and friable textures. Damp surface and wet-on-wet washes are a good base for smooth, time-polished stones. Add a touch of contour line work, dry brush detailing or damp surface spatter, and even the plainest creek pebble will catch the eye of the beholder with its simple, realistic appearance.

When the bare earth is seen as part of a landscape rather than the main subject, keep it simple. Merely *suggest* the terrain with muted washes and a touch of texture here and there.

The natural earth pigments of sienna, umber and ochre are obvious choices when depicting earth textures. However, don't be afraid to add a few spunky hues to the mix. Subtle blends of yellow, orange or magenta will wake up the earthy browns, adding warmth and vibrancy to your work. On the other hand, Payne's gray, blue or violet will cool down your brown mixtures, resulting in perfect hues for deep, cool shadows and damp, dark stones that are cold to the touch.

Begin studying earth textures by taking a walk. Look at the dirt with an artist's eye. Collect a few stones. There is an intriguing variety of shapes, colors and patterns waiting just outside the door and down the path. If you are a city dweller, look up! Brick, adobe, stone masonry and marble walls are rich in texture too.

Soil

Most of the time soil, dirt and bare earth can be adequately represented with a damp to wet surface wash of earth-tone browns and grays, textured with a fine spattering of clear water. Deeper value, dry surface spatter and a touch of ink or liquid acrylic stippling completes the look.

Red Clay Soil

Top Soil

Dry, Dusty Soil

Rich Humus

Burnt Umber &
Ultramarine mixture

(1.)

(2.)

Conifer Forest Duff

1. Begin by masking out pine needle shapes with liquid frisket.
2. Brush an earthy brown wash over the dried frisket - (damp surface).
3. Press a crumpled plastic wrap over the wet wash and let dry.
4. Rub off masking.
5. Use Sienna/Burnt Umber paint mixtures to drybrush the pine needles.
6. Finish with a touch of dark brown spatter and inked scribble lines.

Spatter

(3.)

(4.)

(5.)

ink work

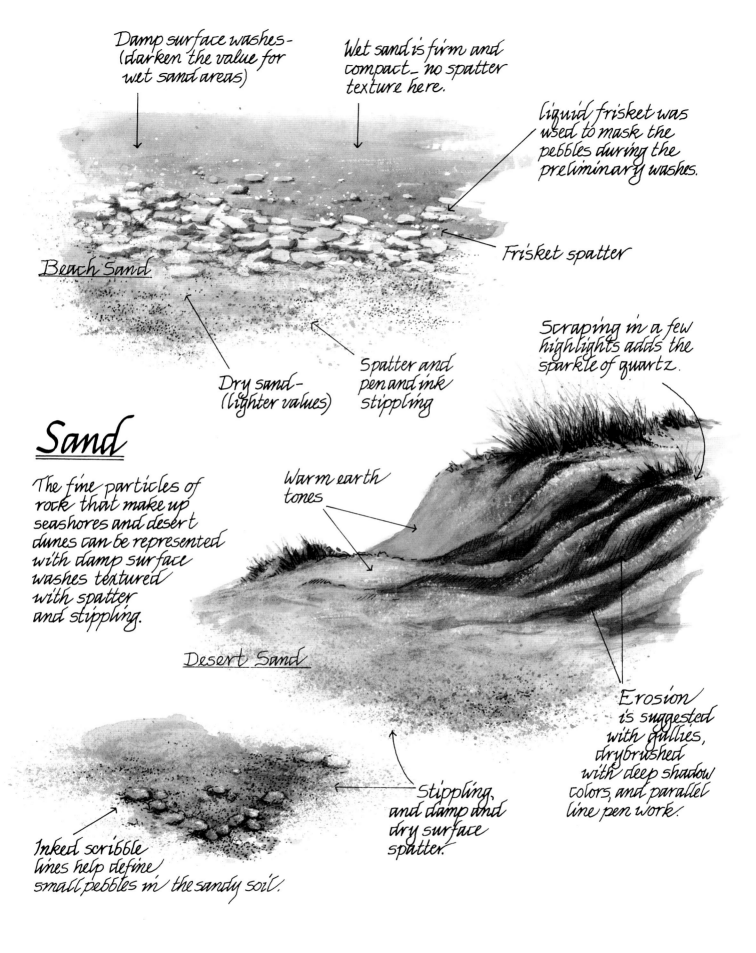

Damp surface washes—
(darken the value for
wet sand areas)

Wet sand is firm and
compact—no spatter
texture here.

liquid frisket was
used to mask the
pebbles during the
preliminary washes.

Beach Sand

Frisket spatter

Scraping in a few
highlights adds the
sparkle of quartz.

Dry sand—
(lighter values)

Spatter and
pen and ink
stippling

Sand

The fine particles of
rock that make up
seashores and desert
dunes can be represented
with damp surface
washes textured
with spatter
and stippling.

Warm earth
tones

Desert Sand

Erosion
is suggested
with gullies,
drybrushed
with deep shadow
colors, and parallel
line pen work.

Stippling,
and damp and
dry surface
spatter.

Inked scribble
lines help define
small pebbles in the sandy soil.

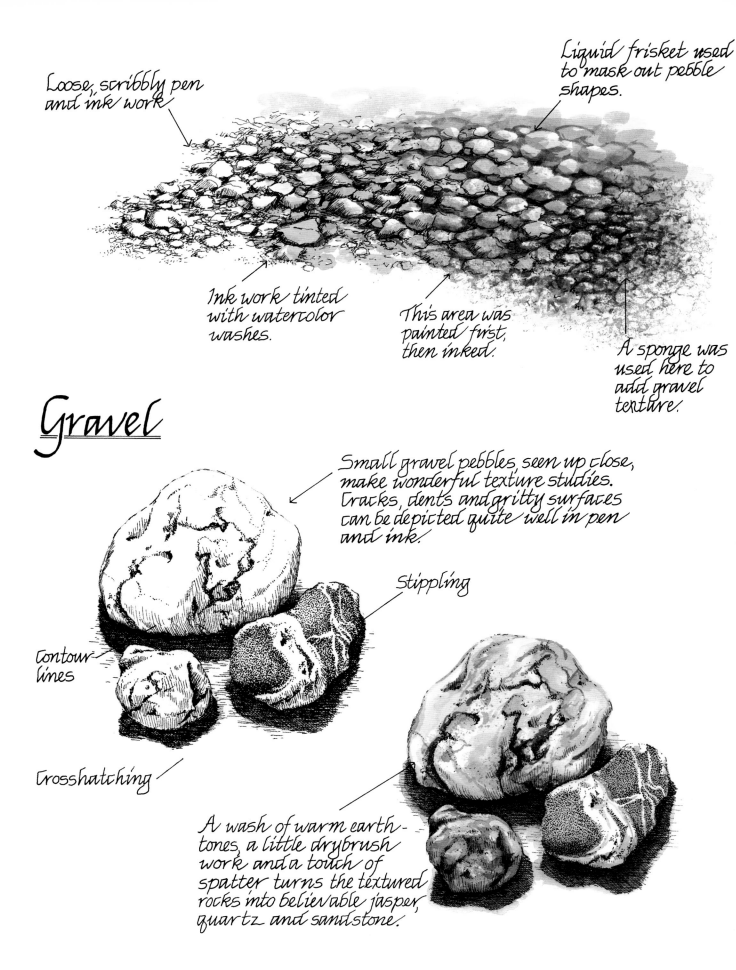

Loose, scribbly pen and ink work

Liquid frisket used to mask out pebble shapes.

Ink work tinted with watercolor washes.

This area was painted first, then inked.

A sponge was used here to add gravel texture.

Gravel

Small gravel pebbles, seen up close, make wonderful texture studies. Cracks, dents and gritty surfaces can be depicted quite well in pen and ink.

Stippling

Contour lines

Crosshatching

A wash of warm earth-tones, a little drybrush work and a touch of spatter turns the textured rocks into believable jasper, quartz and sandstone.

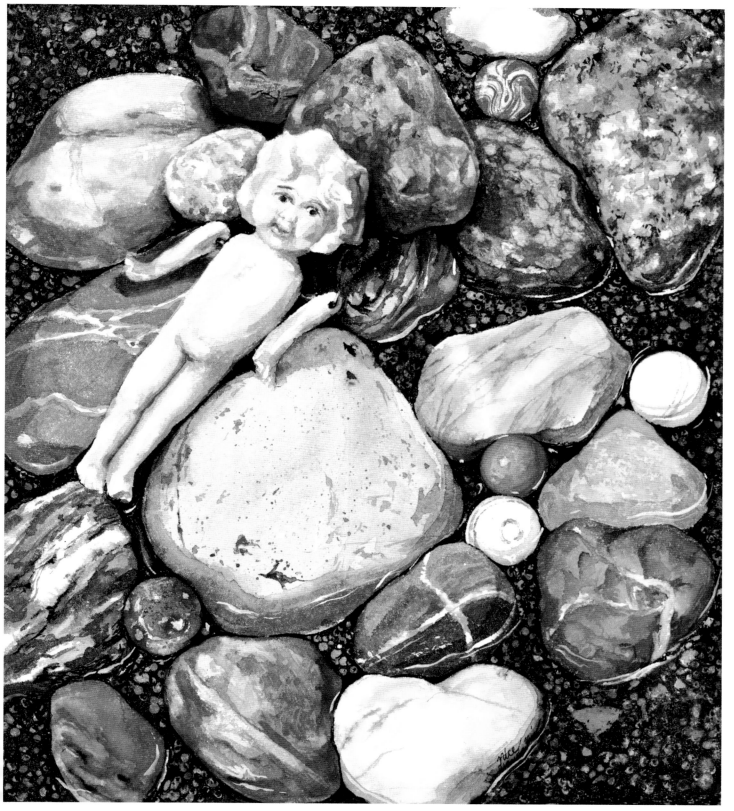

TOYS IN THE CREEK BED, 7½″ × 6½″

Tumbled, water-worn stones are smooth and rounded. Moisture enriches their color and enhances the texture patterns on their surface. The washed gravel seen in this painting represents a small variety of such stones. Each rock consists of several layers of watercolor wash, textured with dry-brush work and a few pen and ink accents. The pea gravel background was worked heavily with pen and ink scribble lines.

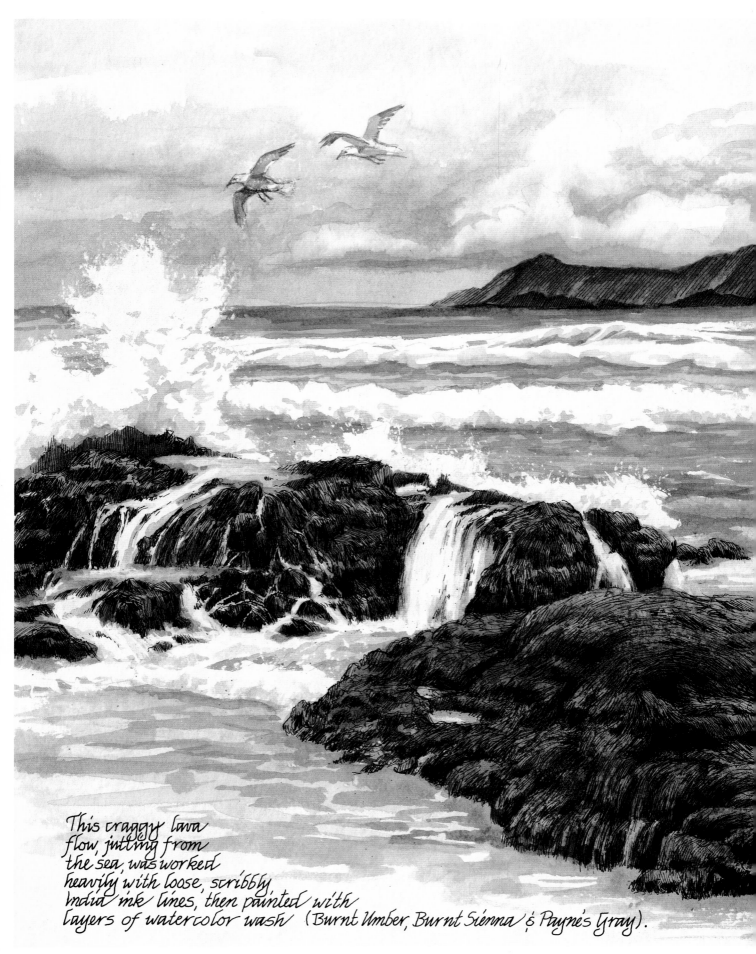

This craggy lava
flow, jutting from
the sea, was worked
heavily with loose, scribbly,
India ink lines, then painted with
layers of watercolor wash (Burnt Umber, Burnt Sienna & Payne's Gray).

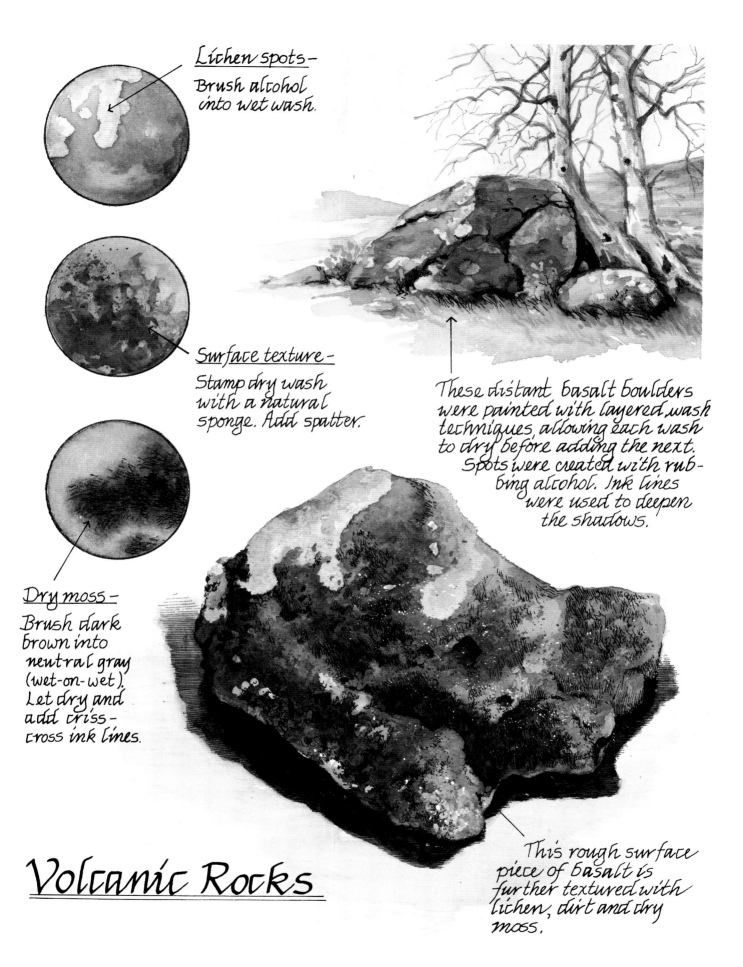

Lichen spots –
Brush alcohol into wet wash.

Surface texture –
Stamp dry wash with a natural sponge. Add spatter.

Dry moss –
Brush dark brown into neutral gray (wet-on-wet). Let dry and add criss-cross ink lines.

These distant basalt boulders were painted with layered wash techniques, allowing each wash to dry before adding the next. Spots were created with rubbing alcohol. Ink lines were used to deepen the shadows.

This rough surface piece of basalt is further textured with lichen, dirt and dry moss.

Volcanic Rocks

a. Preliminary wash – (brushed onto a very damp surface)

б. Shadows deepened

Contours are defined with additional layers of watercolor.

Bruising lines

Spatter

Granite

Pen and ink detailing

c.

Drybrush

At a distance, granite boulders appear smooth, with just a hint of texture.

1. Salt sprinkled onto a damp wash of Raw Sienna, Umbers and Payne's Gray. Let dry.

2. Redampen and stipple in darker values with a round detail brush.

3. Add dark flecks and dots with pen and ink. Spatter lightly with watercolor wash.

Closeup, granite is rough, mottled with mineral crystals.

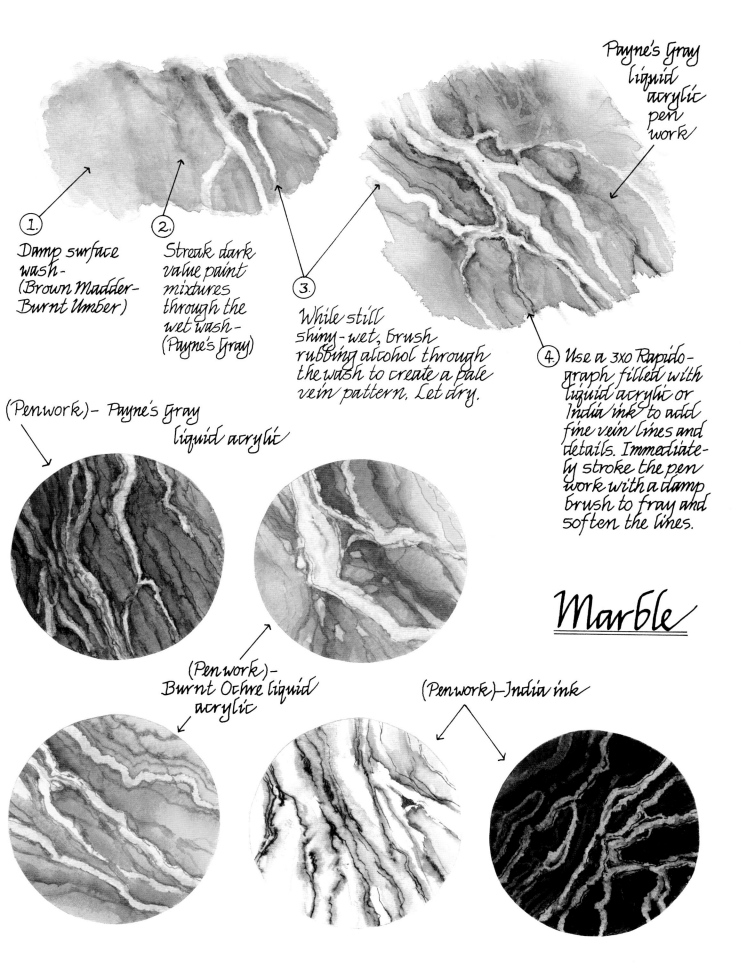

Payne's Gray
liquid
acrylic
pen
work

① Damp surface
wash-
(Brown Madder-
Burnt Umber)

② Streak dark
value paint
mixtures
through the
wet wash-
(Payne's Gray)

③ While still
shiny-wet, brush
rubbing alcohol through
the wash to create a pale
vein pattern. Let dry.

④ Use a 3x0 Rapido-
graph filled with
liquid acrylic or
India ink to add
fine vein lines and
details. Immediate-
ly stroke the pen
work with a damp
brush to fray and
soften the lines.

(Penwork)- Payne's Gray
liquid acrylic

(Penwork)-
Burnt Ochre liquid
acrylic

(Penwork)-India ink

Marble

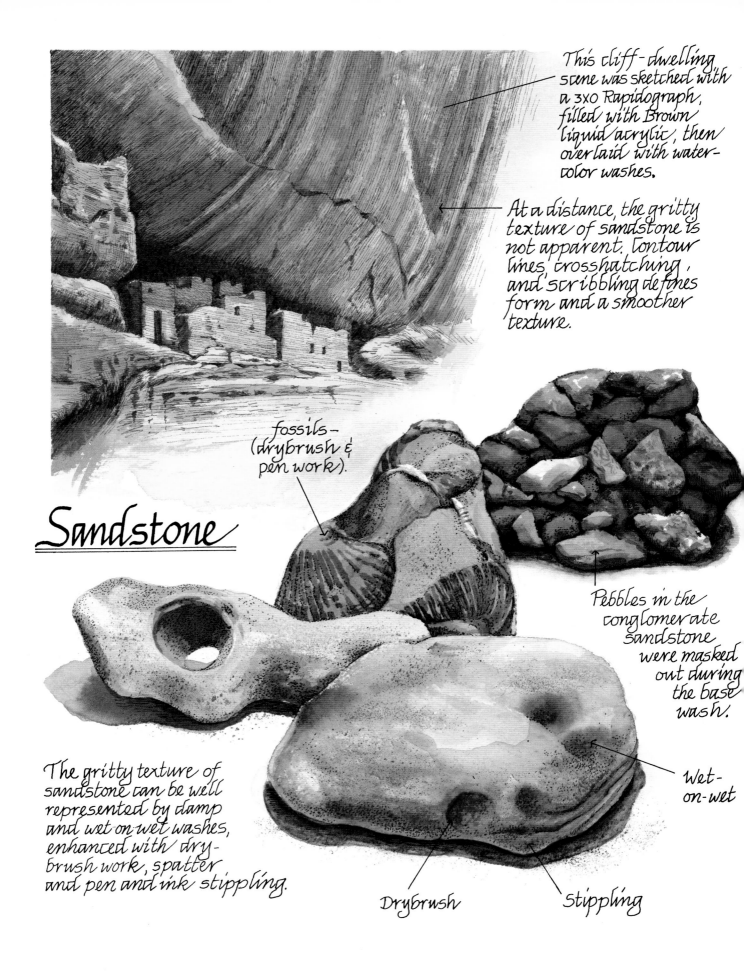

This cliff-dwelling scene was sketched with a 3x0 Rapidograph, filled with Brown liquid acrylic, then overlaid with water-color washes.

At a distance, the gritty texture of sandstone is not apparent. Contour lines, crosshatching, and scribbling define form and a smoother texture.

fossils – (drybrush & pen work).

Sandstone

Pebbles in the conglomerate sandstone were masked out during the base wash.

The gritty texture of sandstone can be well represented by damp and wet on wet washes, enhanced with dry-brush work, spatter and pen and ink stippling.

Wet-on-wet

Drybrush

Stippling

Adobe & Brick

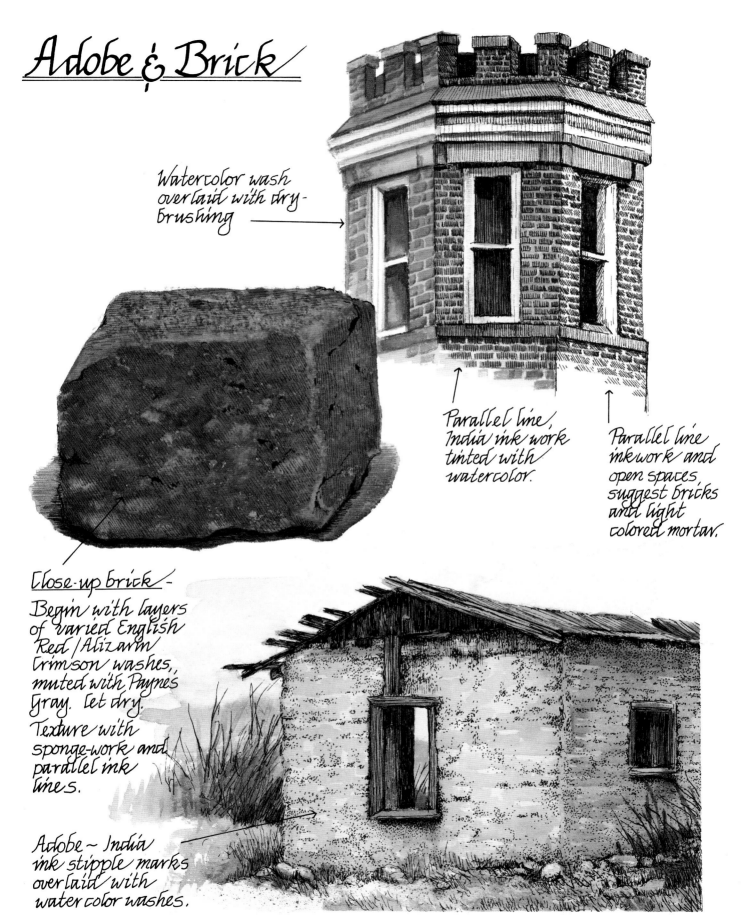

Watercolor wash overlaid with dry-brushing

Parallel line, India ink work tinted with watercolor.

Parallel line inkwork and open spaces, suggest bricks and light colored mortar.

Close-up brick —
Begin with layers of varied English Red/Alizarin Crimson washes, muted with Paynes Gray. Let dry. Texture with sponge-work and parallel ink lines.

Adobe — India ink stipple marks overlaid with watercolor washes.

Stone Masonry

Lay down varied damp surface washes in the shape of flag stones.

Use a lighter valued wash to suggest mortar.

Texture with drybrush & spatter.

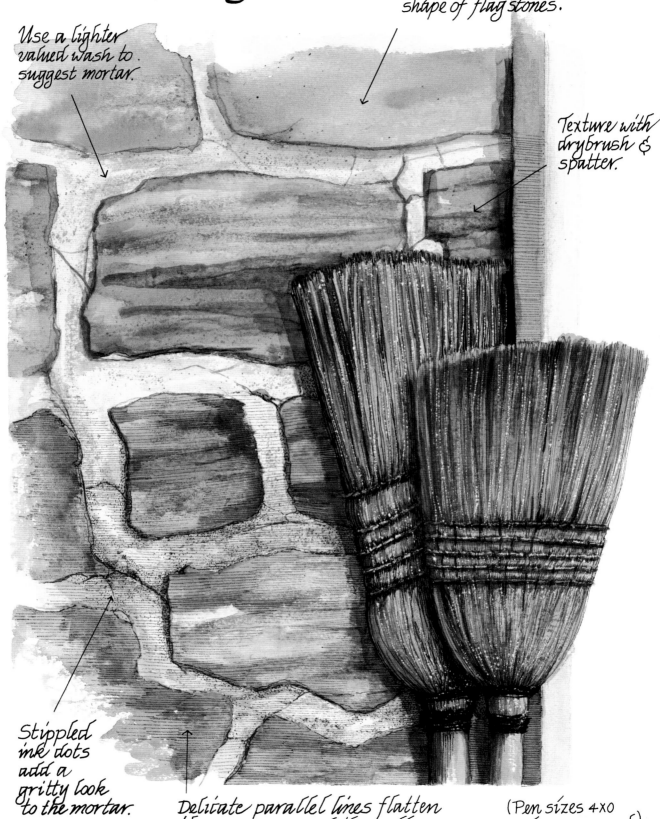

Stippled ink dots add a gritty look to the mortar.

Delicate parallel lines flatten the appearance of the wall.

(Pen sizes 4x0 and 3x0 were used)

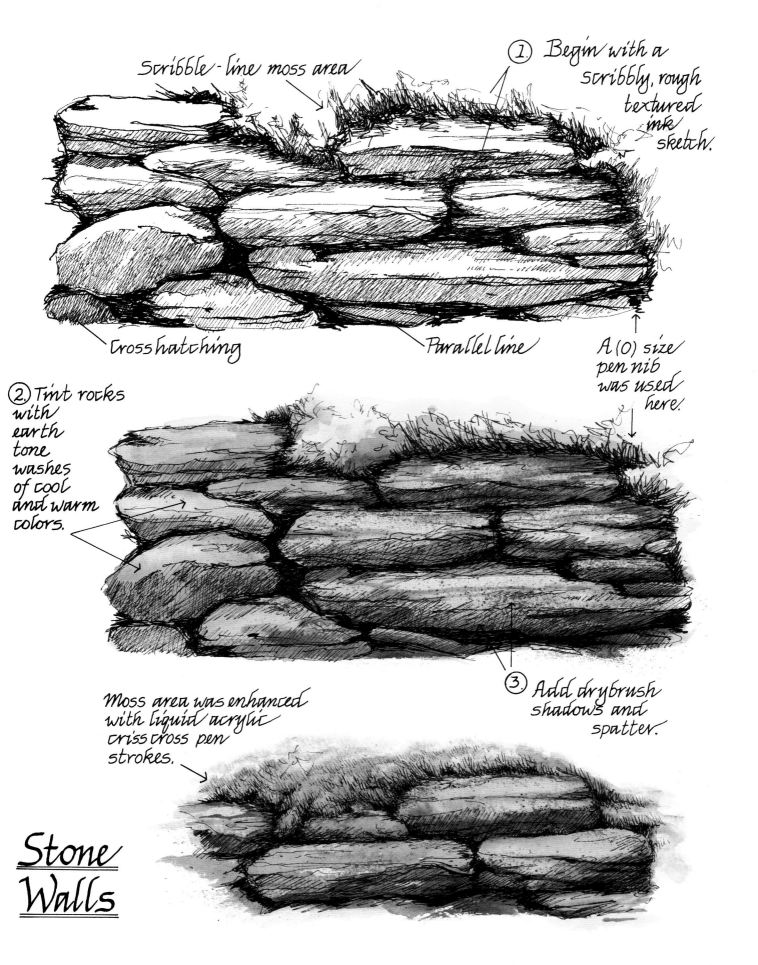

Scribble-line moss area

① Begin with a scribbly, rough textured ink sketch.

Cross hatching

Parallel line

A (0) size pen nib was used here.

② Tint rocks with earth tone washes of cool and warm colors.

③ Add drybrush shadows and spatter.

Moss area was enhanced with liquid acrylic criss cross pen strokes.

Stone Walls

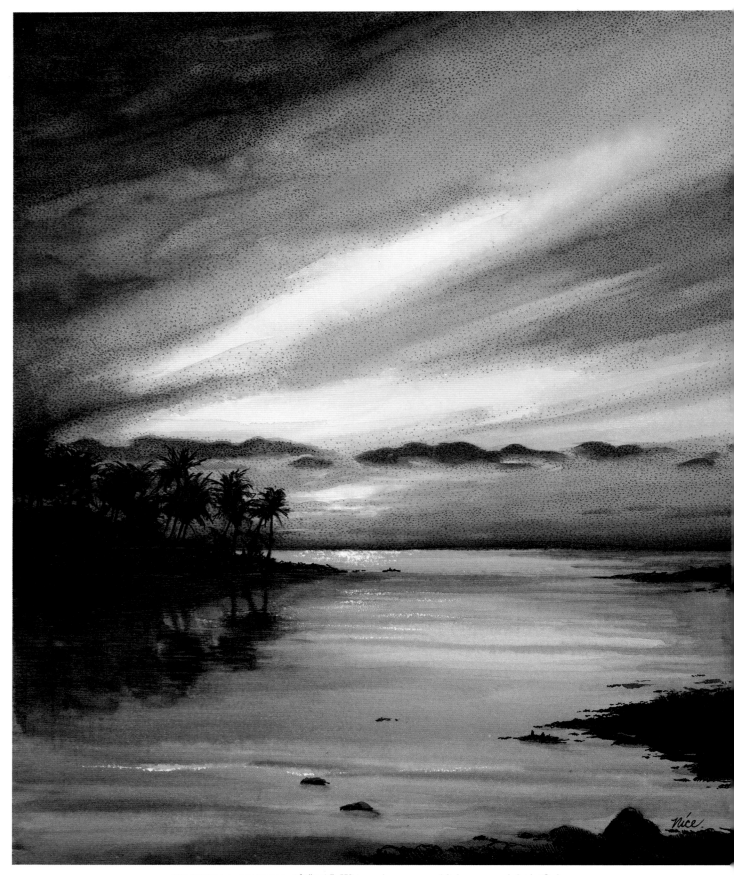

TROPICAL SUNSET, 8⅝″×7″, Watercolor, pen and ink, pen and ArtistColor.

SKIES AND WEATHER

The sky is often portrayed as a calm, blue, hardly noticed backdrop. However, when clouds pile up into fluffy mountains or march troop-like in ominous formations or burn the heavens with reflected color, there is enough drama to catch our full attention. No other subject is quite as changeable or challenging as a cloud, whose elusive nature can be both thick, dark and threatening, and as delicately transparent as silken cobwebs.

To maintain the fragile aspect of clouds, I begin my sky depictions with wet-on-wet watercolor washes. As darker values are stroked in place, pastel or unpainted areas form spontaneous cloud shapes with soft, naturally blended edges. This process is not complete until the paper is dry. Don't be afraid to blot in a few highlights, re-align a shape with a damp brush or change the flow with a spray mister. However, keep in mind that overworking wet wash areas can result in water flow marks, puddling and muddy, tired paper. When something pleasing happens, leave it alone! Values can be darkened, color highlighted, and additional cloud formations added once the initial wet-on-wet work is completely dry. Stroke the additional washes *lightly* over the surface so as not to disturb the underlying paint. Gently blend the moist edges with a clean, damp brush.

The last step is to decide if the addition of pen work would benefit the composition. A bit of stippling can add textural interest to a cloud formation—defining the shape and deepening the shadows. Parallel lines provide strong definition and create the appearance of wind, rain and movement. If India Ink is too harsh, use colored inks or liquid acrylic. Yes, even a plain blue sky can be texturally exciting when enhanced with the stroke of a pen.

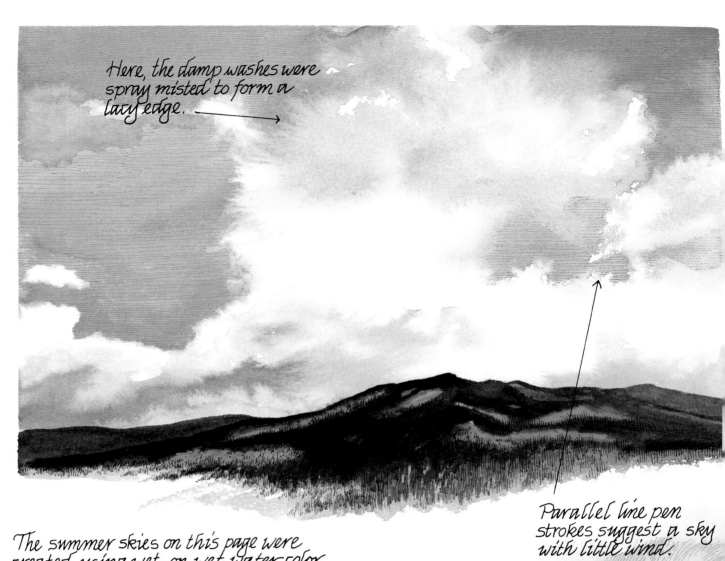

Here, the damp washes were spray misted to form a lacy edge.

Parallel line pen strokes suggest a sky with little wind.

The summer skies on this page were created using wet-on wet water color techniques. Unpainted areas formed spontaneous clouds.

Delicate wavy line pen work suggests wind movement.
(Process Cyan Artist Color was used in a 3x0 Rapidograph)

Cumulus Clouds

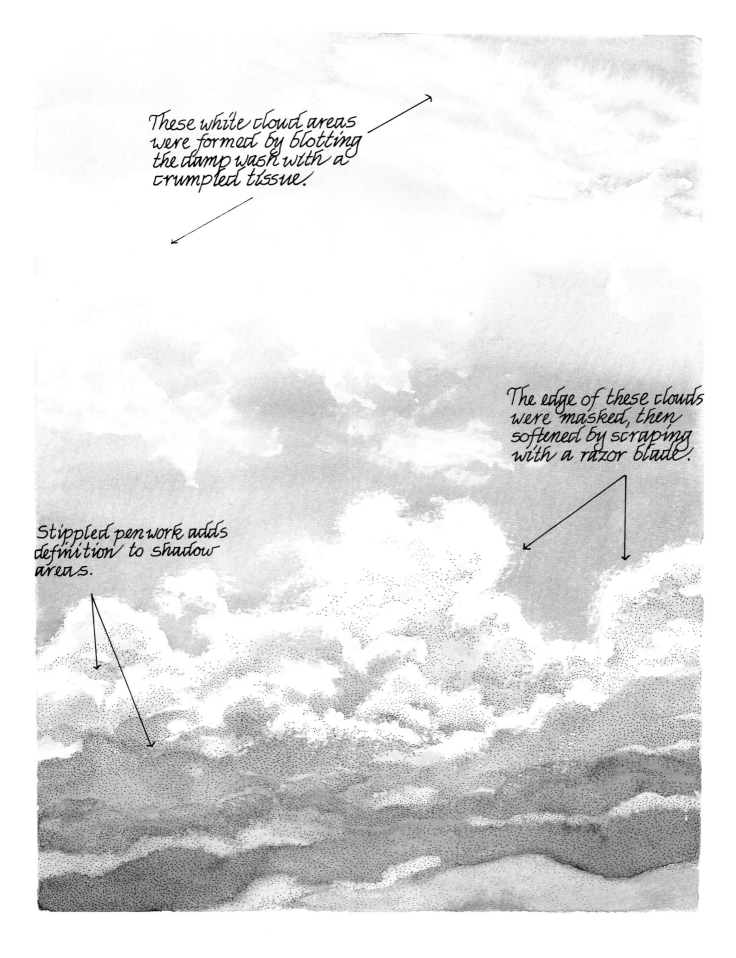

These white cloud areas were formed by blotting the damp wash with a crumpled tissue.

The edge of these clouds were masked, then softened by scraping with a razor blade.

Stippled pen work adds definition to shadow areas.

Rain Clouds

Nimbus (rain) clouds consist of moisture laden stratus (layered) clouds, heaped up cumulus clouds or a mixture of both.

Begin painting these rain cloud formations with wet-on-wet washes of varied values. Use dark violet / Payne's Gray mixtures against pale grays, pastels and white unpainted areas, for drama and contrast.

Diagonal, parallel pen strokes worked over the dry washes, suggest wind and rainfall.

Texturing the clouds with stippled penwork adds a bold, heavy quality to the scene.

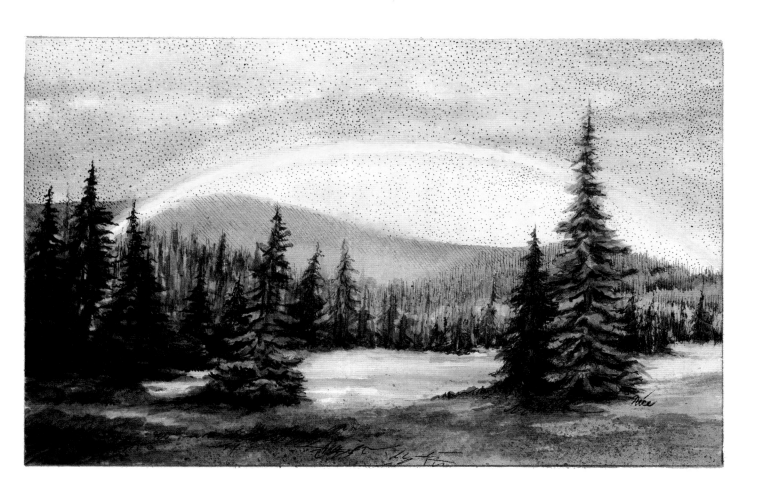

Rainbows

① Lay down a damp surface wash of pale yellow. Let dry.

② Add a pale red-orange stripe to the top of the bow, and a blue-green and lavender stripe to the bottom. Blend with a damp, detail brush. →

③ Moisten the areas above and below the arc and lay in a wet-on-wet cloud formation. →

Accent the clouds with stippled pen work.

(3xo above arc & 4xo below)

Area below arc is lighter in value.

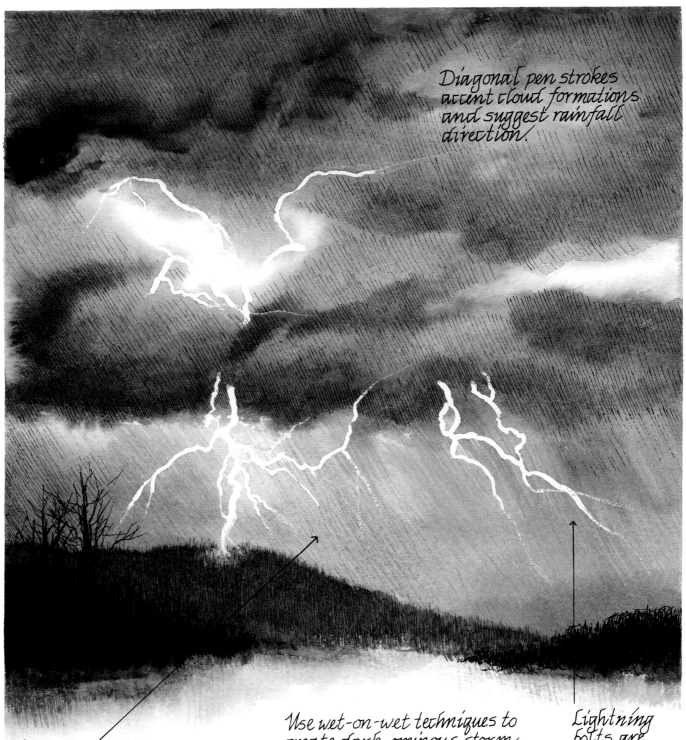

Diagonal pen strokes accent cloud formations and suggest rainfall direction.

Fan brush used to suggest rainfall. (drybrush)

Use wet-on-wet techniques to create dark, ominous storm clouds, leaving lightly painted areas for contrast. Let dry.

Drybrush additional, dark cloud formations into place. Soften the edges with a clean, damp brush.

Lightning bolts are masked with liquid frisket. (Fine lines were scratched in with razor.)

Thunderstorms

Snow

A winter sky, sprinkled with delicate snowflakes, has no need for further texturing with the ink pen.

Tree branches rendered in pen, ink and drybrush were carefully added around the snowflakes.

Salt reacts especially well in washes of Payne's Gray, producing white, fluffy flakes.

Foreground snowflakes were scratched in.

Nice

Sunset

Begin with pastel, wet-on-wet watercolor washes. While the paper is still moist, add darker cloud shapes. Let dry. <u>Don't over work</u>!

Additional clouds can be added using drybrush and damp brush blending techniques.

Diagonal, parallel ink lines add texture, definition and an upward lift to the horizontal cloud formations.

Mixtures of Payne's Gray, Indigo, Blue-Violet and Sepia, accented with pen work, make good silhouettes.

Black silhouettes tend to look stiff and unnatural.

Bodies of water reflect the coloration of the sunset.

White areas blotted
with a tissue.

This sunrise is a simple wet-on-wet
watercolor wash - no inkwork added.

In brighter skies, the
careful use of penwork
over dry washes will
add focus to the
clouds.

Brown pen stippling

Payne's Gray penwork

India Ink detailing

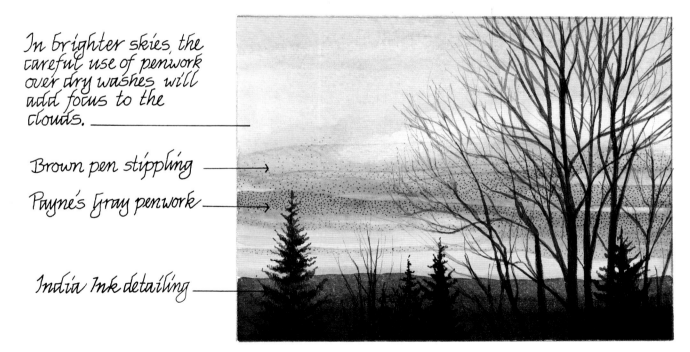

Sunrise

Traditionally, the sunrise has been thought of
as pastel and delicate. In truth, the sunrise can
rival the sunset in coloration.

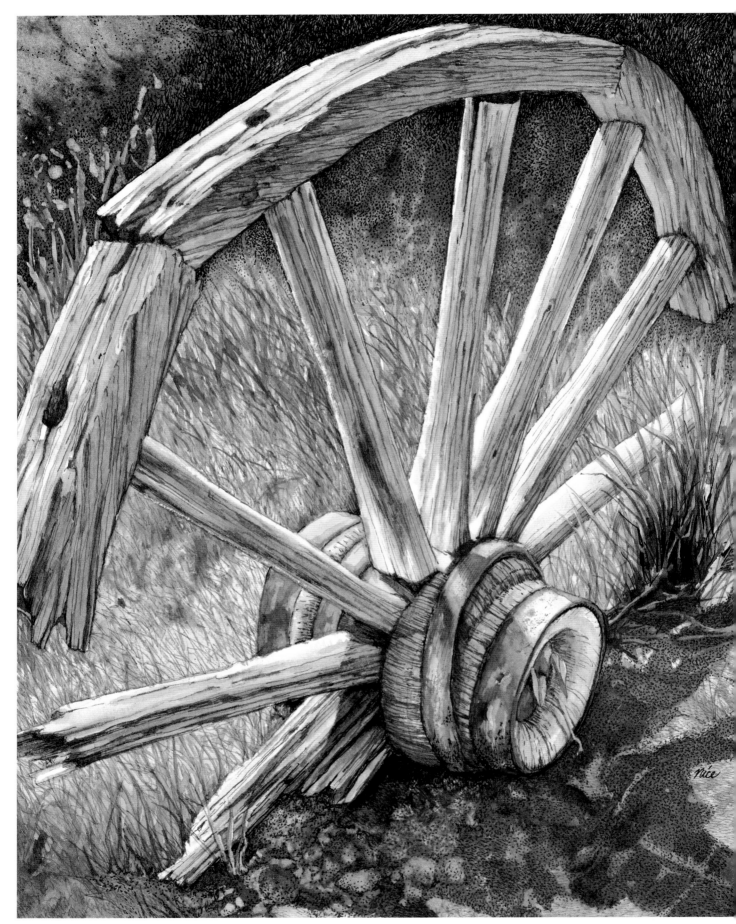

ALONG THE TRAIL, 9″×7″, Watercolor, pen and ink, pen and ArtistColor.

WOOD GRAIN PATTERNS

There is something nostalgic about wood, especially old weathered wood. Like the wrinkles on an old face, each crack and grain line bespeaks of bygone memories and stories untold. Creating wood grain is almost as much fun as the memories it inspires . . . and there's more than one way to do it.

The most obvious way to duplicate the grain of wood is to draw it in, using pen and ink, or for a more subtle look, pen and liquid acrylic. Wavy lines are the ideal stroke. If the lines appear too bold, blend and soften them as soon as they are laid down, with a moist brush. If you're using India Ink, you must be quick.

One can also drybrush the grain lines in, over layered washes, using a fan brush or the tip of a round detail brush. In a moist wash, bruising is very effective.

There are lots of artistic tricks to further age and weather that old fence post or paint-peeled barn board. Experiment with spatter, salt and alcohol techniques and the introduction of contrasting earth tones, using the spontaneous flow of wet-on-wet.

Rusty nails, spots of lichen and washes of green algae or moss also add to the weathered, corroded look. However, keep in mind that distance will dictate how much detail is needed. While little wood grain is seen in the faraway fence, up close only the imagination can limit the amount of texture portrayed.

Wood Grain

Continuous or broken wavy line pen strokes are ideal for depicting the grain patterns of cut wood.

The design patterns depend upon the wood type and how the wood was cut.

This block of Hemlock wood was textured with Brown pen work and over laid with watercolor.

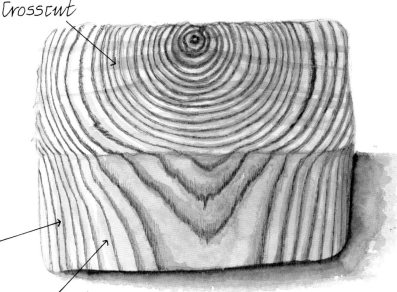

Crosscut

Cut with the grain

← Rough wood - Use a larger size nib and sketchy strokes.

Smooth wood - Use a fine nib (4x0 or 3x0) and precise, flowing pen strokes. →

← India ink tinted with watercolor →

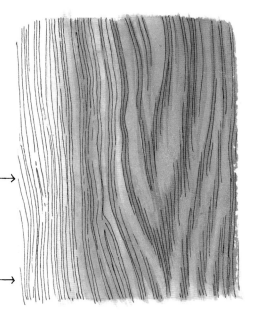

② Dry fan brush work

③ Additional washes are laid on and blended with a clean, damp brush.

① Damp surface wash

Walnut wood

④ Wood grain texture lines are added using pen and ink.

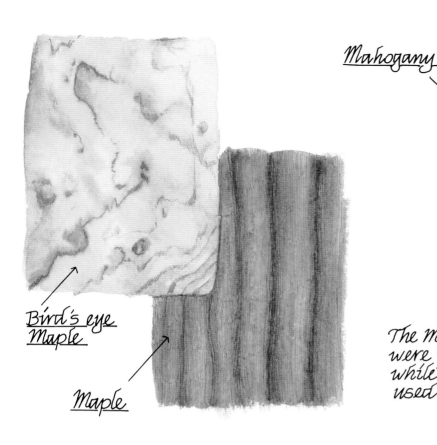

Mahogany

Bird's eye Maple

Maple

The Mahogany and Oak wood grains were penned with India ink, while Brown liquid acrylic was used to texture the lighter woods.

Watercolor washes may be added before or after the pen work.

Watercolor spatter

The pen work in the Maple and Cedar sketches were stroked promptly with a damp brush to blend and soften their appearance.

Distressed Ash Wood

Cedar

Oak

A fan brush was used here for additional texture.

Bruising is an
additional method
of creating a realistic
wood grain
appearance

1. Begin with a varied
damp surface wash.

2. Using a wavy line
pattern, bruise the
paper with a stylus.

3. If desired
accent with a
little brown
pen work.

Layered washes,
textured with
dry brush and
pen and ink.

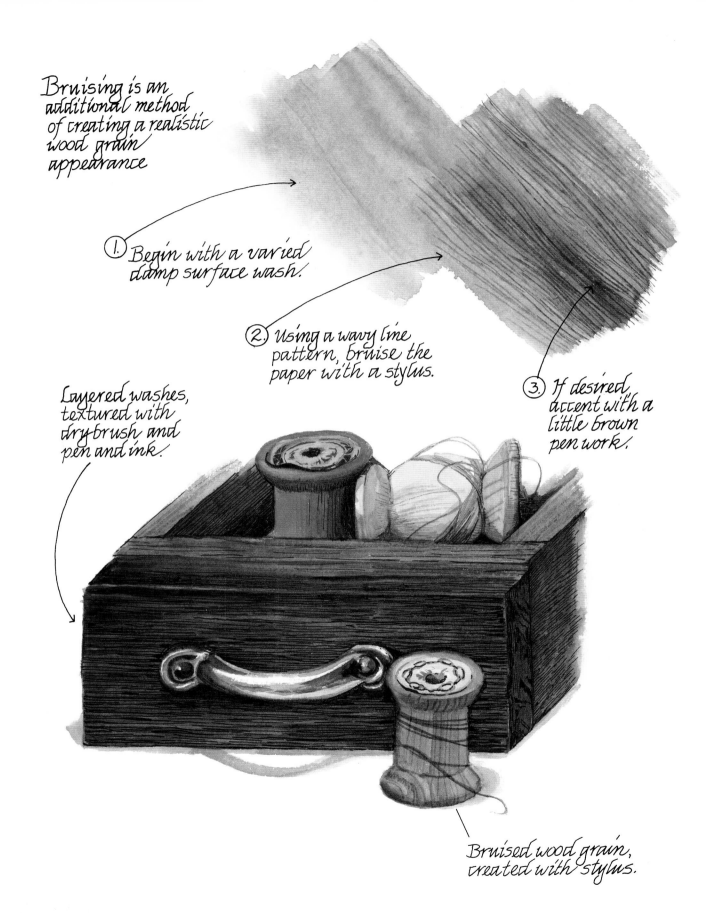

Bruised wood grain,
created with stylus.

Polished Wood

Like shiny metal, polished wood has strong value patterns and lots of reflective color.

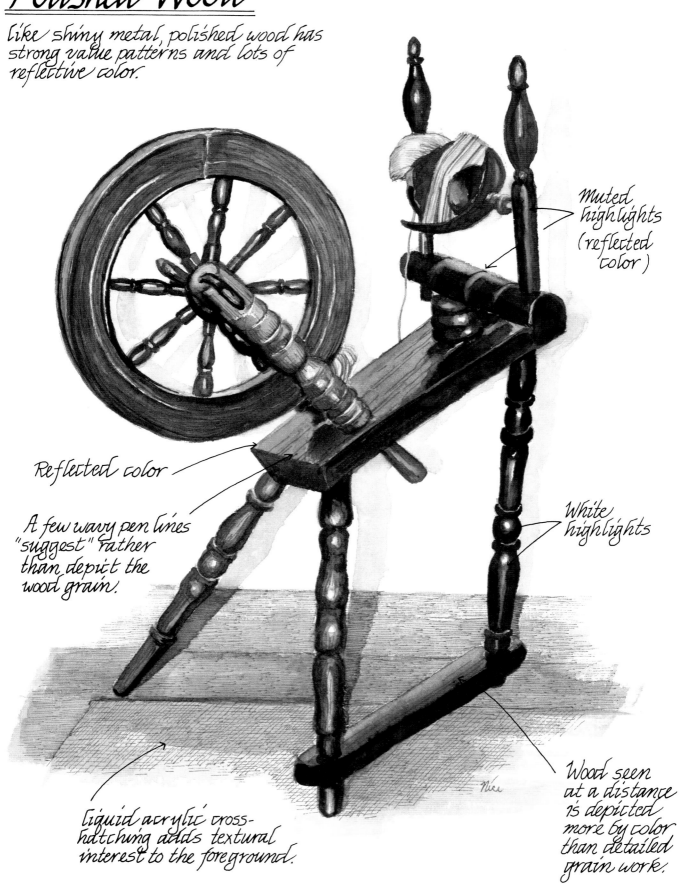

Muted highlights (reflected color)

Reflected color

A few wavy pen lines "suggest" rather than depict the wood grain.

White highlights

Liquid acrylic cross-hatching adds textural interest to the foreground.

Wood seen at a distance is depicted more by color than detailed grain work.

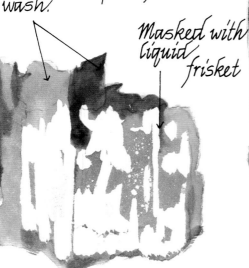

Varied damp surface wash.

Masked with liquid frisket

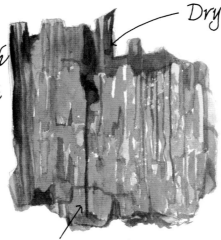

Dry brush wood grain and shadows

Lay in old paint areas.

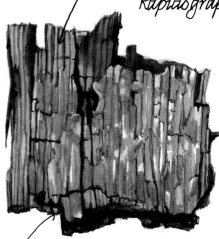

Brown liquid acrylic in 3x0 Rapidograph

Deep cracks defined with pen and India ink.

Weathered Wood ~ Old Paint

Begin with damp surface, off-white wash.

While still damp, brush in brown, wavy line streaks.

Use round brush to detail wood grain, cracks, holes and shadows.

Spatter provides textural variety.

Add fine details with pen —

Wood grain stroked with India ink.

Paint cracks were penned using earth tone liquid acrylic.

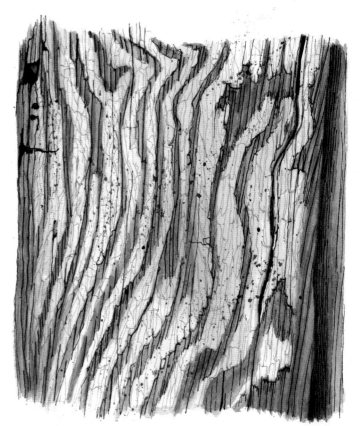

Aged Fencing

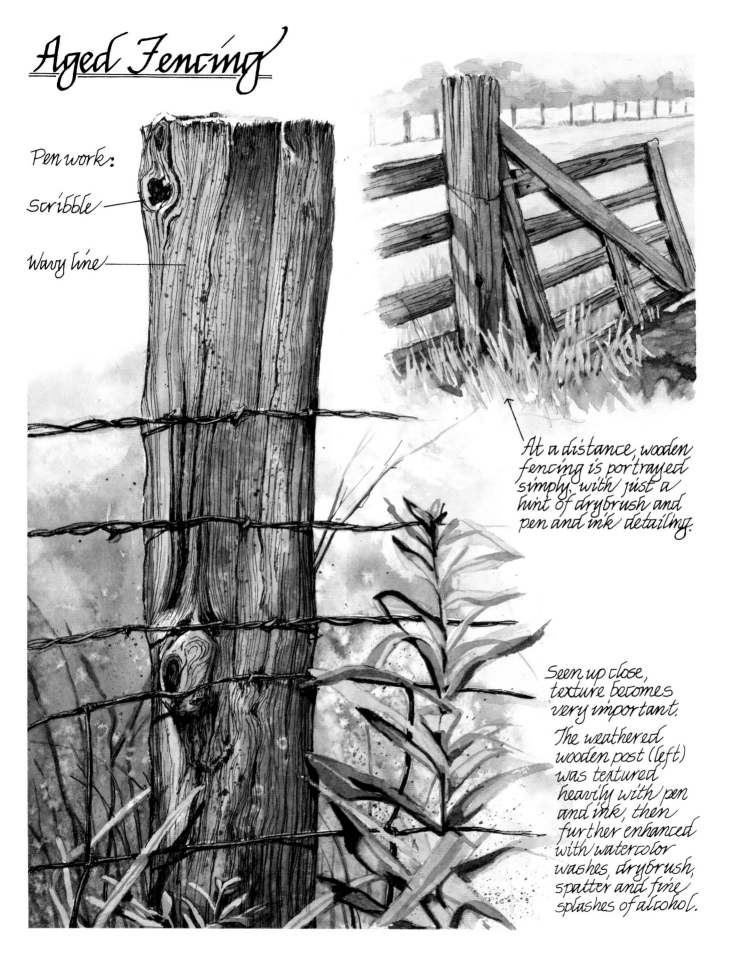

Pen work:

scribble

Wavy line

At a distance, wooden fencing is portrayed simply, with just a hint of drybrush and pen and ink detailing.

Seen up close, texture becomes very important.

The weathered wooden post (left) was textured heavily with pen and ink, then further enhanced with watercolor washes, drybrush, spatter and fine splashes of alcohol.

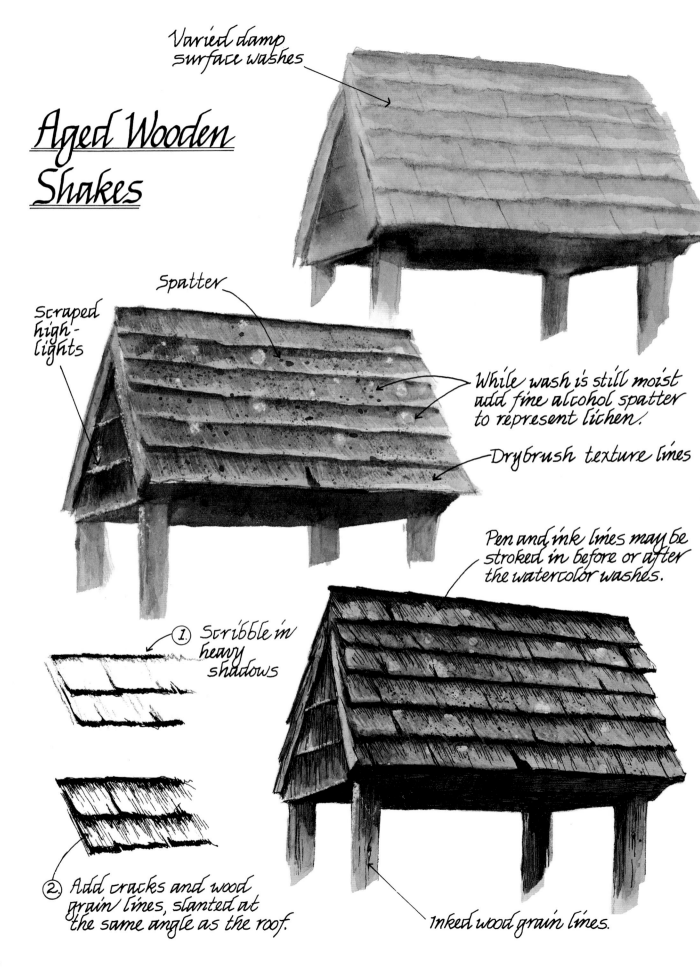

Varied damp surface washes

Aged Wooden Shakes

Spatter

Scraped high-lights

While wash is still moist add fine alcohol spatter to represent lichen.

Drybrush texture lines

Pen and ink lines may be stroked in before or after the watercolor washes.

① Scribble in heavy shadows

② Add cracks and wood grain lines, slanted at the same angle as the roof.

Inked wood grain lines.

Old Wooden Structures

Use muted colors for background buildings.

Watercolor washes were laid in before ink work. →

Parallel line ink work suggests the hazy look of distance.

Drybrush detailing is stroked in the direction of the boards

Barn wood is tinted with a mixture of Burnt Umber and Payne's Gray.

It's up to the artist whether the ink work is completed before or after the watercolor washes.

A touch of bright color suggests old paint.

Parallel ink lines mingled with wavy lines depict board direction and texture.

Driftwood

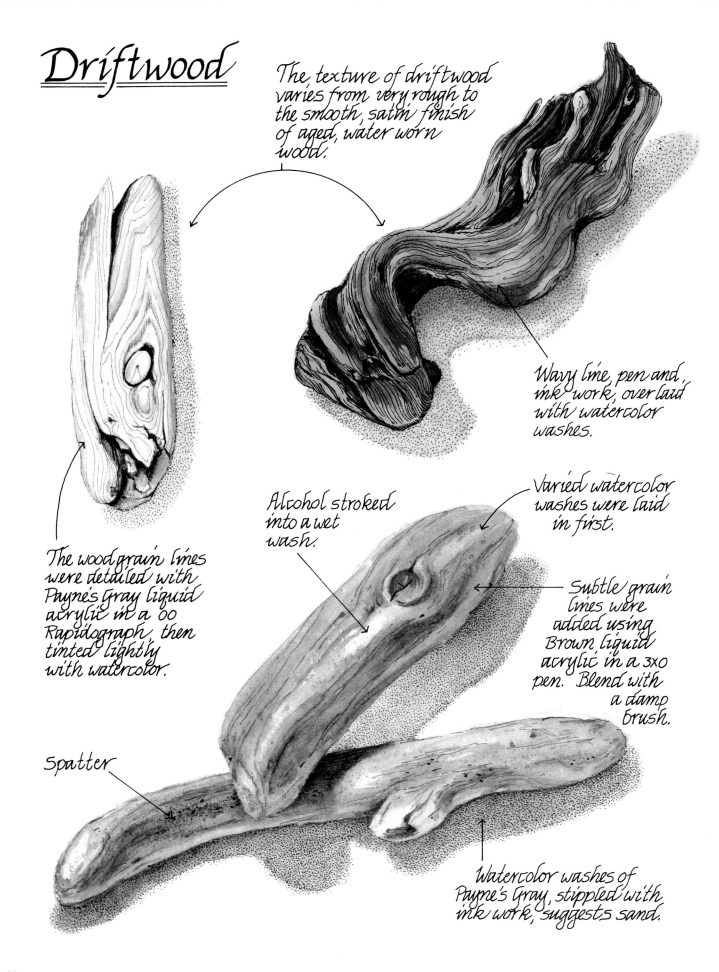

The texture of driftwood varies from very rough to the smooth, satin finish of aged, water worn wood.

Wavy line, pen and ink work, over laid with watercolor washes.

The wood grain lines were detailed with Payne's Gray liquid acrylic in a 00 Rapidograph, then tinted lightly with watercolor.

Alcohol stroked into a wet wash.

Varied watercolor washes were laid in first.

Subtle grain lines were added using Brown liquid acrylic in a 3x0 pen. Blend with a damp brush.

Spatter

Watercolor washes of Payne's Gray, stippled with ink work, suggests sand.

Detailed pen and ink driftwood studies will help the artist develop realistic wood grain patterns.

Wavy line ink strokes.

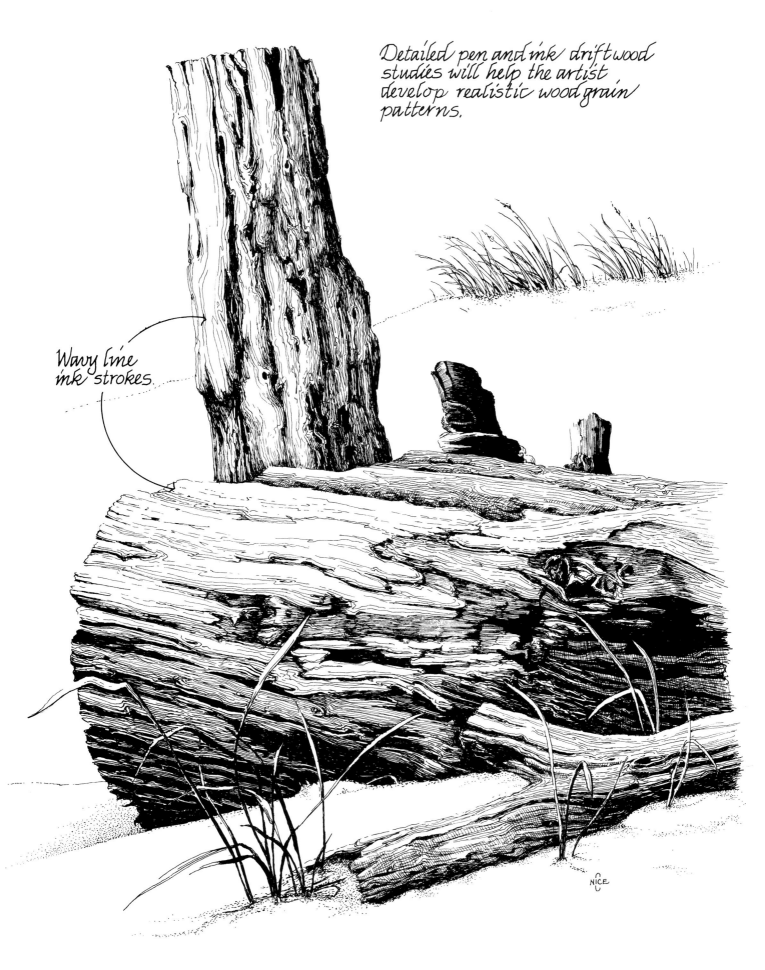

NICE

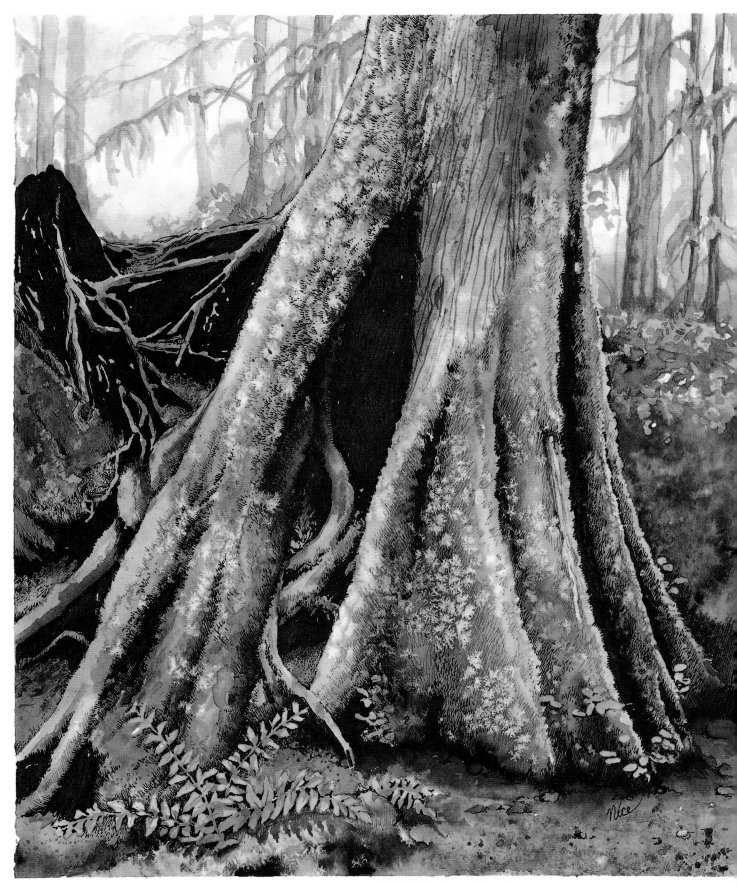

BENEATH THE TREES, 8″×9½″ (20.3cm×24.1cm),
watercolor washes textured with salt and penwork

TREES AND FORESTS

Rare is the landscape without trees or shrubbery of some sort. They are as natural and important to the outdoor scene as sky and earth. Beneath the trees, lush mosses, ferns and vining ground cover spring from the rich humus or the bark of fallen giants. Look carefully among the greenery and see the shy woodland wildflowers. Violets, lilies and dwarf orchids peek out from their hiding places in quiet splendor. Bold mushrooms pop up and stand guard like toy soldiers in oversized helmets.

In this chapter I have "zeroed in" on a few of my favorite tree and forest subjects. Complicated flora and fauna can be broken down into basic shapes, or in the case of some plants, simply "printed" into place. Once they're sketched, just add color and texture to bring them to life. I'll guide you in the mixture of some lifelike earth hues and the creation of realistic texture, using a variety of fun techniques.

When the individual trees and forest characters have become familiar friends, I'll show you how to combine them into a composition. You are welcome to duplicate my paintings or alter them to fit your own visions. Better yet, stroll into the forest where the sights, sounds and smells are vivid, and see where the inspiration will lead your own creativity.

Conifer Tree Bark

Trees in the evergreen family tend to have heavily textured bark. The old timers sport deep creases and plate-like folds that are perfect to sketch in pen and ink.

The conifers on this page were rendered in India ink, then tinted with watercolor.

Crosshatching

Scribble

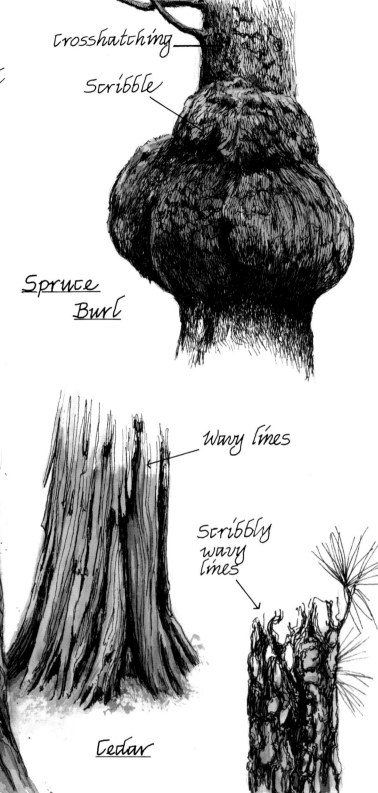

Spruce Burl

Scribble lines

Salt technique patterns suggest moss.

Spatter

Douglas Fir

Wavy lines

Cedar

Scribbly wavy lines

Sugar Pine

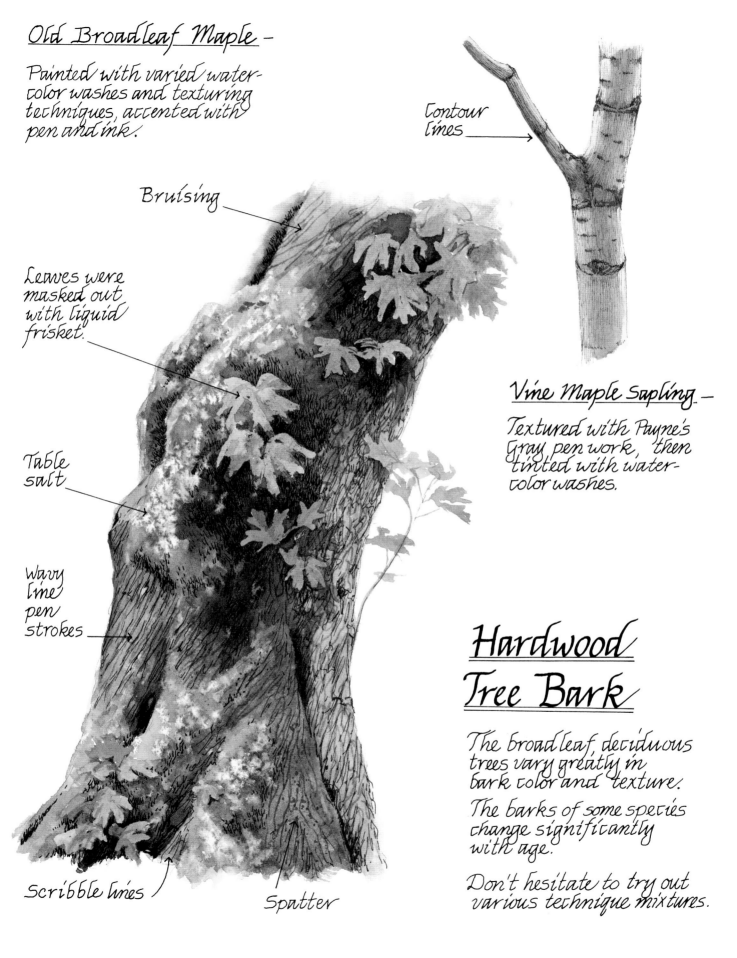

Old Broadleaf Maple –

Painted with varied water-color washes and texturing techniques, accented with pen and ink.

Bruising

Leaves were masked out with liquid frisket.

Table salt

Wavy line pen strokes

Scribble lines

Spatter

Contour lines

Vine Maple Sapling –

Textured with Payne's Gray pen work, then tinted with water-color washes.

Hardwood Tree Bark

The broadleaf, deciduous trees vary greatly in bark color and texture.

The barks of some species change significantly with age.

Don't hesitate to try out various technique mixtures.

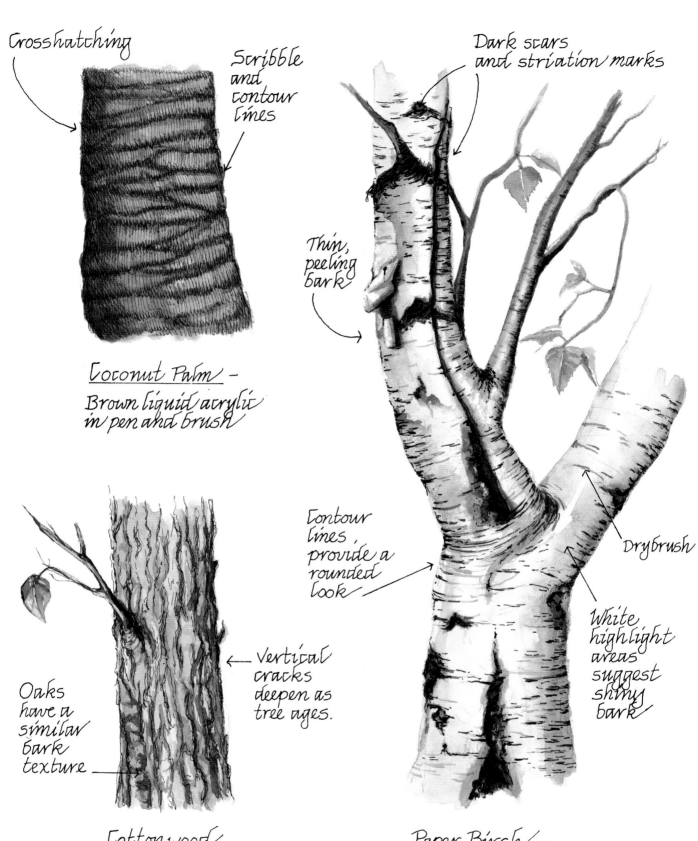

Crosshatching

Scribble and contour lines

Coconut Palm –
Brown liquid acrylic
in pen and brush

Dark scars
and striation marks

Thin,
peeling
bark

Contour
lines
provide a
rounded
look

Drybrush

White
highlight
areas
suggest
shiny
bark

Oaks
have a
similar
bark
texture

Vertical
cracks
deepen as
tree ages.

Cottonwood –
Watercolor wash
over pen and ink.

Paper Birch –
Light, varied watercolor
wash, accented with
drybrush and pen work.

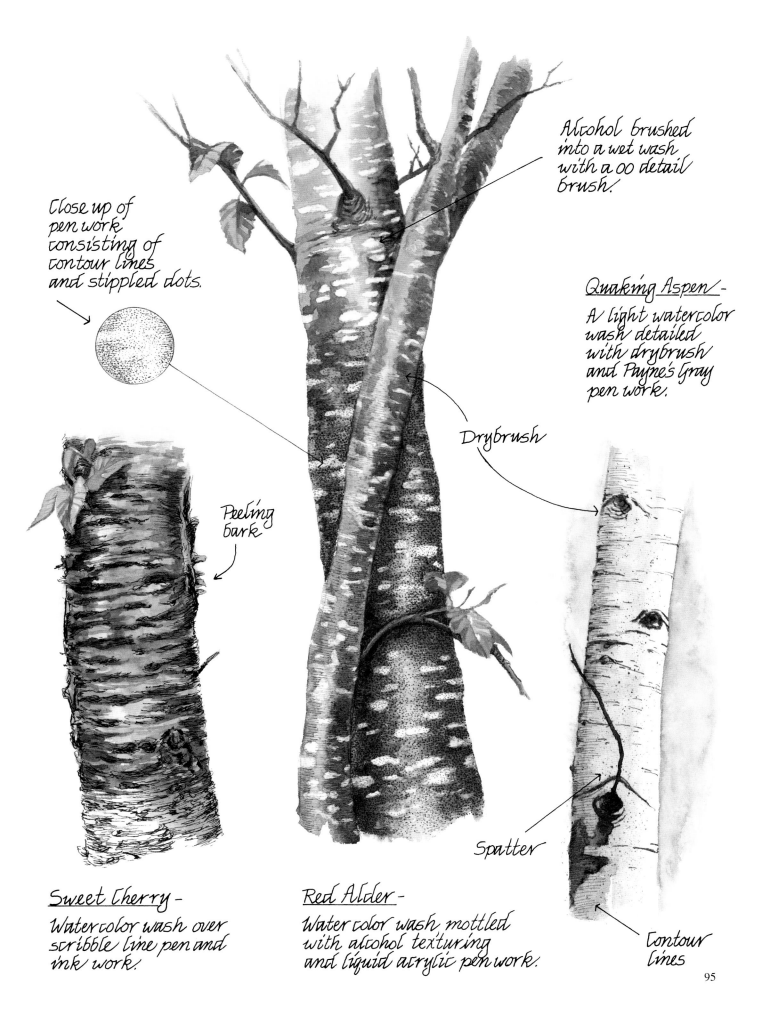

Close up of pen work consisting of contour lines and stippled dots.

Alcohol brushed into a wet wash with a 00 detail brush.

Quaking Aspen -
A light watercolor wash detailed with drybrush and Payne's Gray pen work.

Drybrush

Peeling bark

Spatter

Contour lines

Sweet Cherry -
Watercolor wash over scribble line pen and ink work.

Red Alder -
Water color wash mottled with alcohol texturing and liquid acrylic pen work.

Roots

These root studies began as highly detailed pen and ink drawings. Contour lines depict tangled, weather-worn roots, while rough and mossy areas are suggested with crosshatching and scribble lines.

Maintain light value areas when adding washes.

Contour lines

Sepia, Payne's Gray and Sienna mixtures accent the pen and ink work.

Bright watercolor washes add richness.

scribble

crosshatch

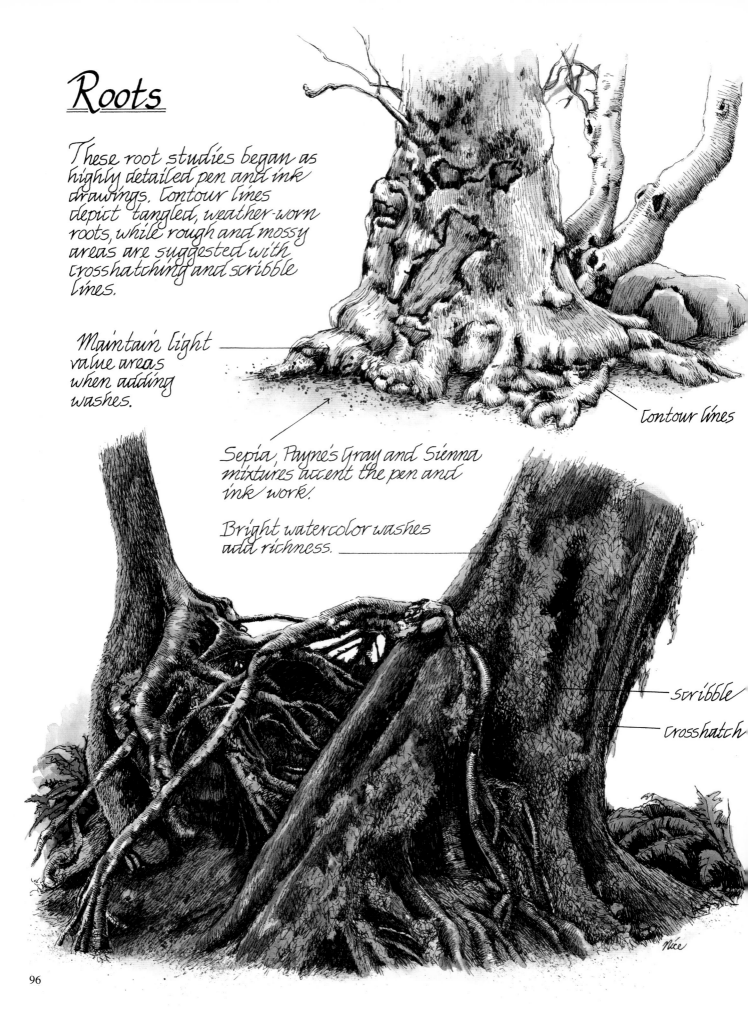

Nice

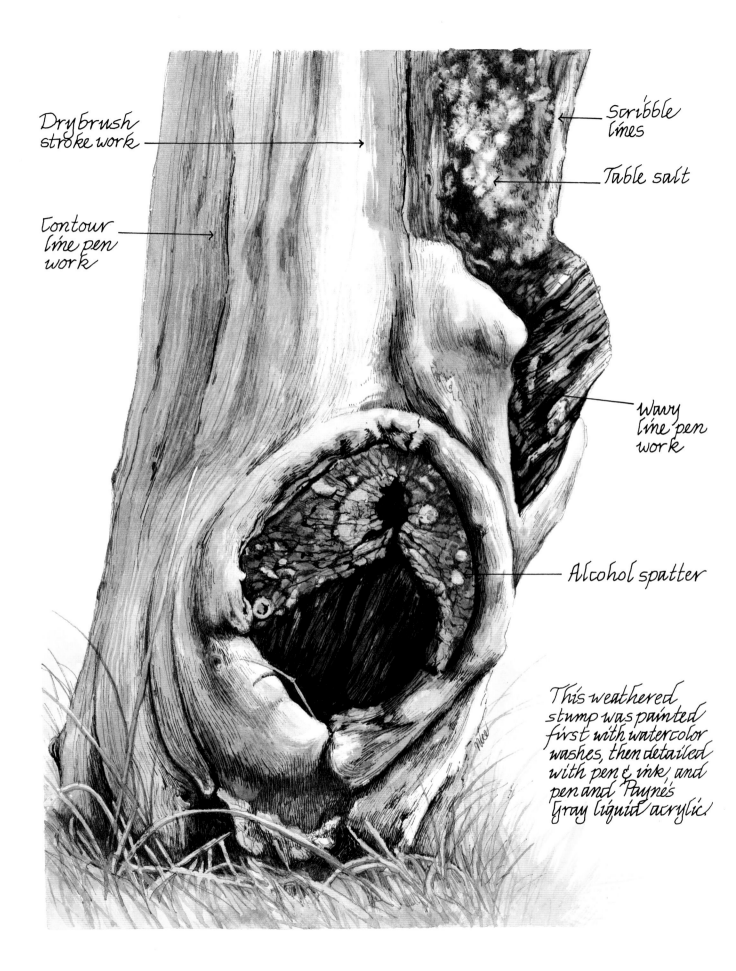

Dry brush
stroke work

Contour
line pen
work

Scribble
lines

Table salt

Wavy
line pen
work

Alcohol spatter

This weathered
stump was painted
first with watercolor
washes, then detailed
with pen & ink, and
pen and Payne's
Gray liquid acrylic

97

Branches

Winter is the best time to study the shape and texture of tree branches. Ice, painted like clear glass, can add contrast and textural variety to the sketch.

The background of this winter scene is painted wet-on-wet, then over-laid with parallel line ink work in Payne's Gray liquid acrylic.

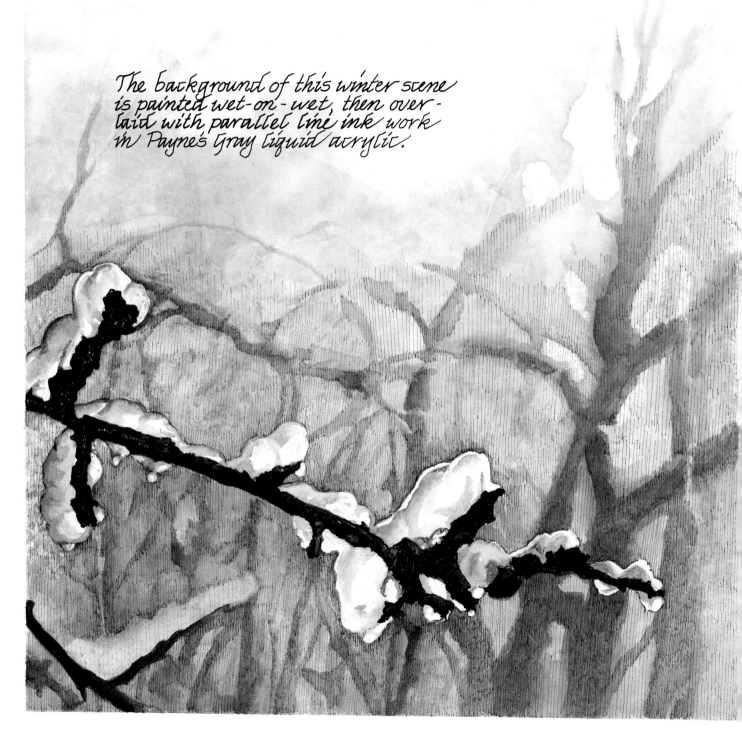

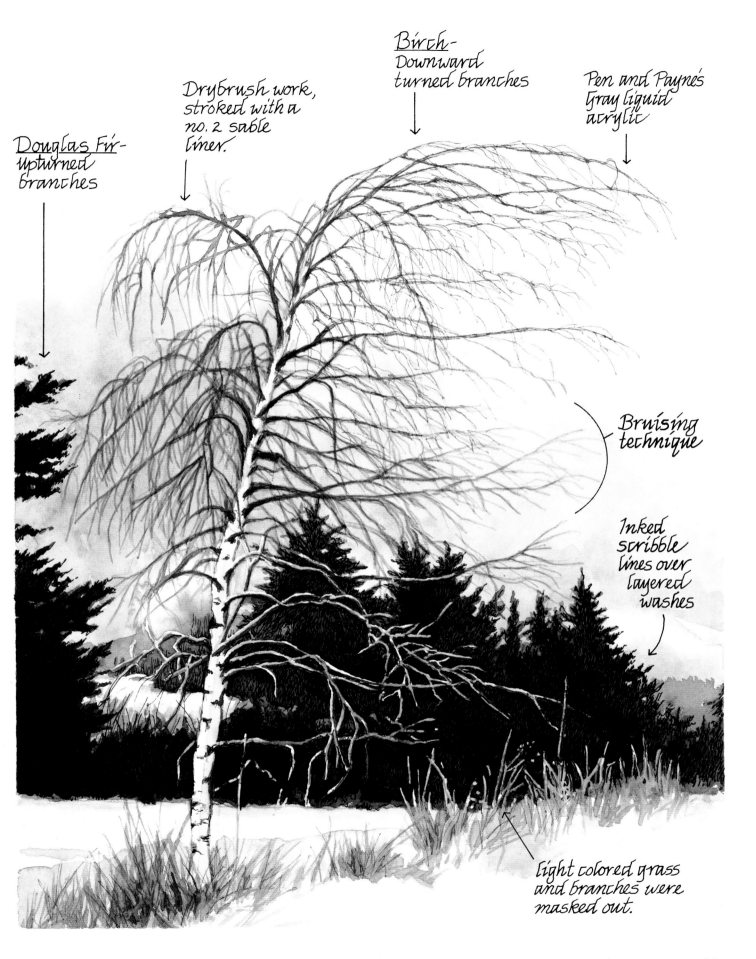

Birch-
Downward
turned branches

Drybrush work,
stroked with a
no. 2 sable
liner.

Pen and Payne's
Gray liquid
acrylic

Douglas Fir-
upturned
branches

Bruising
technique

Inked
scribble
lines over
layered
washes

Light colored grass
and branches were
masked out.

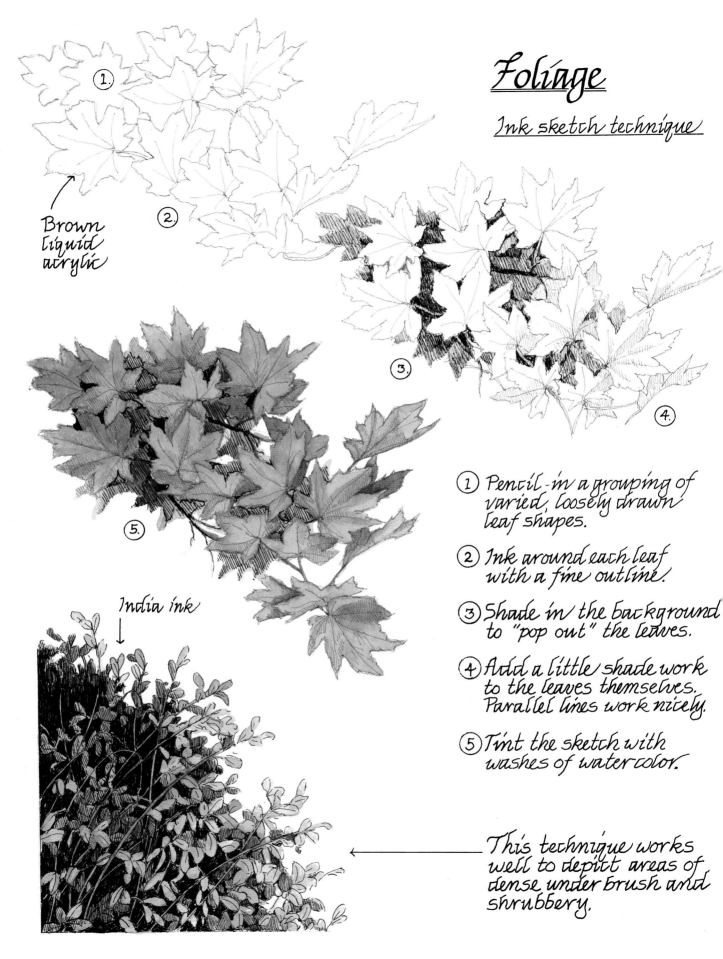

Foliage

Ink sketch technique

①.

②.

③.

④.

⑤.

Brown liquid acrylic

India ink

① Pencil-in a grouping of varied, loosely drawn leaf shapes.

② Ink around each leaf with a fine outline.

③ Shade in the background to "pop out" the leaves.

④ Add a little shade work to the leaves themselves. Parallel lines work nicely.

⑤ Tint the sketch with washes of water color.

This technique works well to depict areas of dense under brush and shrubbery.

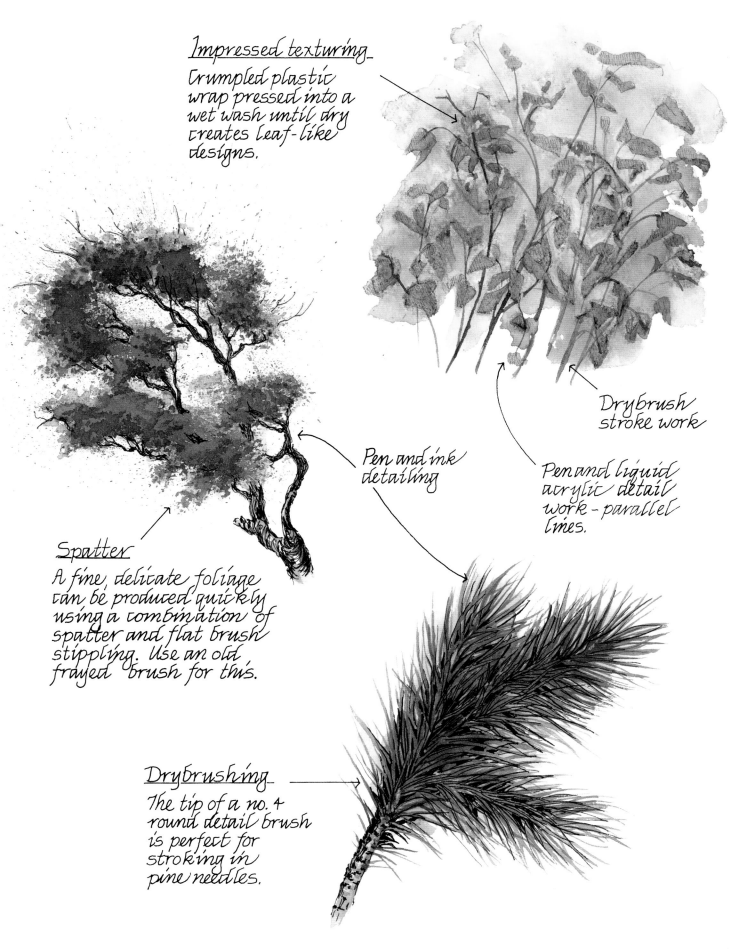

Impressed texturing

Crumpled plastic wrap pressed into a wet wash until dry creates leaf-like designs.

Drybrush stroke work

Pen and ink detailing

Pen and liquid acrylic detail work - parallel lines.

Spatter

A fine, delicate foliage can be produced quickly using a combination of spatter and flat brush stippling. Use an old frayed brush for this.

Drybrushing

The tip of a no. 4 round detail brush is perfect for stroking in pine needles.

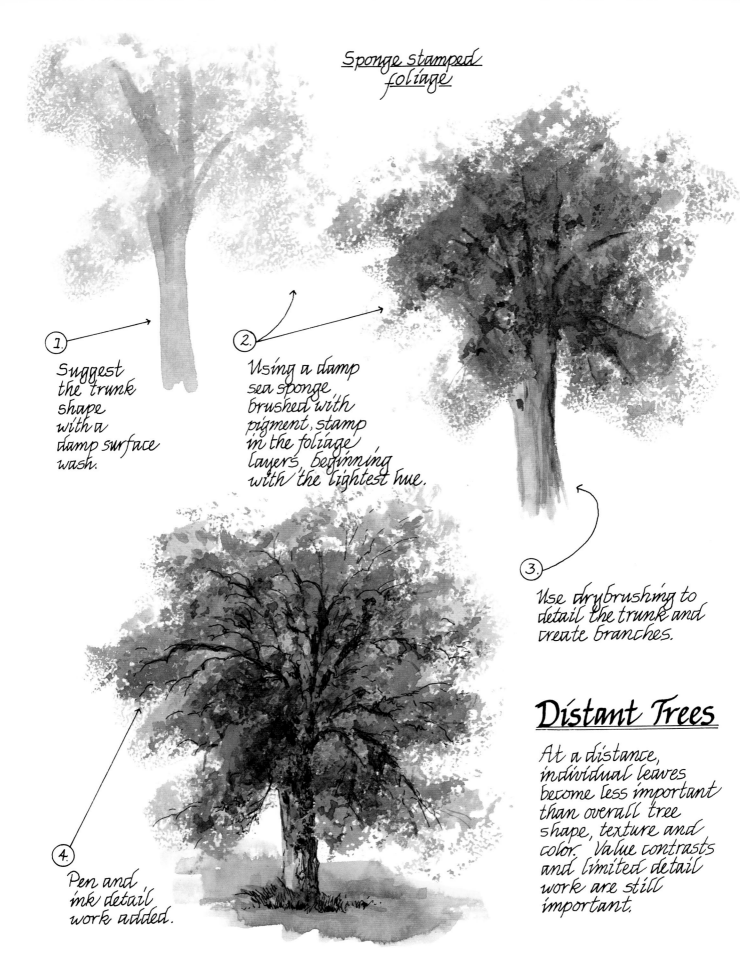

Sponge stamped foliage

1. Suggest the trunk shape with a damp surface wash.

2. Using a damp sea sponge brushed with pigment, stamp in the foliage layers, beginning with the lightest hue.

3. Use drybrushing to detail the trunk and create branches.

4. Pen and ink detail work added.

Distant Trees

At a distance, individual leaves become less important than overall tree shape, texture and color. Value contrasts and limited detail work are still important.

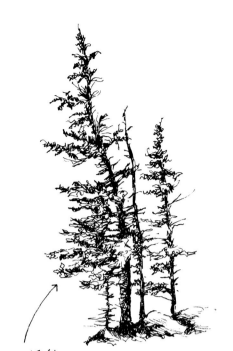

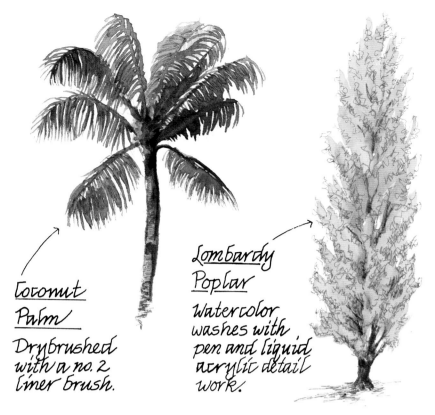

Coconut Palm
Drybrushed with a no. 2 liner brush.

Lombardy Poplar
Watercolor washes with pen and liquid acrylic detail work.

White Spruce
Pen and ink - scribble lines

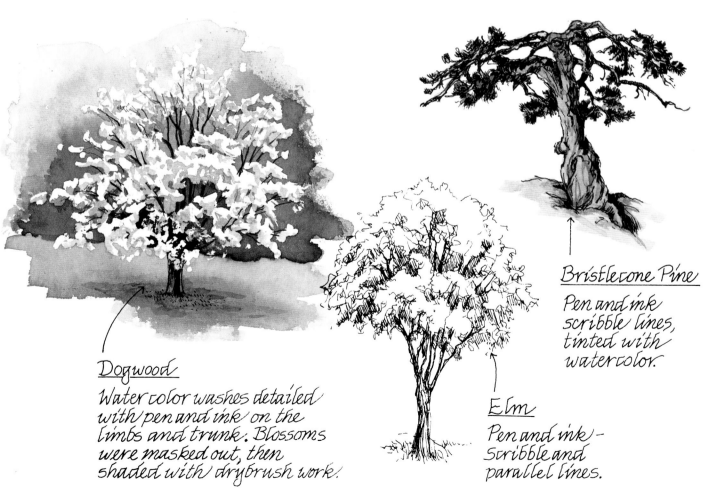

Dogwood
Water color washes detailed with pen and ink on the limbs and trunk. Blossoms were masked out, then shaded with drybrush work.

Elm
Pen and ink - scribble and parallel lines.

Bristlecone Pine
Pen and ink scribble lines, tinted with watercolor.

Background Trees

As trees recede farther into the distance, texture is flattened, color is muted and shape is merely suggested.

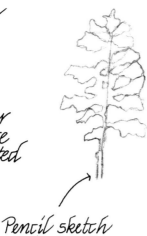

Pencil sketch of basic pine tree shape.

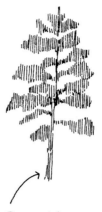

Parallel line ink texturing.

Shadows added.

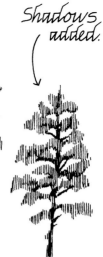

Watercolor wash added.

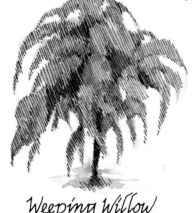

Weeping Willow

Muted watercolor wash overlaid with Payne's gray pen work.

Parallel ink lines tinted with color

Crosshatching

Background forest of mixed trees and shrubs.

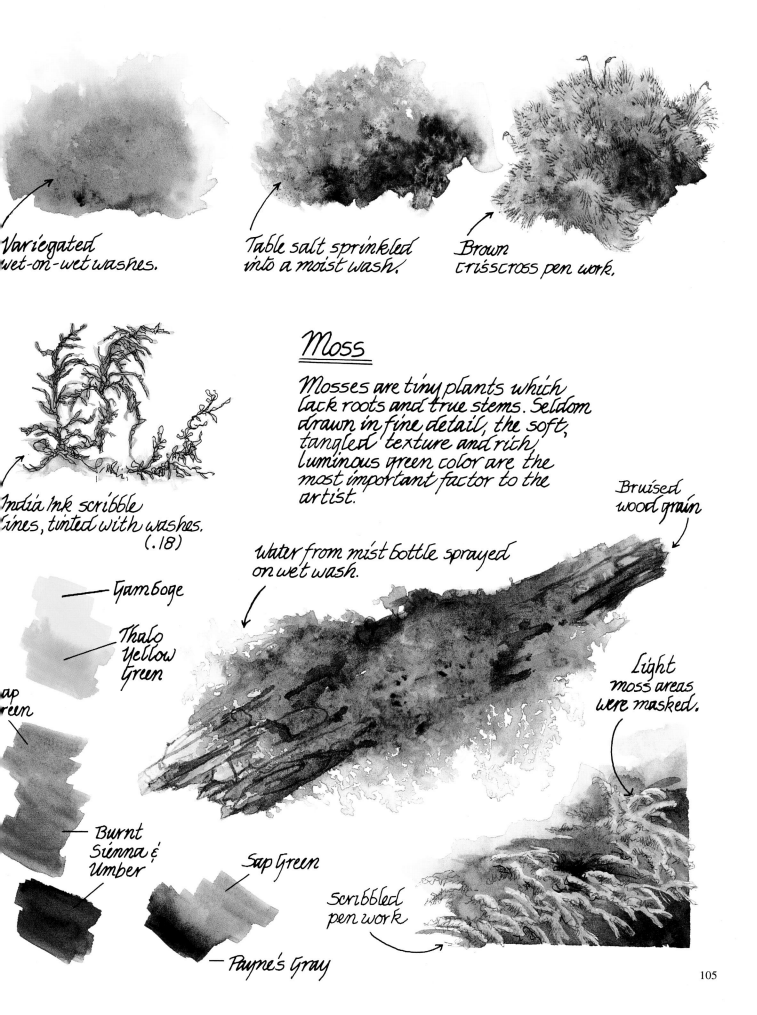

Variegated
wet-on-wet washes.

Table salt sprinkled
into a moist wash.

Brown
crisscross pen work.

India Ink scribble
lines, tinted with washes.
(.18)

Moss

Mosses are tiny plants which
lack roots and true stems. Seldom
drawn in fine detail, the soft,
tangled texture and rich,
luminous green color are the
most important factor to the
artist.

Water from mist bottle sprayed
on wet wash.

Bruised
wood grain

Light
moss areas
were masked.

Gamboge

Thalo
Yellow
Green

Sap
Green

Burnt
Sienna &
Umber

Sap Green

Scribbled
pen work

Payne's Gray

105

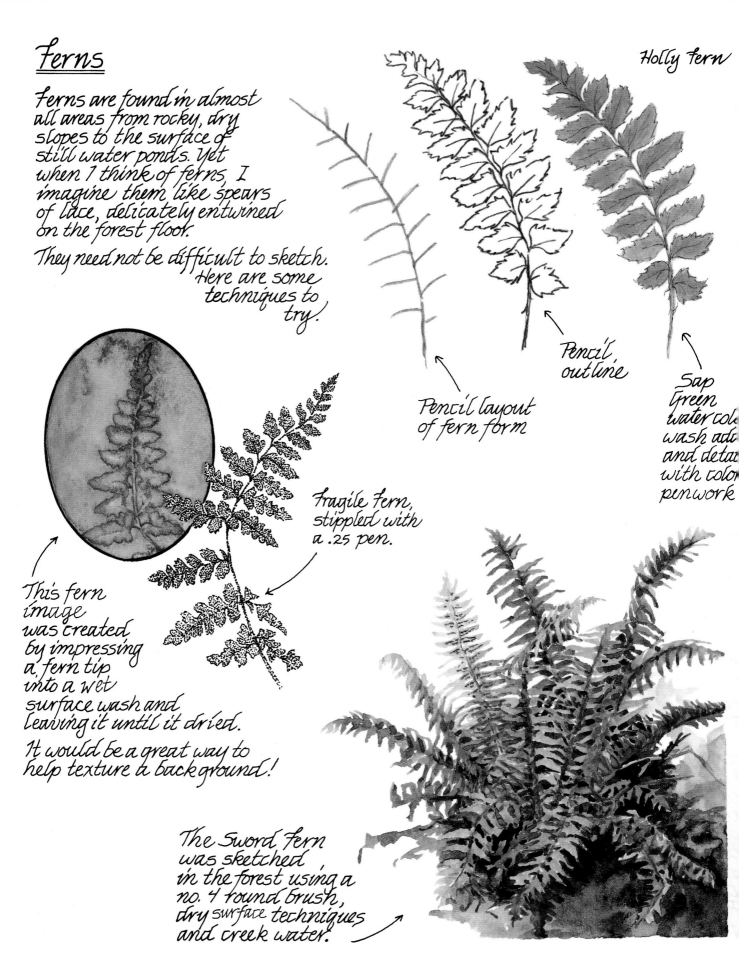

Ferns

Ferns are found in almost all areas from rocky, dry slopes to the surface of still water ponds. Yet when I think of ferns, I imagine them like spears of lace, delicately entwined on the forest floor.

They need not be difficult to sketch. Here are some techniques to try.

Holly Fern

Pencil layout of fern form

Pencil outline

Sap Green water color wash add and detai with color penwork

Fragile Fern, stippled with a .25 pen.

This fern image was created by impressing a fern tip into a wet surface wash and leaving it until it dried.

It would be a great way to help texture a background!

The Sword Fern was sketched in the forest using a no. 4 round brush, dry surface techniques and creek water.

Young, tender ferns can be used for stenciling and stamping techniques. (Stiff, contoured ones need to be pressed and dried.)

Stenciled Oak fern

Stippled pen work

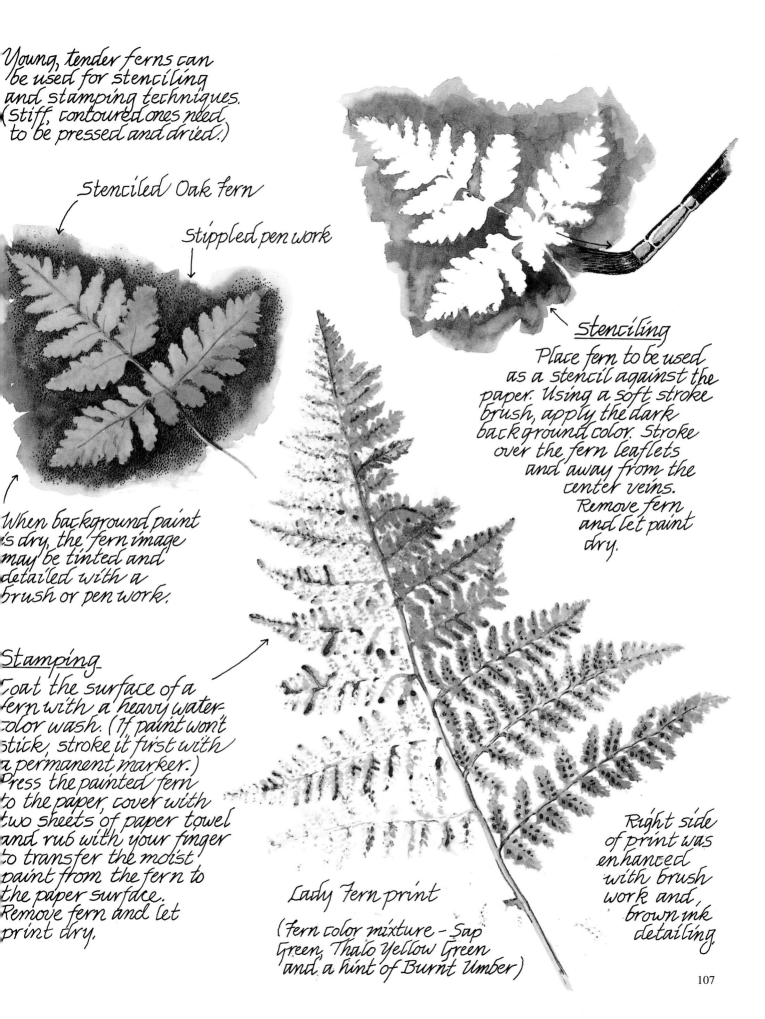

When background paint is dry, the fern image may be tinted and detailed with a brush or pen work.

Stamping

Coat the surface of a fern with a heavy watercolor wash. (If paint won't stick, stroke it first with a permanent marker.) Press the painted fern to the paper, cover with two sheets of paper towel and rub with your finger to transfer the moist paint from the fern to the paper surface. Remove fern and let print dry.

Stenciling

Place fern to be used as a stencil against the paper. Using a soft stroke brush, apply the dark background color. Stroke over the fern leaflets and away from the center veins. Remove fern and let paint dry.

Right side of print was enhanced with brush work and brown ink detailing

Lady Fern print

(Fern color mixture - Sap Green, Thalo Yellow Green and a hint of Burnt Umber)

"Fox Sparrow And Ferns" was painted in the rich greens and earthy browns that bring to mind the lush colors of a moss laden rain forest.

The aged brown fern and the edges of the bird and mossy stump were masked, then the entire background area was painted with a medium, wet-on-wet wash of Thalo Yellow Green, Sap Green and Burnt Umber in varied mixtures.

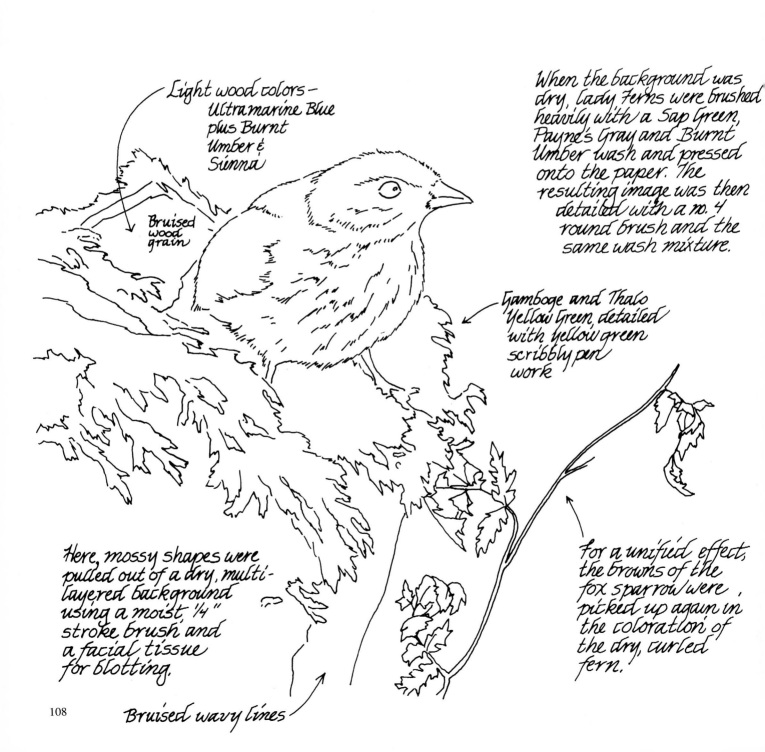

Light wood colors— Ultramarine Blue plus Burnt Umber & Sienna

Bruised wood grain

When the background was dry, Lady Ferns were brushed heavily with a Sap Green, Payne's Gray and Burnt Umber wash and pressed onto the paper. The resulting image was then detailed with a no. 4 round brush and the same wash mixture.

Gamboge and Thalo Yellow Green, detailed with yellow green scribbly pen work

Here, mossy shapes were pulled out of a dry, multi-layered background using a moist, 1/4" stroke brush and a facial tissue for blotting.

For a unified effect, the browns of the fox sparrow were picked up again in the coloration of the dry, curled fern.

Bruised wavy lines

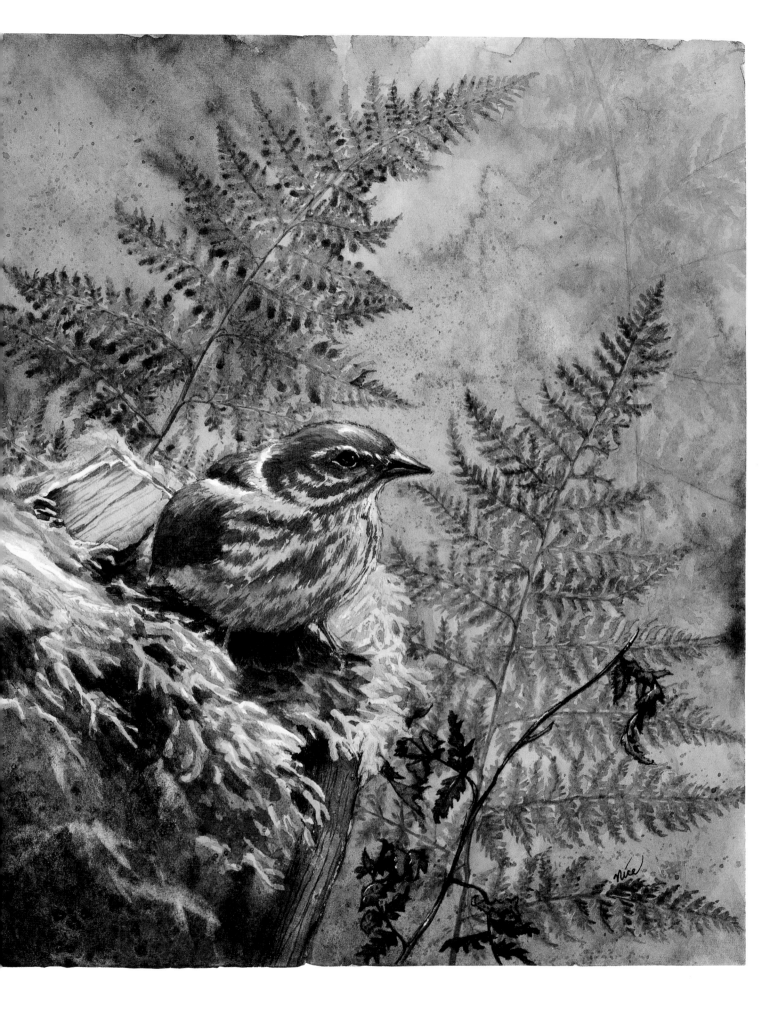

Mushrooms

Mushrooms, with their unusual shapes and varied colors, make wonderful subjects to complement a forest scene or quick sketch into a journal. The mushrooms drawn on this page can be found growing throughout most of North America.

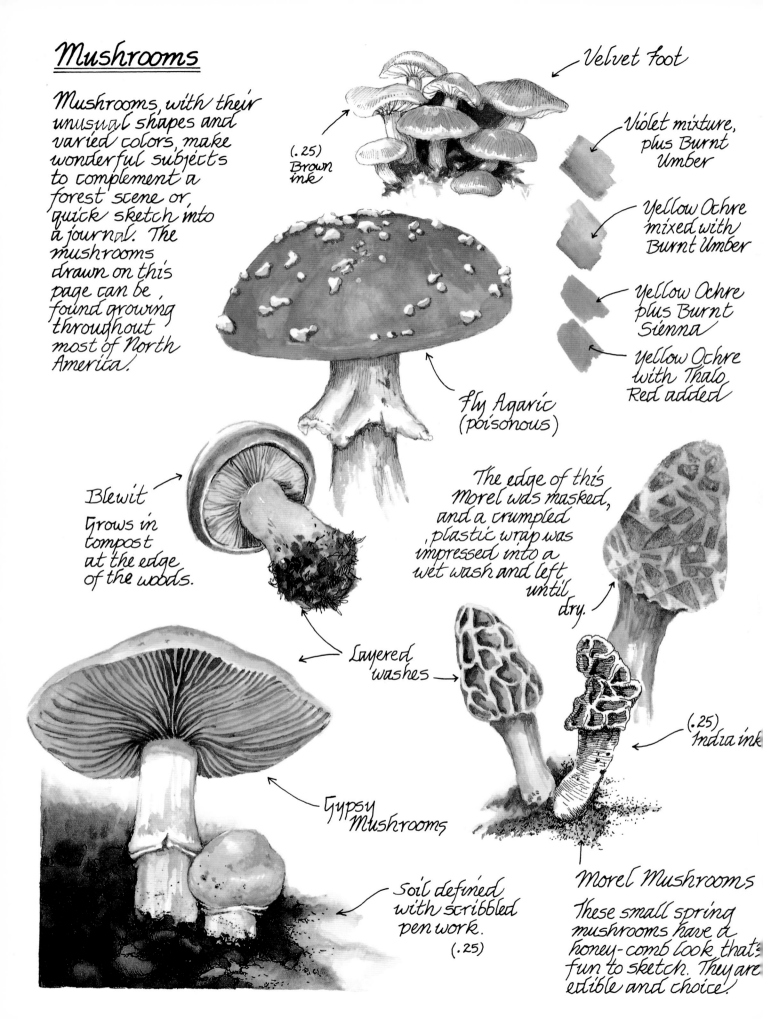

Velvet foot

(.25) Brown ink

Violet mixture, plus Burnt Umber

Yellow Ochre mixed with Burnt Umber

Yellow Ochre plus Burnt Sienna

Yellow Ochre with Thalo Red added

Fly Agaric (poisonous)

Blewit
Grows in compost at the edge of the woods.

The edge of this Morel was masked, and a crumpled plastic wrap was impressed into a wet wash and left until dry.

Layered washes

(.25) India ink

Gypsy Mushrooms

Soil defined with scribbled pen work.
(.25)

Morel Mushrooms
These small spring mushrooms have a honey-comb look that's fun to sketch. They are edible and choice.

Soil Textures

Just as soil make-up and color may vary from place to place, ways to depict the soil are also quite numerous. I usually begin with a flat or varied (damp surface) wash, then add a little texture.

Burnt Umber & Ultramarine Blue

Burnt Sienna with streaks of Burnt Umber & Payne's Gray

Stamped with a man-made sponge

Spattered with water drops

Burnt Umber & Payne's Gray

Stippled with a bristle brush and spattered

Sandy Soil
(Detailed with stippling- .25)

Red Clay Loam
(finished with a spattering of varied, dark washes)

Damp Top Soil

Burnt Umber and Payne's Gray, impressed with plastic wrap

Stippled pen work

Humus With Bark Chips

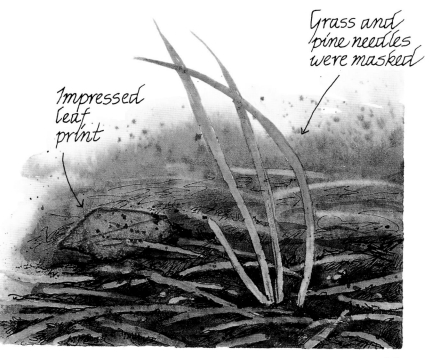

Impressed leaf print

Grass and pine needles were masked

Conifer Forest Duff

111

Forest Amphibians

These shy creatures are moisture seekers. Tree-frogs use enlarged sticky toes to climb amongst damp foliage, while newts and salamanders burrow under fallen leaves and rotten wood. These terrestrial amphibians return to water to breed.

The Spring Peeper (left) and the Gray Treefrog (below) are both nocturnal treefrogs found in eastern America.

(.18) Ink

(.25) Brown ink

Preliminary pencil sketch

Pacific Treefrog (West coast)

flat washes

Additional wash layers provide shading, while pen stippling creates texture.

Most tree-frogs can change color and tend to assume the hues of their chosen habitat.

— Lemon Yellow plus Sap Green

— Thalo Green added to above mixture

— Burnt Sienna plus Burnt Umber

— Burnt Umber and violet

Brown contour pen line

Maple Leaf

Painted with a flat wash of Yellow Ochre and layered with mixtures of Burnt Sienna, Burnt Umber and violet.

Spotted Salamander (Eastern)

(.18) India ink

The Rough-skinned Newt of the west coast is a muted brown color with a yellow-orange belly.

Fallen Leaves

The forest floor is littered by leaves shed to the ground by storms, disease and the annual autumn process.

As they weather, color fades to earthy browns — sienna, umber, ochre and muted violet.

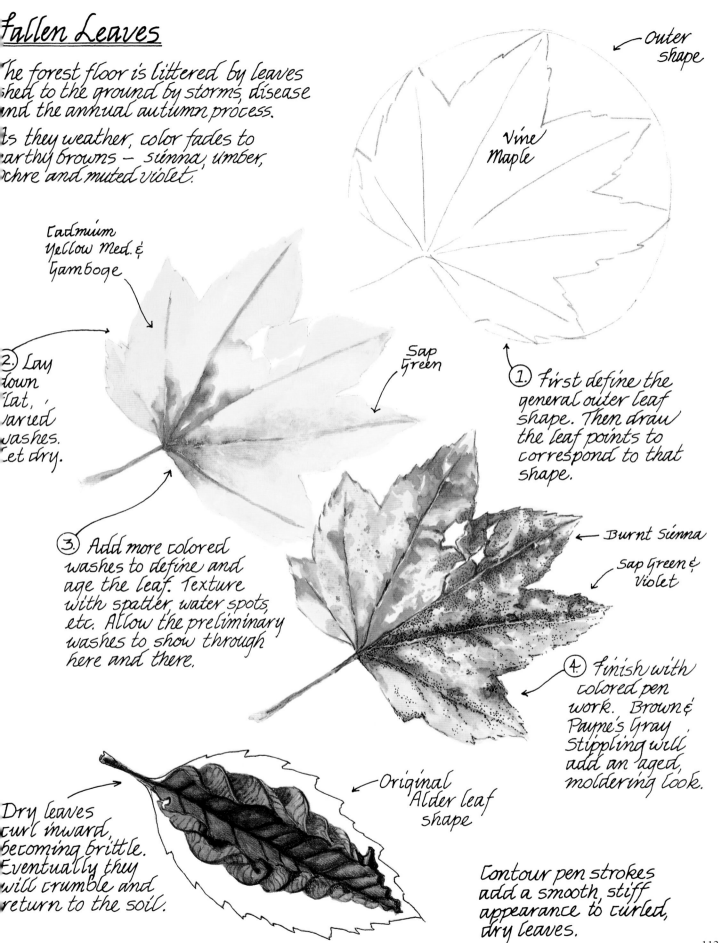

Outer shape

Vine Maple

Cadmium Yellow Med. & Gamboge

2.) Lay down flat, varied washes. Let dry.

Sap Green

1.) First define the general outer leaf shape. Then draw the leaf points to correspond to that shape.

3.) Add more colored washes to define and age the leaf. Texture with spatter, water spots, etc. Allow the preliminary washes to show through here and there.

Burnt Sienna

Sap Green & Violet

4.) Finish with colored pen work. Brown & Payne's Gray Stippling will add an aged, moldering look.

Original Alder leaf shape

Dry leaves curl inward, becoming brittle. Eventually they will crumble and return to the soil.

Contour pen strokes add a smooth, stiff appearance to curled, dry leaves.

"Leaf Litter" is a complicated piece which is easy to conquer one area at a time.

The background was laid in first, beginning with the Sword Fern leaf prints. The Thalo/Sap Green prints were enhanced with additional washes of Sap Green, applied with a round detail brush.

The background wash is a Burnt Umber & Payne's Gray mix, with a spattering of water drops for texture.

The leaves are layered washes, enhanced and textured with Payne's Gray and Brown pen work.

The Pacific Treefrog sets this as a Western forest scene. An Eastern amphibian could have been used.

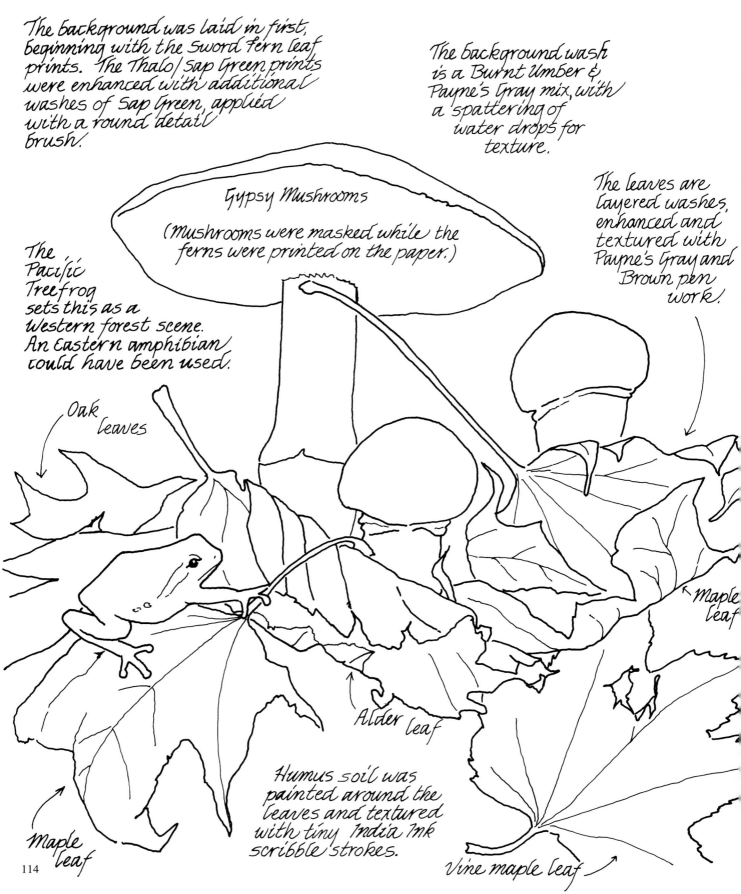

Gypsy Mushrooms

(Mushrooms were masked while the ferns were printed on the paper.)

Oak leaves

Maple leaf

Maple leaf

Alder leaf

Humus soil was painted around the leaves and textured with tiny India Ink scribble strokes.

Vine maple leaf

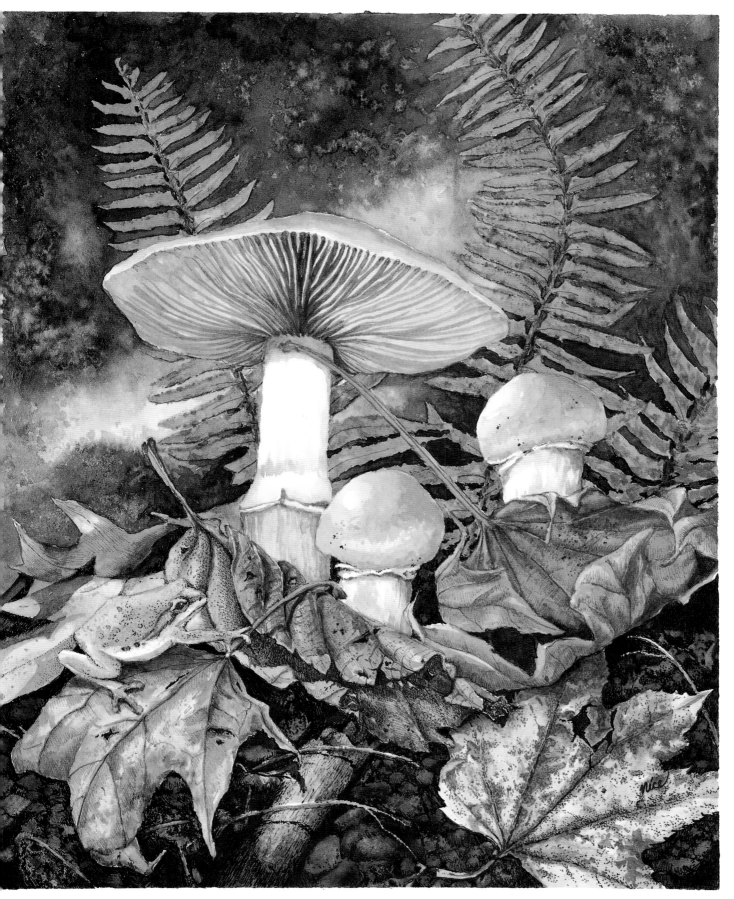

LEAF LITTER, 8″×10″ (20.3cm×25.4cm), layered watercolor
washes textured with spattering, stippling and penwork

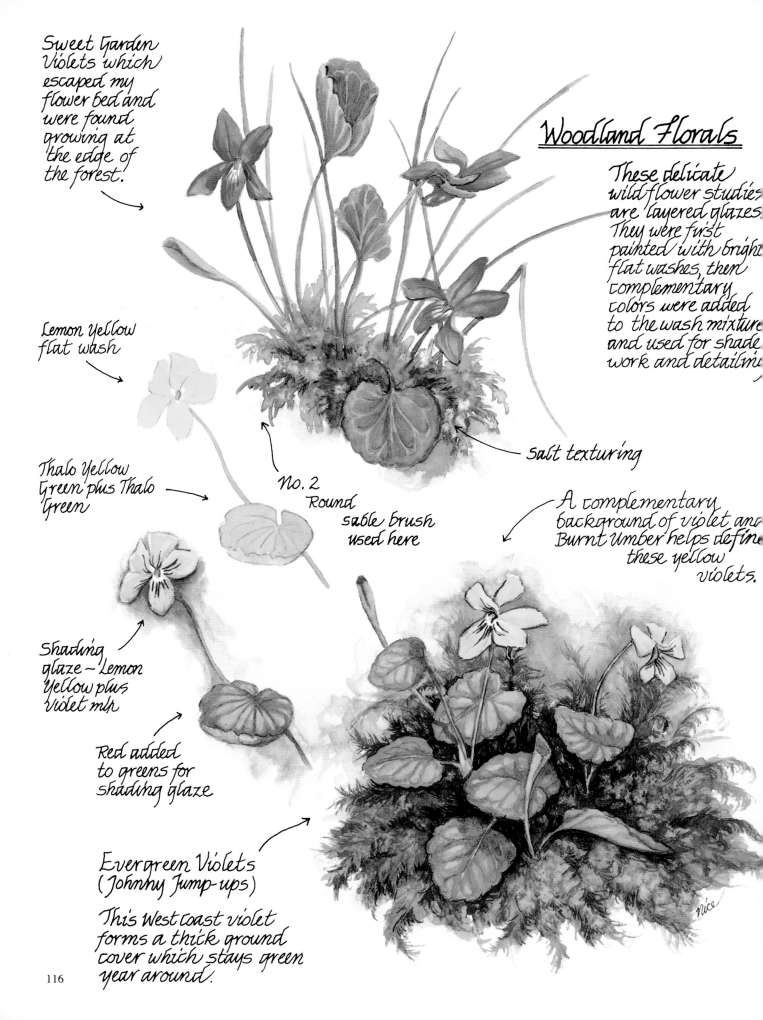

Sweet Garden Violets which escaped my flower bed and were found growing at the edge of the forest!

Woodland Florals

These delicate wildflower studies are layered glazes. They were first painted with bright flat washes, then complementary colors were added to the wash mixture and used for shade work and detailing.

Lemon Yellow flat wash

Thalo Yellow Green plus Thalo Green

No. 2 Round sable brush used here

salt texturing

A complementary background of violet and Burnt Umber helps define these yellow violets.

Shading glaze — Lemon Yellow plus violet mix

Red added to greens for shading glaze

Evergreen Violets (Johnny Jump-ups)

This West Coast violet forms a thick ground cover which stays green year around.

nice

116

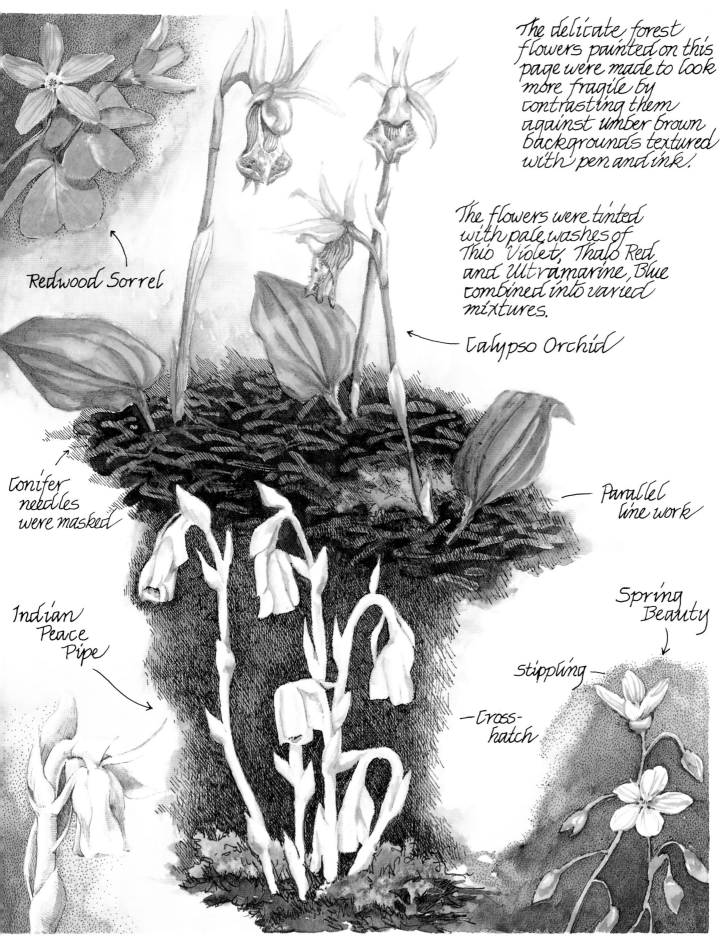

The delicate forest flowers painted on this page were made to look more fragile by contrasting them against umber brown backgrounds textured with pen and ink.

The flowers were tinted with pale washes of Thio Violet, Thalo Red and Ultramarine Blue combined into varied mixtures.

Redwood Sorrel

Calypso Orchid

Conifer needles were masked

Parallel line work

Indian Peace Pipe

Spring Beauty

stippling

Cross-hatch

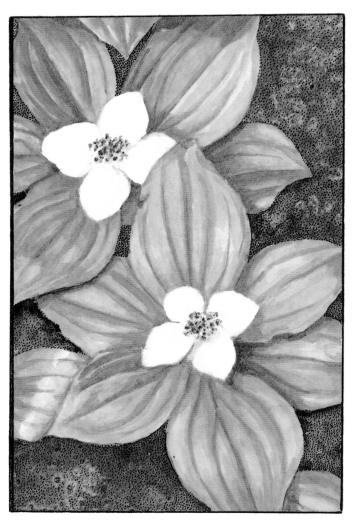

Bunchberry

Wild Geranium

Jack-In-The-Pulpit

Tiger Lily

As seen in these close-up studies, forest flowers make excellent miniature groupings. The blossoms and leaves were painted using layered, blended washes. The textured backgrounds are varied watercolor washes, (some were salted), over laid with stippled pen work in brown or India ink. (.25, .35)

Note that the florals are drawn a little larger than life, completely filling their frames. This creates interesting negative spaces in the background.

Oregon Grape

Trillium

Poison Delphinium

The background of the Douglas'
Squirrel painting is a mix of
Paynes Gray and Thalo Blue,
applied wet-on-wet and
blotted with crumpled
facial tissue.

Tree Squirrels

These bushy-tailed rodents are
forest inhabitants, nesting in trees
and foraging on the forest floor for
nuts, berries and in the case of the
west coast Douglas' Squirrel -
mushrooms.

① Payne's Gray
colored pen
work. (.25)

Fox
Squirrel
(Eastern
U.S.)

② Add Brown
criss cross
pen strokes

Criss cross pen
strokes. Watch
line direction
and length
of stroke

Scratched in
with a razor
blade.

Layered
"dirty palet"
washes and
brown ink
work.

India ink field
sketch.

③ Tint ink
work with
washes of
water-
color.

Red Squirrel
(Upper North America)

Yellow Ochre
plus Burnt
Sienna

Burnt Umber
and Sienna,
plus Thio Violet

Payne's
Gray added

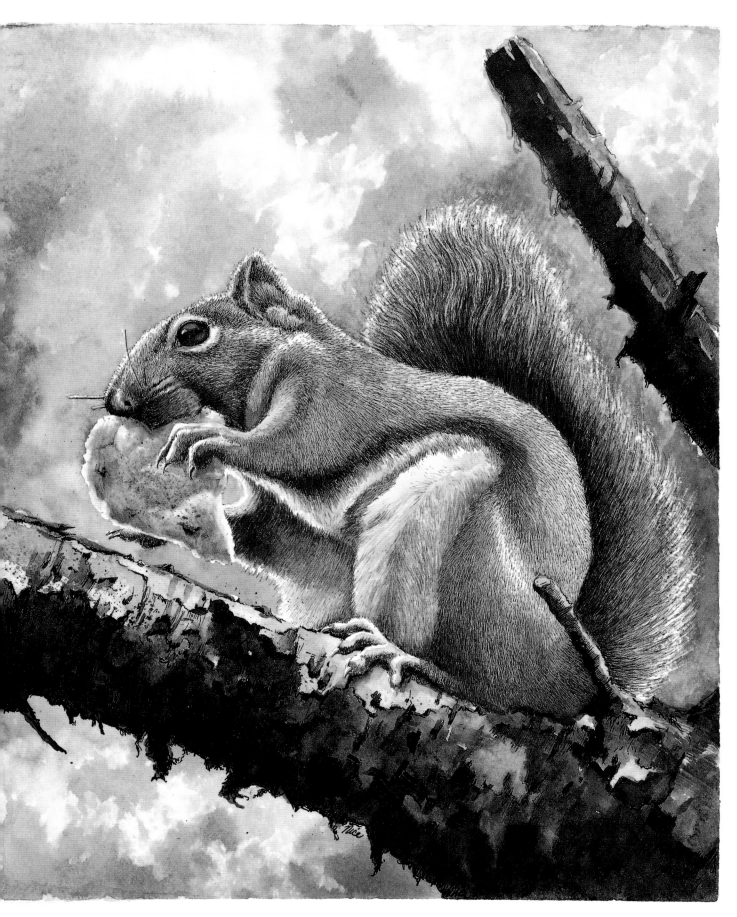

DOUGLAS SQUIRREL, 8″×10″ (20.3cm×25.4cm), colored penwork
tinted with watercolor washes and detailed with India ink

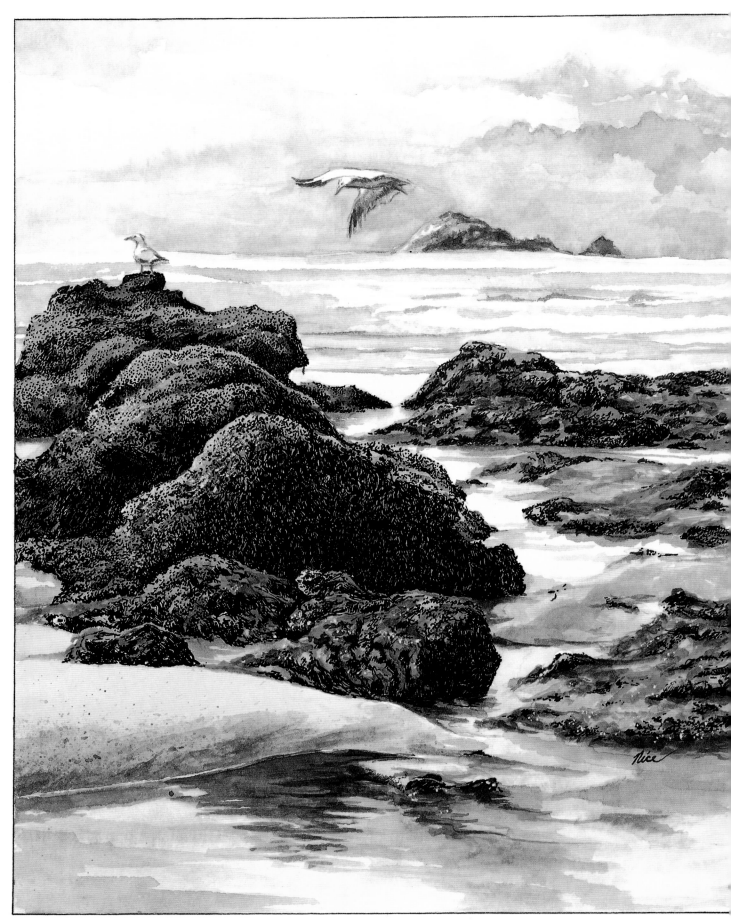

LOW TIDE, 7″×9″ (17.8cm×22.9cm), watercolor washes textured with penwork

TIDE POOLS AND TROPICAL REEFS

It is possible to wear a full smile of delight inside a snorkeling mask. I know, because that's just what happened the first time I donned one and floated into the fantasy world of the tropical reef. I found the water too blue to be believed. Near the surface it undulated in vivid shades of turquoise, changing to cobalt, then deep ultramarine in the shadowy depths. Against this azure backdrop swam wildly patterned fish whose colors were completely uninhibited, as if they had been designed in a creative frenzy by a child with a new box of crayons. In this anything-goes, watery realm, the imagination is set free and artistic license takes on a new meaning. Observation and visual recall are doubly important because on-location sketching is next to impossible. Although my photographs never seem to capture the colors of the reef in accurate splendor, they are valuable in recording shapes, textures and tricky light patterns. Inexpensive, single-use underwater cameras can provide excellent resource material and are effective down to ten feet.

Perhaps you're a landlubber and don't like the idea of swimming with the denizens of the deep, tropical or otherwise. There are alternatives. Most marine aquariums have reef exhibits where the beauty of the undersea world may be enjoyed and sketched in dry comfort. Or check out a pet store specializing in saltwater fish.

Along the rocky coasts, the cold water oceans form their own type of undersea garden: the tide pool. Here, at low tide, the inquisitive explorer can find one visual treasure after another. Seaweeds, anemones, urchins, mollusks and starfish cling to the craggy walls in bright profusion, while tiny crabs scurry over a mosaic floor of broken shells and water-polished pebbles. Tiny fish in sand-colored camouflage dart into the shadows to hide. Always, there's the unexpected: Perhaps you'll spot a fragile jellyfish, trapped by the receding tide. As you walk out among the tide pools, keep the following suggestions in mind. Slip-resistant shoes are a must. Polarized sunglasses will help you see into the pools more clearly. A campstool will add to your comfort if you plan to sketch. Above all, watch the tide—the receding water will return, often with surprising swiftness.

The Reef

Coral colonies consist of small animals (polyps) which surround themselves with a limey material, which in turn hardens into the rigid coral head.

Algae living within the coral provides its coloration of green, brown, ochre, yellow or pinkish tan.

Alcohol spatter

Tropical sea color —

Thalo Green & Thalo Blue

(Graded wash)

Dead, eroded coral spire was painted with a wet-on-wet varied wash, then impressed with plastic wrap.

(Protect background with a paper or film stencil during the procedure.)

Payne's Gray added to Thalo Green and Blue to suggest shadowy, distant reef formation

Yellow Ochre, daubed with earthy browns.

Live coral head was painted with a wet-on-wet varied wash of Yellow Ochre, Burnt Sienna and Burnt Umber.

India ink stipple work (.25, .50)

Texture was added with spatter, and Brown and Sepia pen work. (.25, .35)

Stippled edge

Besides numerous coral types, there are an overwhelming variety of sponges, sea feathers, fan worms, sea anemones etc. clinging to the reef, each adding a bit of frilly texture and color. To represent them at a distance, try the following technique!

Puddingwife (juvenile)

Fish eye and spots were darkened with India ink.

① Repeating the colors of the fish and sea water, paint a patch work design over the reef area. Work on a dry surface and let the results dry completely before continuing.

This large Wrasse fish inhabits rock and coral reefs from North Carolina to Brazil.

② Working in small sections, layer on a thin, dark wash. (Varied mixes of Siennas, Umbers and Payne's Gray.) Add texture to each area before moving on.

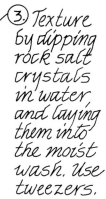
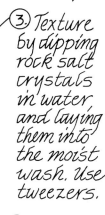

③ Texture by dipping rock salt crystals in water, and laying them into the moist wash. Use tweezers.

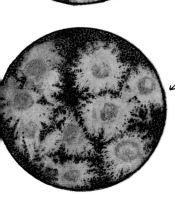

④ Leave salt crystals in place until dry then remove. Darken background areas if needed and stipple them with sepia or India ink. (.25, .35)

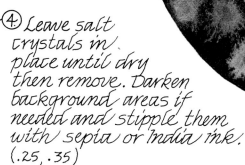

Note: Table salt may be used to represent smaller or more distant reef creatures.

Reef Fish

Like sea going butterflies, the reef fish come in an amazing assortment of shapes and colors, each with its own life-style and peculiar habits. Bright, primary colors are at home on these fish, contrasted with blue blacks, dark earthy browns and complementary mixtures.

Most of these fish are Hawaiian inhabitants unless otherwise noted.

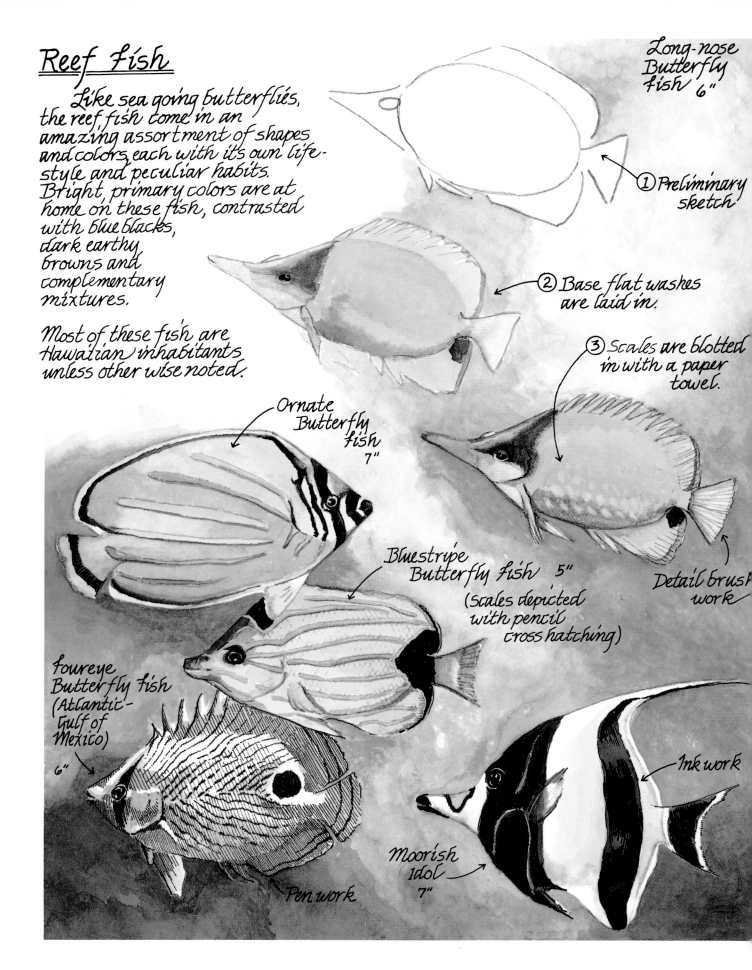

Long-nose Butterfly fish 6"

① Preliminary sketch

② Base flat washes are laid in.

③ Scales are blotted in with a paper towel.

Detail brush work

Ornate Butterfly fish 7"

Bluestripe Butterfly fish 5"
(scales depicted with pencil cross hatching)

foureye Butterfly fish (Atlantic-Gulf of Mexico) 6"

Ink work

Pen work

Moorish Idol 7"

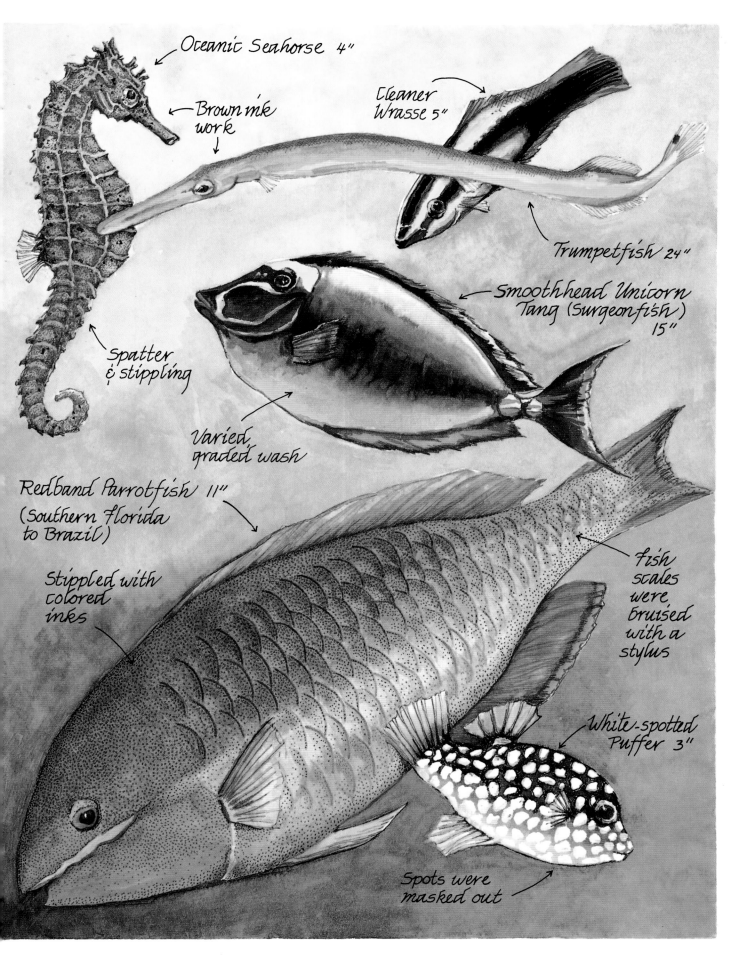

Oceanic Seahorse 4"

Brown ink work

Cleaner Wrasse 5"

Trumpetfish 24"

Smoothhead Unicorn Tang (Surgeonfish) 15"

Spatter & stippling

Varied graded wash

Redband Parrotfish 11" (Southern Florida to Brazil)

fish scales were bruised with a stylus

Stippled with colored inks

White-spotted Puffer 3"

Spots were masked out

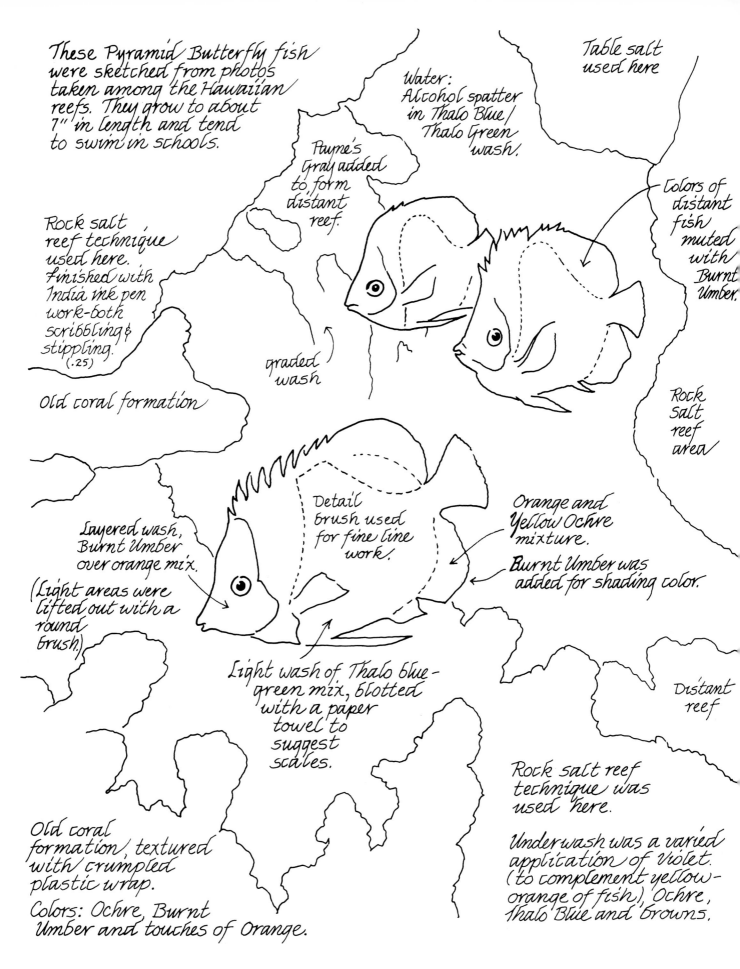

These Pyramid Butterfly fish were sketched from photos taken among the Hawaiian reefs. They grow to about 7" in length and tend to swim in schools.

Table salt used here

Water: Alcohol spatter in Thalo Blue/Thalo Green wash.

Payne's Gray added to form distant reef.

Colors of distant fish muted with Burnt Umber

Rock salt reef technique used here. Finished with India ink pen work—both scribbling & stippling. (.25)

Old coral formation

graded wash

Rock Salt reef area

Detail brush used for fine line work.

Orange and Yellow Ochre mixture.

Burnt Umber was added for shading color.

Layered wash, Burnt Umber over orange mix. (Light areas were lifted out with a round brush.)

Light wash of Thalo blue-green mix, blotted with a paper towel to suggest scales.

Distant reef

Rock salt reef technique was used here.

Old coral formation, textured with crumpled plastic wrap.
Colors: Ochre, Burnt Umber and touches of Orange.

Underwash was a varied application of violet. (to complement yellow-orange of fish), Ochre, Thalo Blue and Browns.

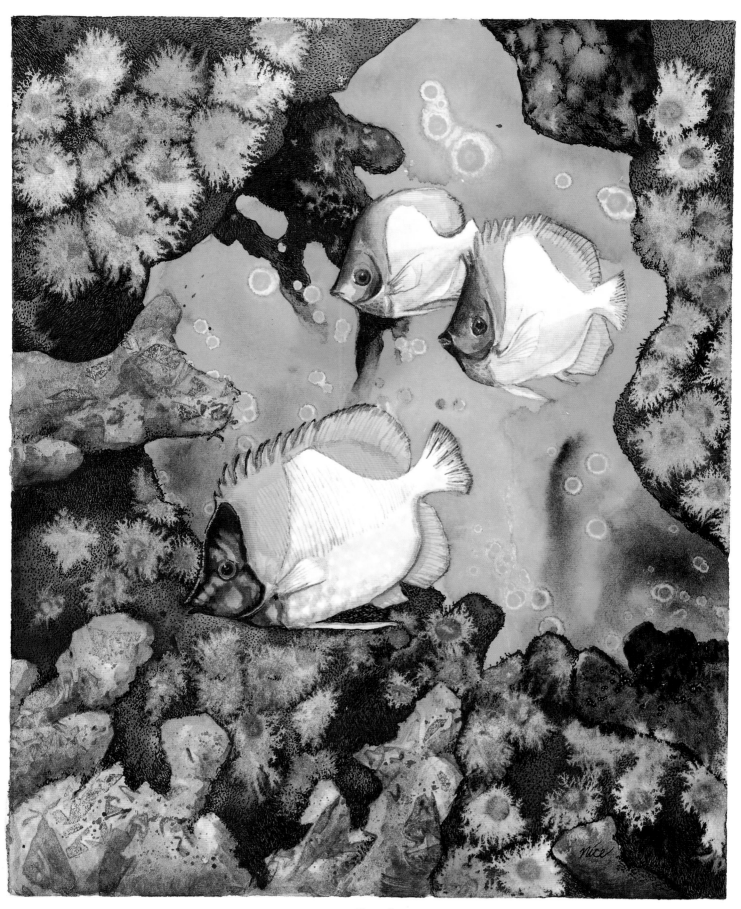

PYRAMID BUTTERFLY FISH, 8″ × 10″ (20.3cm × 25.4cm), water-
color with salt and alcohol techniques and pen and ink stippling

These Rectangular Trigger fish have the ability to wedge themselves firmly into rock crevices, by raising and locking their spiny dorsal fins. The front spine can not be lowered until the trigger-like second spine is lowered - thus the name. 9"

Painted from sketches made in Hawaii.

Background fish muted with a glaze of Thalo Blue / Burnt Umber.

Water:
Alcohol drops in a damp wash of Thalo Blue and Thalo Green.

coral

coral

Coral head

yellow Ochre

ink

Red Orange

India Ink

Thalo Blue muted with a touch of Burnt Umber.

Fine line detailing added with small round brush.

Wet-on-wet wash of Yellow Ochre, Burnt Umber and orange Textured with brown ink. (.25)

Rock salt texturing technique used to suggest reef.

Under painting is a varied wash of Thalo Blue, violet and "dirty palette browns."

Pen work over reef is India ink. (.25)

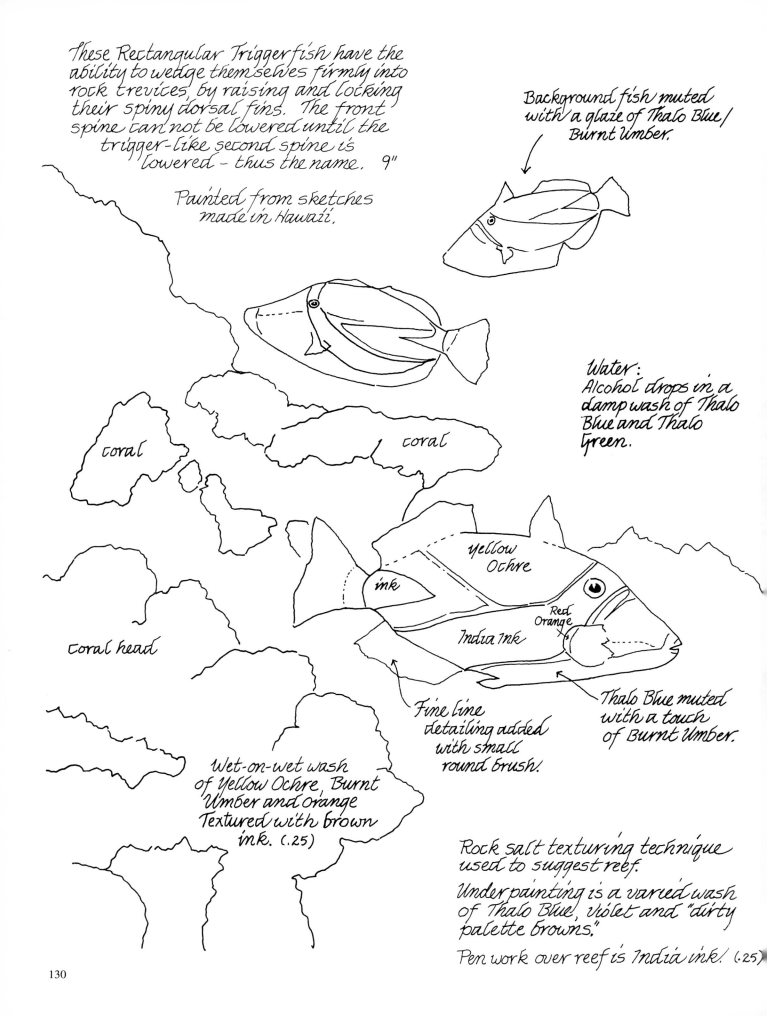

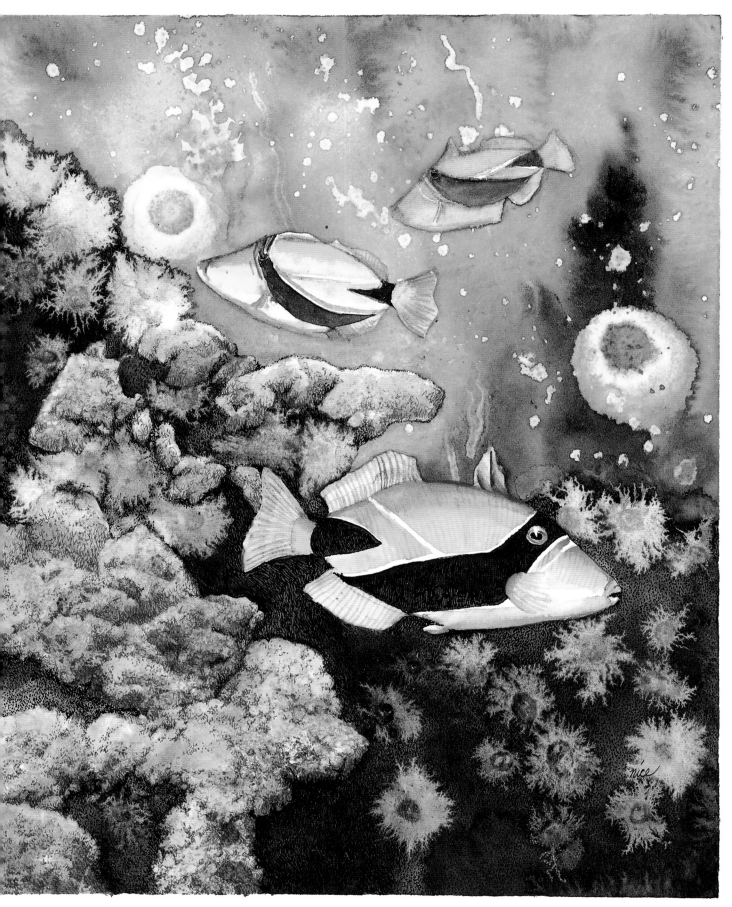

TRIGGERFISH, 8″×10″ (20.3cm×25.4cm), water-
color with salt and alcohol techniques and penwork

Tide Pool Backgrounds

Tide pools are found on rocky shores, in the intertidal zone, where the relentless surf and sea life carve holes in the stone, and the tides ebb and flow, filling them with sea water and sea debris — sand, fine gravel, smooth pebbles and bits of broken shell.

sand

Ⓐ Lay down a varied wash, (Payne's Gray, Burnt Umber, and dirty palette browns,) over a fine spattering of masking fluid.

Ⓑ Texture with fine water color spatter. Remove masking and add pen stippling as needed. (.25)

Pebbles and shell pieces

Use grays, browns and muted hues from the composition.

Mask out white areas.

① Use small stroke brush to rough in rounded shapes on a dry surface.

② Darken crevices with pen and ink.

③ Shade with detail brush.

Encrusting Coral Algae forms bright pink calcium scales on rocks, in lower intertidal pools.

Payne's Gray & Burnt Umber mixtures.

Alcohol spatter

Coralline Algae (Layered washes of Burnt Sienna & Brown Madder.)

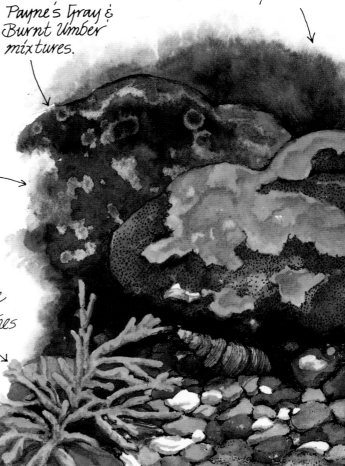

Encrusting Creatures

Clinging tenaciously to wave-swept rocks are leaf barnacles, common barnacles and mussels, forming thick crusty colonies. On top crawl the snails and limpets, feeding on algae. Pen and ink works well to depict these highly textured animals. A light wash of water color will bring them to life.

(.25)

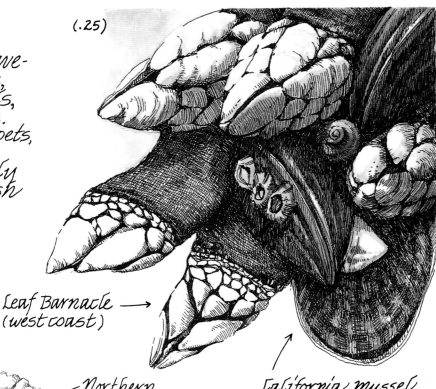

Leaf Barnacle → (west coast)

California Mussel (west coast)

Blue Mussel (both coasts)

Northern Rock Barnacle (North east coast)

Sepia ink

Barnacle quick studies in gray ink

Cayenne Keyhole Limpet
Volcano Limpet (below)

Atlantic Dogwinkles

Unicorn

Beaded Miter (east coast)

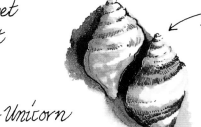

Emarginate Dogwinkle

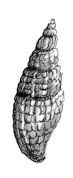

Black Turban Snail (Algae on shell)

West coast

133

Crabs

The crabs living in the inter tidal zone are small, with earth tone shells that match their surroundings. Sponging provides a fun way to depict their rough, crusty texture.

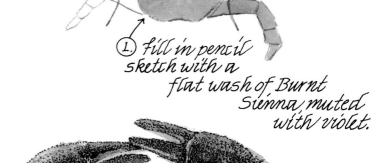

Flat Porcelain Crab (west coast)
1"

Mask joints

① Fill in pencil sketch with a flat wash of Burnt Sienna muted with violet.

② Mask out the background and daub the crab with a sea sponge dipped in the same watercolor mixture.

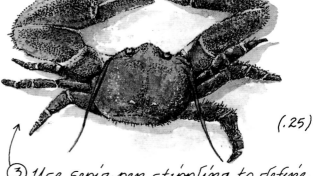

(.25)

③ Use sepia pen stippling to define and further texture the crab shell.

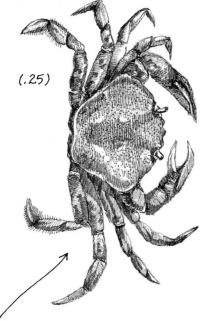

(.25)

Preliminary flat washes.

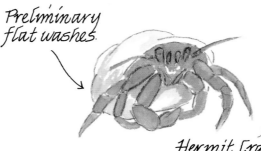

Hermit Crab

Brown ink study of a North east coast Green Crab. 3 1/8"

Crab shaded and defined with dry brush detailing and pen work. White dots were added with razor blade.

Molted shells of larger deep water crabs are often found in tide pools.

134

Sea Stars And Urchins

Sea stars and urchins are closely related, both having a spiny shell and tiny tube feet. Their color range includes brown, green, purple and red. Sea stars can also be pink, ochre and bright orange. They inhabit rocky walls in tide pools and deeper.

Sand dollars prefer sand bottoms, and are seldom found alive in tide pools.

① Pencil sketch

Spines net like

② Mask out spines in a dotted pattern and brush on a flat wash.

Ochre Sea Star (West coast)

③ Shade the sea star with pen stippling and blended washes of the same mixture, darkened.

← Northern Sea Star (North east coast)

Row of spines down center of arm

Purple Sea Urchin

Spines were masked out while body was painted

Dry brush accents

Sand dollar shells, like this Eccentric, are sometimes washed into tide pools and make interesting additions to sketches.

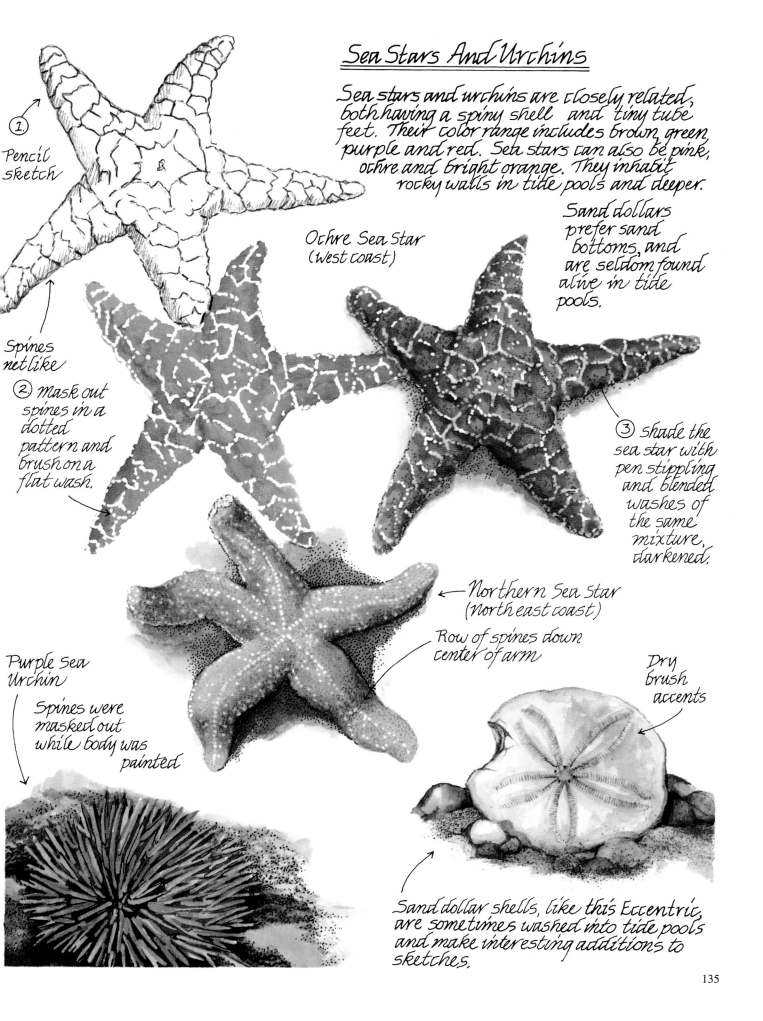

135

Tentacles are used to capture food.

① ② ③ ④

Sea Anemones

Sea anemones look like symmetrical flowers, but are actually long-lived animals. There are over 1,000 species, ranging from tide pool dwellers to inhabitants of the deep sea trenches. The Giant Green Anemone illustrated on this page colonizes tide pools from Japan, Siberia and Alaska to Panama.

Distant sea anemones can be suggested using rock salt.

① Outline the tentacles lightly in pencil and mask with masking fluid, leaving body area open.

② Paint the body and background areas. let dry. (A wash of Thalo Green, Thalo Yellow Green and Burnt Sienna, to mute color, was used on the body.)

③ Shade body and add cast shadows with a darker wash mixture.

④ Remove masking fluid with masking tape and tint the tentacles with a very pale wash.

The base is textured with brown ink stippling.

The fish is a Tide Pool Sculpin.

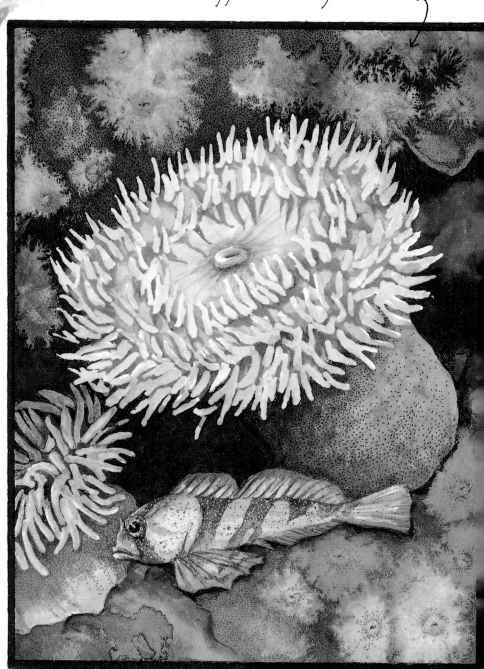

Jellyfish

Sea Jellies don't live in tide pools, but may be swept in during high tide. Depicting their delicate, translucent bodies can be a fun challenge.

The distant jellyfish on either side began with a large drop of alcohol, dropped on a moist surface wash. Brushed alcohol streamers were added to the jelly on the right.

Detailing was a combination of razor blade scratches, dip pen applied white ink and white acrylic paint.

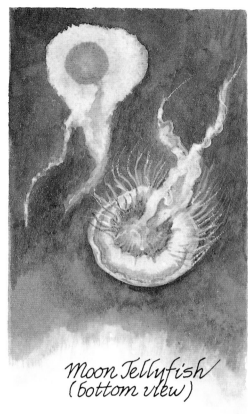

Moon Jellyfish (top view)

Moon Jellyfish (bottom view)

For transparent look, let background color show through body.

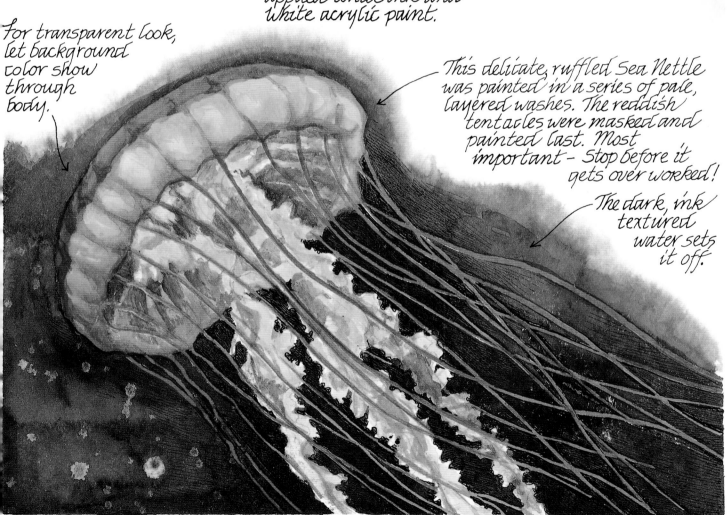

This delicate, ruffled Sea Nettle was painted in a series of pale, layered washes. The reddish tentacles were masked and painted last. Most important - Stop before it gets over worked!

The dark, ink textured water sets it off.

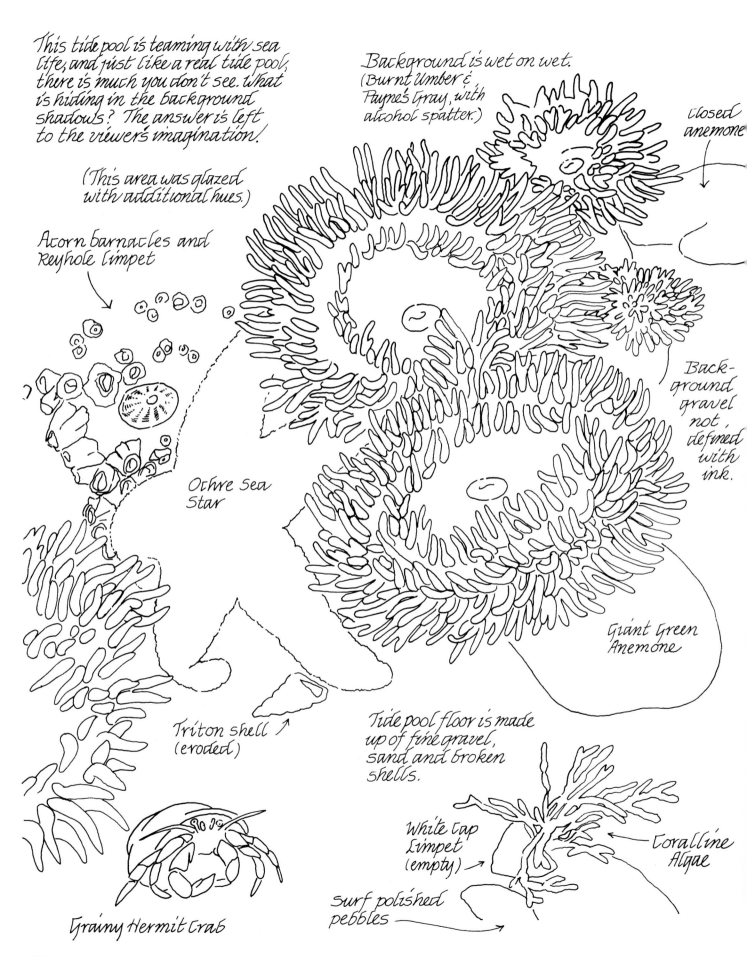

This tide pool is teaming with sea life, and just like a real tide pool, there is much you don't see. What is hiding in the background shadows? The answer is left to the viewer's imagination.

(This area was glazed with additional hues.)

Acorn barnacles and Keyhole Limpet

Ochre Sea Star

Background is wet on wet. (Burnt Umber & Payne's Gray, with alcohol spatter.)

Closed anemone

Background gravel not defined with ink.

Giant Green Anemone

Triton shell ↗ (eroded)

Tide pool floor is made up of fine gravel, sand and broken shells.

White Cap Limpet (empty) ↗

Coralline Algae

surf polished pebbles ——→

Grainy Hermit Crab

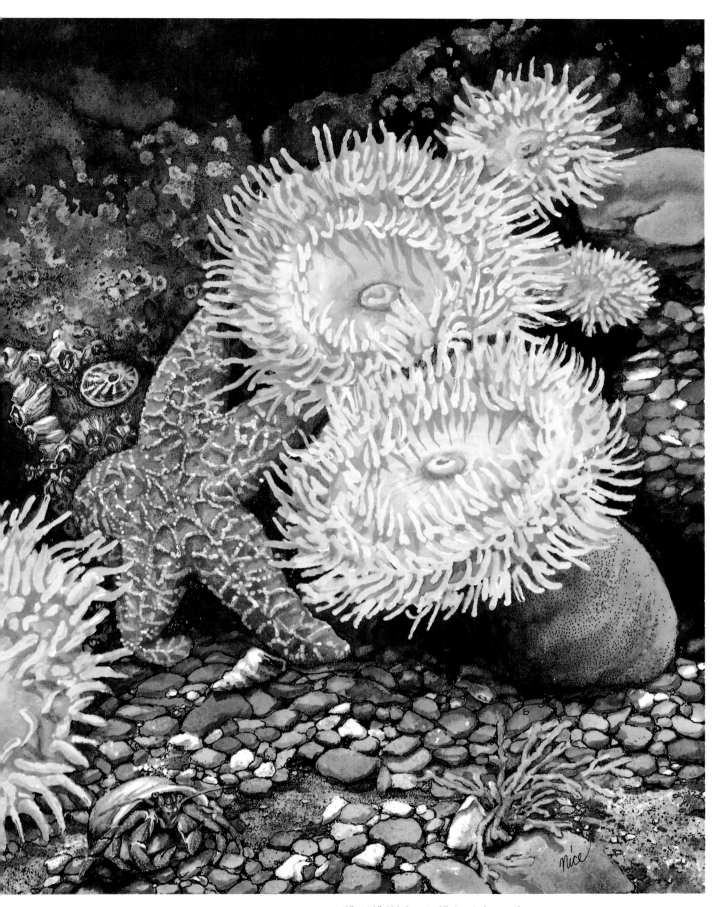

TIDE POOL TERRITORY, 8″ × 10″ (20.3cm × 25.4cm), layered
watercolor washes textured with penwork and spatter

Green Seaweeds

These large algae plants are abundant in the tidal areas where they cling to rocks, shells and other solid objects. Their shapes and textures vary greatly, allowing the use of numerous techniques in their portrayal.

Sepia ink scribble lines

The flat Sap Green wash was scraped with a small chisel when it was near dry.

Surf Grass
Dry brushed with a no. 4 round brush.

Sea Lettuce
Thin, lettuce-like plants that live in the upper inter tidal zone on both coasts.

Layered wash of Sap Green and Burnt Umber.

Sugar Wrack (both coasts)
A kelp with blades of up to 2 feet in length.

Rockweeds (both coasts)
These thin, rubbery plants have swollen tips.

Sea Sack (west coast)
Hollow, thin-walled plants filled near the top with gas. May be yellow green to purplish.

Graded wash

contour lines

Thalo Blue, Payne's Gray and Burnt Umber

Ochre and Sap Green

"Incoming Tide" (opposite) captures the exact moment the sea returns to the rocks, seaweed and barnacles. This is a complete pen and ink drawing, to which water color washes were added. The white water was protected with masking fluid.

140

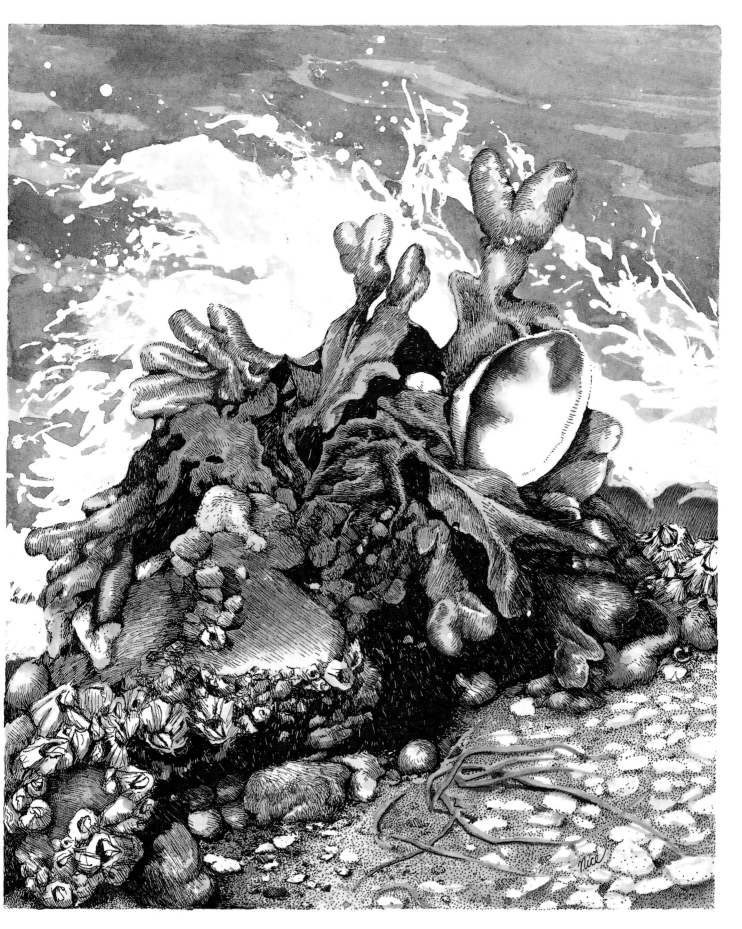

INCOMING TIDE, 7″ × 9½″ (17.8cm × 24.1cm),
Pen and ink drawing tinted with watercolor washes

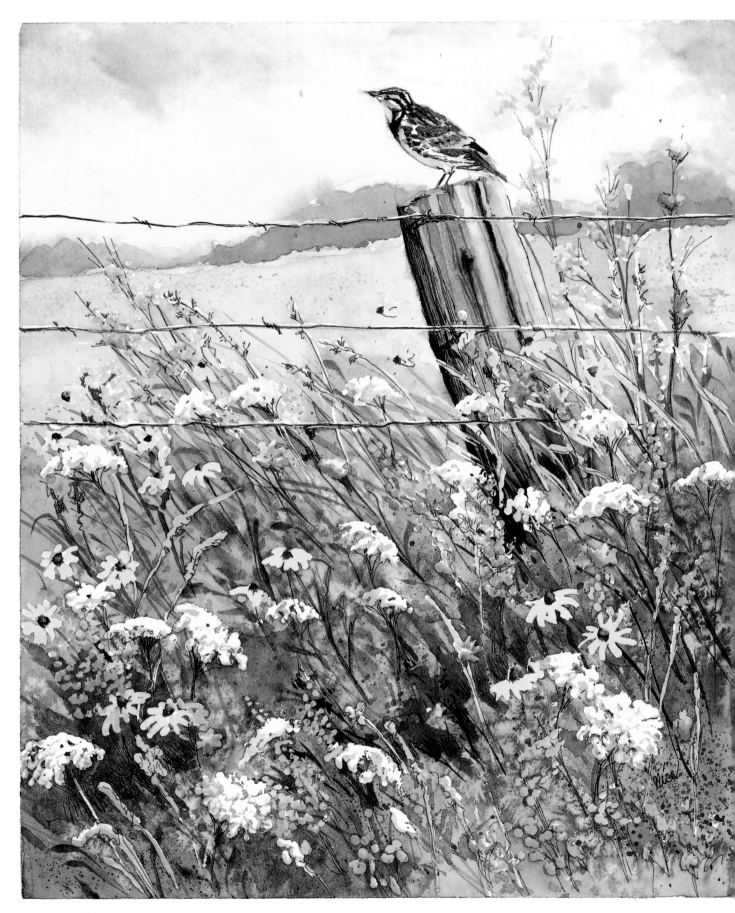

MEADOWLARK, 8″×10″ (20.3cm×25.4cm), masked
flowers, watercolor wash and Sepia ink detailing

FIELDS OF FLOWERS

Like a bright patchwork quilt cast across a bed, the spring wildflowers ripple across the face of the prairie, dancing in the dappled light of the forest meadows and meandering gaily through the open countryside to celebrate the sun. Wherever there are open fields, there are wildflowers. Some blossoms are bold with carnival-bright colors, while others are shy, hiding among the grasses in subtle pastel dress. All are beautiful. In nature's garden, there are no weeds—each plant has a purpose. Each bud, blossom, leaf and seed is a potential subject for the sketchbook.

In the field, the flowers have a vitality that cannot be duplicated in the studio with cut flowers. The still life is just that—still—the life force beginning to ebb from the blossoms.

Sit awhile among the flowers of the field and notice how the sun plays across the petals, creating a translucent quality not unlike stained glass. The colors are brighter in the natural light, requiring purer color mixtures on your palette. Linger long enough and you will see that the flowers are not the only inhabitants of the fields. The hum of insects and the twitter of the birdsong is all about. A hummingbird may zoom by on an important nectar-finding mission, while butterflies flit among the flowers in a silent ritual.

Wearing the earthy colors of the soil, rabbits, prairie dogs and mice keep watch among the grasses. Don't be afraid to add a creature or two to your flower paintings. They can provide an additional splash of color (butterflies and birds), create a point of interest (creeping insects) or provide earthy contrast hues (small animals). But don't try to draw it all. A simple study, devoid of background, is often more pleasing to the eye than an overwhelming tangle of foliage.

On the following pages the weather is clear, the flowers are in full bloom and the animals are cooperative, so don your sunglasses and join me in the field of flowers.

Drawing The Flower

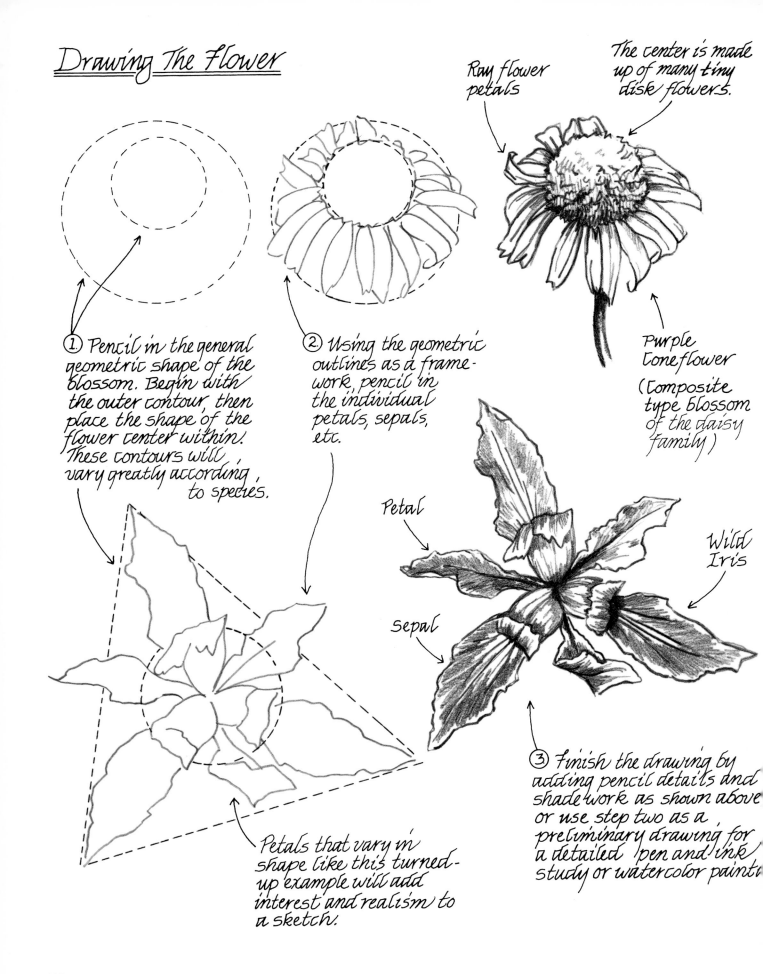

Ray flower petals

The center is made up of many tiny disk flowers.

① Pencil in the general geometric shape of the blossom. Begin with the outer contour, then place the shape of the flower center within. These contours will vary greatly according to species.

② Using the geometric outlines as a framework, pencil in the individual petals, sepals, etc.

Purple Coneflower (Composite type blossom of the daisy family)

Petal

Sepal

Wild Iris

Petals that vary in shape like this turned-up example will add interest and realism to a sketch.

③ Finish the drawing by adding pencil details and shade work as shown above or use step two as a preliminary drawing for a detailed pen and ink study or watercolor painti

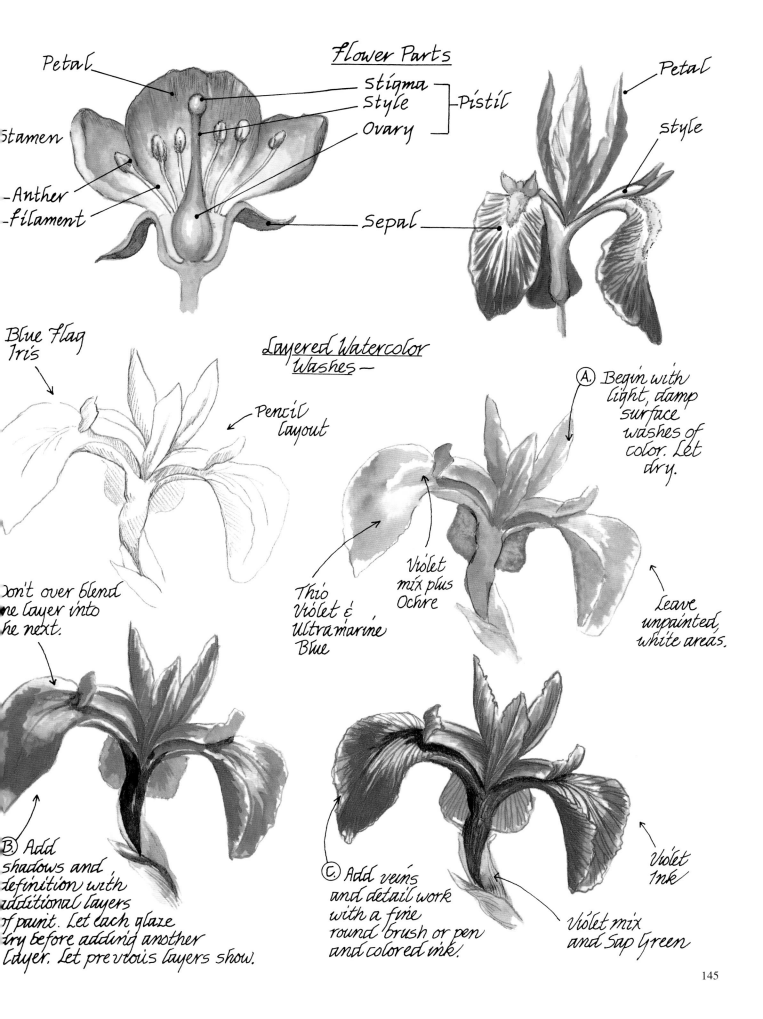

Flower Parts

Petal

Stigma
Style ⎤ Pistil
Ovary ⎦

Stamen

Anther

Filament

Sepal

Petal

Style

Layered Watercolor Washes —

Blue Flag Iris

Pencil Layout

A. Begin with light, damp surface washes of color. Let dry.

Thio Violet & Ultramarine Blue

Violet mix plus Ochre

Leave unpainted white areas.

Don't over blend one layer into the next.

B. Add shadows and definition with additional layers of paint. Let each glaze dry before adding another layer. Let previous layers show.

C. Add veins and detail work with a fine round brush or pen and colored ink.

Violet mix and Sap Green

Violet Ink

145

More layered-wash blossoms to experiment with —

Garden Coreopsis

① Pencil in flower shape and base wash the ray petals with Gamboge.

(Damp surface wash.)

② While the yellow rays are still moist, paint the center with Brown Madder and let it "bleed" onto the inner edges of the ray petals. Let dry.

③ Add Thio Violet to Gamboge and use mix to shade and define ray petals.

Use a second layer of Brown Madder to define flower center.

④ Texture the flower center with India ink scribble lines.

Ⓐ Begin painting with damp surface washes —

Grumbacher Red & Thio Violet mixed

Blend edges

Thalo Yellow Green

Ⓑ Second layer is a Thalo Yellow Green, Sap Green & Thalo Green mix.

Ⓒ Third layer is a mix of Thio Violet / Grumbacher Red with a touch of dark green from step B added.

Ⓓ Fourth layer is the dark green from step B, with Grumbacher Red added.

The edges of each additional layer were softened and blended with a clean, damp, no. 4 round brush.

Indian Paintbrush

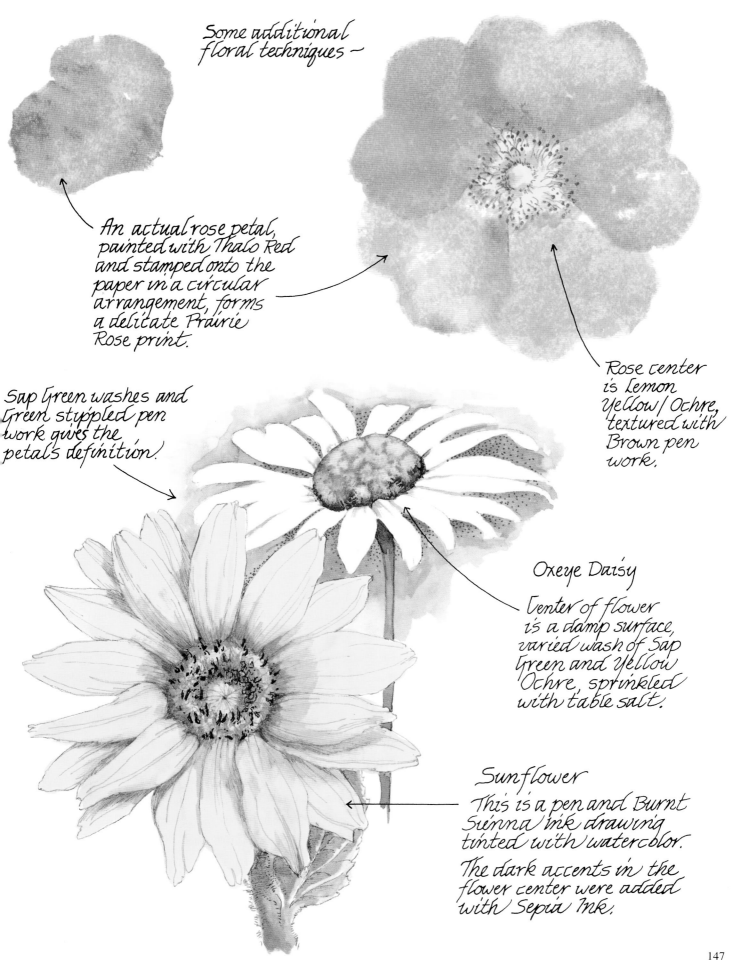

Some additional floral techniques ~

An actual rose petal, painted with Thalo Red and stamped onto the paper in a circular arrangement, forms a delicate Prairie Rose print.

Rose center is Lemon Yellow/Ochre, textured with Brown pen work.

Sap Green washes and Green stippled pen work gives the petals definition!

Oxeye Daisy

Center of flower is a damp surface, varied wash of Sap Green and Yellow Ochre, sprinkled with table salt.

Sunflower

This is a pen and Burnt Sienna ink drawing tinted with watercolor.

The dark accents in the flower center were added with Sepia Ink.

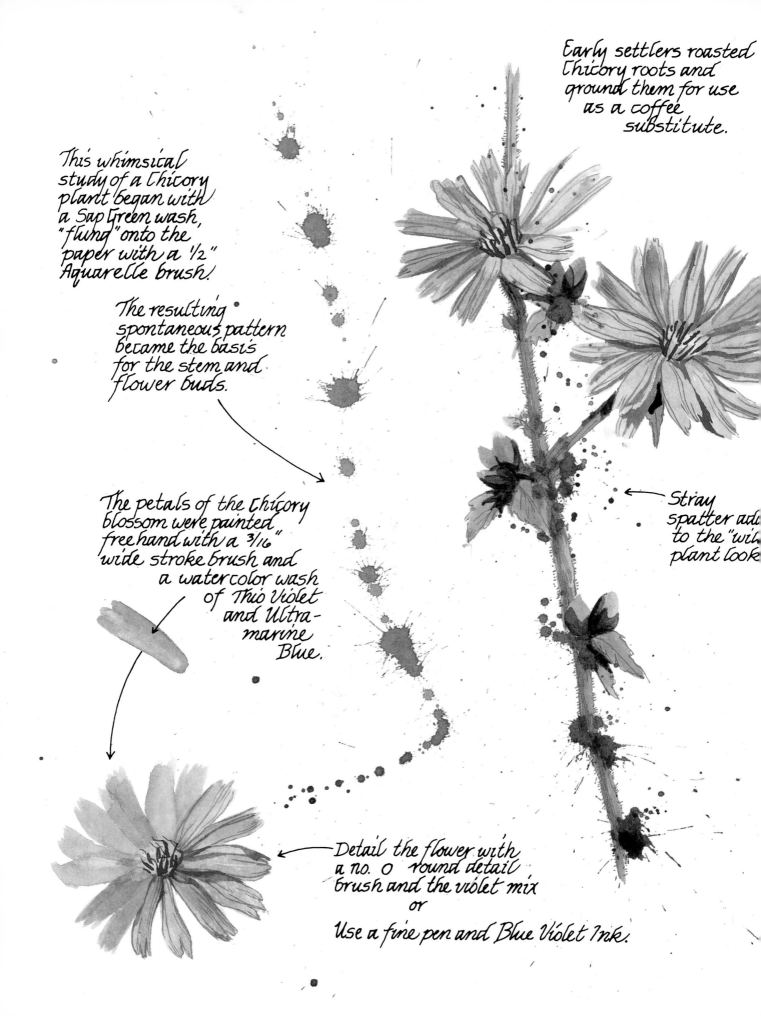

Early settlers roasted
Chicory roots and
ground them for use
as a coffee
substitute.

This whimsical
study of a Chicory
plant began with
a Sap Green wash,
"flung" onto the
paper with a ½"
Aquarelle brush!

The resulting
spontaneous pattern
became the basis
for the stem and
flower buds.

The petals of the Chicory
blossom were painted
freehand with a ³/₁₆"
wide stroke brush and
a watercolor wash
of Thio Violet
and Ultra-
marine
Blue.

Stray
spatter add
to the "wil
plant look

Detail the flower with
a no. 0 round detail
brush and the violet mix
or
Use a fine pen and Blue Violet Ink.

When painting white, lacy flowers, the background is the most important element. A medium to dark background provides the striking value contrast that gives the delicate flowers their definition!

① Apply masking fluid to block out the flowers and foreground foliage.

Spatter

Varied washes: Sap Green, Yellow Ochre & Burnt Sienna

③

Pearly Everlasting

table salt

Flower centers are background washes, detailed with Burnt Sienna ink.

② Use a ½" to ¾" Aquarelle brush to lay in the earthy background washes (Wet-on-wet or a damp surface). Add interest to the background with impressed leaves, salt and spatter. Let dry and remove masking.

③ Use a violet wash to shade the blossoms. Dry brush in details and paint the foliage with layered washes.

④ Add scribbly, colored ink lines to further define the flowers. Keep it light, loose and airy.

Payne's Gray ink

Queen Anne's Lace

Impressed grass blade

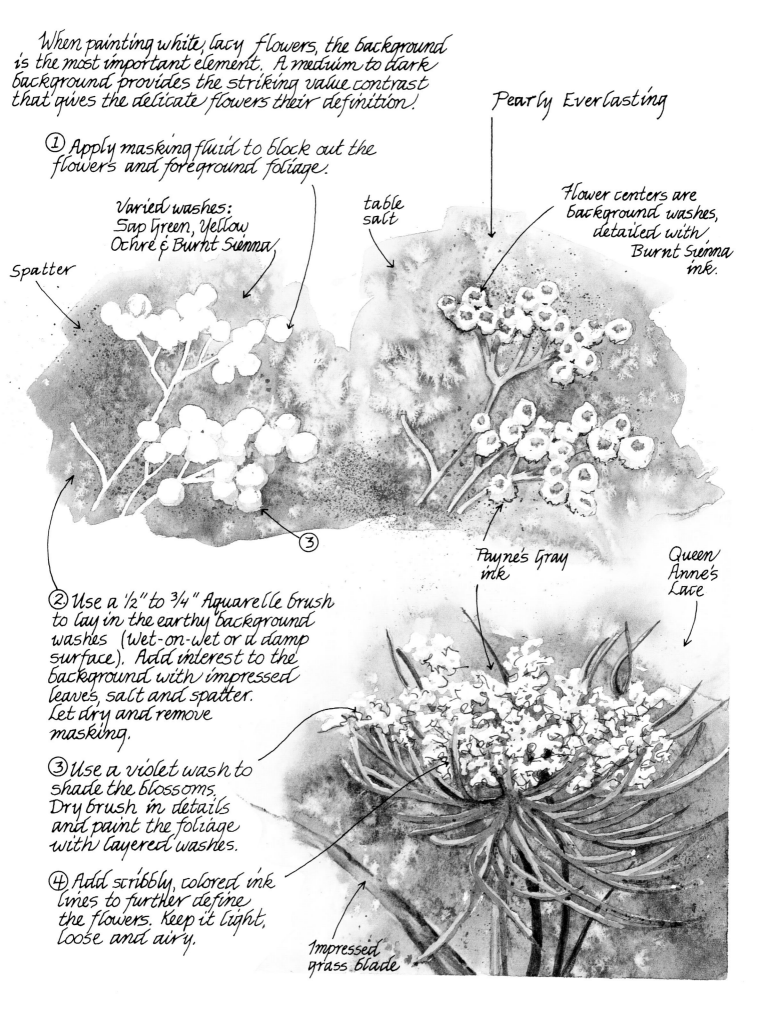

Insects

Insects are woven intricately into the floral tapestry of the grasslands. Therefore it is quite natural to include them in flower sketches. Here are some of my favorites.

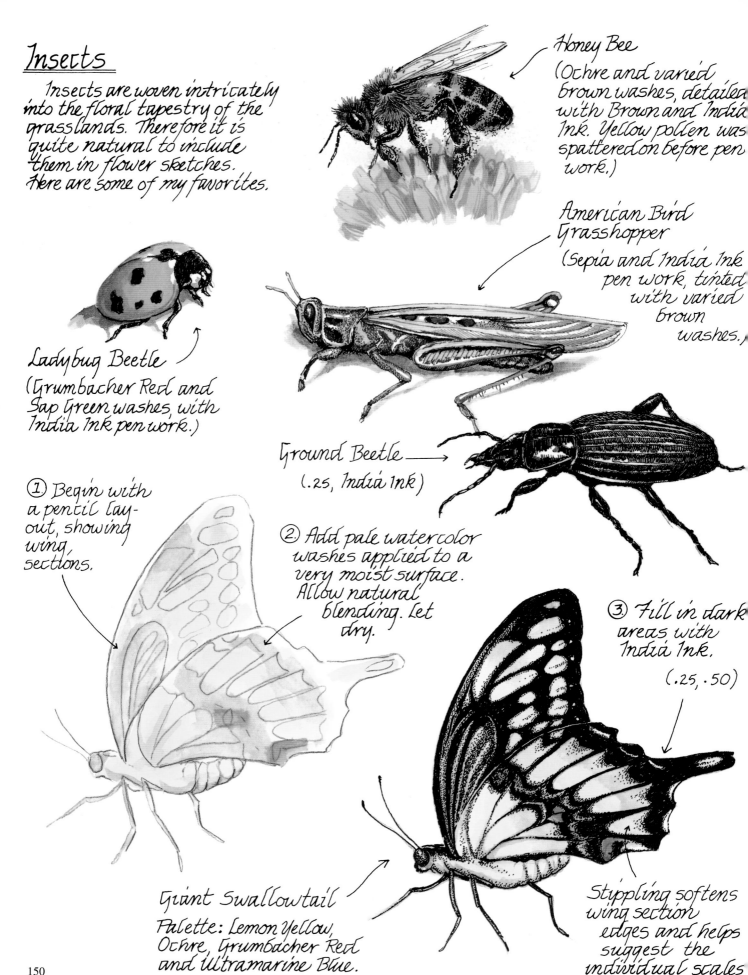

Honey Bee
(Ochre and varied brown washes, detailed with Brown and India Ink. Yellow pollen was spattered on before pen work.)

American Bird Grasshopper
(Sepia and India Ink pen work, tinted with varied brown washes.)

Ladybug Beetle
(Grumbacher Red and Sap Green washes, with India Ink pen work.)

Ground Beetle
(.25, India Ink)

① Begin with a pencil layout, showing wing sections.

② Add pale watercolor washes applied to a very moist surface. Allow natural blending. Let dry.

③ Fill in dark areas with India Ink.
(.25, .50)

Giant Swallowtail
Palette: Lemon Yellow, Ochre, Grumbacher Red and Ultramarine Blue.

Stippling softens wing section edges and helps suggest the individual scales

The butterfly sketched on this page is the Painted Lady. It can be found in gardens and meadows worldwide.

Textured with Sepia ink pen work (.25)

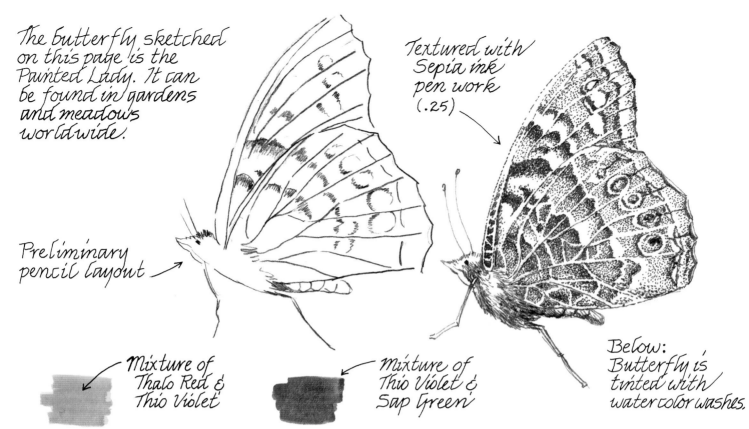

Preliminary pencil layout

Mixture of Thalo Red & Thio Violet

Mixture of Thio Violet & Sap Green

Below: Butterfly is tinted with water color washes.

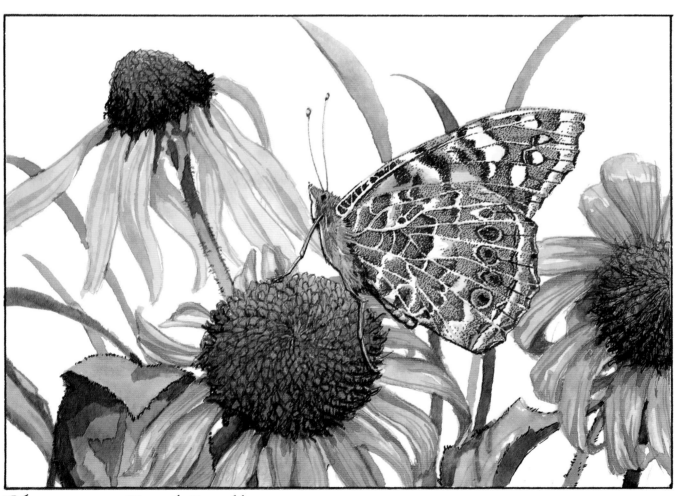

Blossoms are Purple Coneflowers.
Flower centers were textured with Sepia and India Ink scribble lines.

Hummingbirds

No bird is more at home around nectar-rich flowers than the feisty hummingbird. Preferring, bright, reddish blossoms like phlox, paintbrush and bee balm, the "hummer" jealously guards his favorite garden patch with angry chatter and dive-bombing displays.

Costa's Hummingbird

The blurry look of wet-on-wet and salt techniques adds a feeling of motion.

Head is large compared to body size.

Long, narrow bill, designed for dipping into tubular blossoms.

Tiny feet allow bird to perch, but not walk.

Feathers were textured with the bruising technique.

Rufous Hummingbirds

These perched "hummers" were loosely sketched using a .25 Rapidograph pen and Sepia Ink.

Male

Female

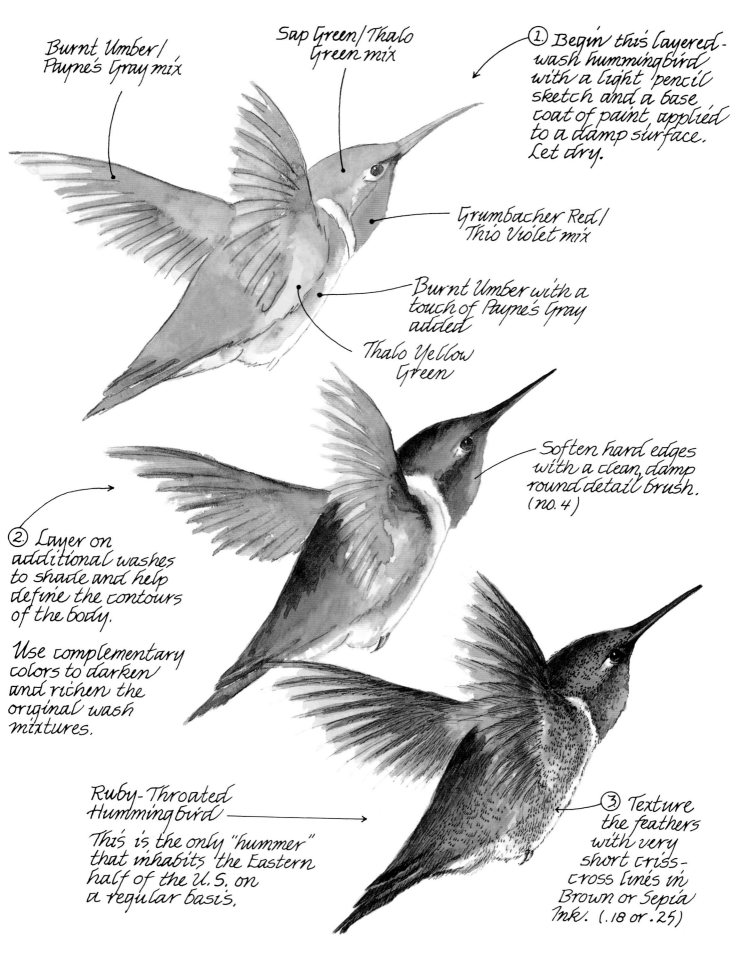

Burnt Umber / Payne's Gray mix

Sap Green / Thalo Green mix

① Begin this layered-wash hummingbird with a light pencil sketch and a base coat of paint, applied to a damp surface. Let dry.

Grumbacher Red / Thio Violet mix

Burnt Umber with a touch of Payne's Gray added

Thalo Yellow Green

Soften hard edges with a clean, damp round detail brush. (no. 4)

② Layer on additional washes to shade and help define the contours of the body.

Use complementary colors to darken and richen the original wash mixtures.

Ruby-Throated Hummingbird ⟶

This is the only "hummer" that inhabits the Eastern half of the U.S. on a regular basis.

③ Texture the feathers with very short criss-cross lines in Brown or Sepia Ink. (.18 or .25)

153

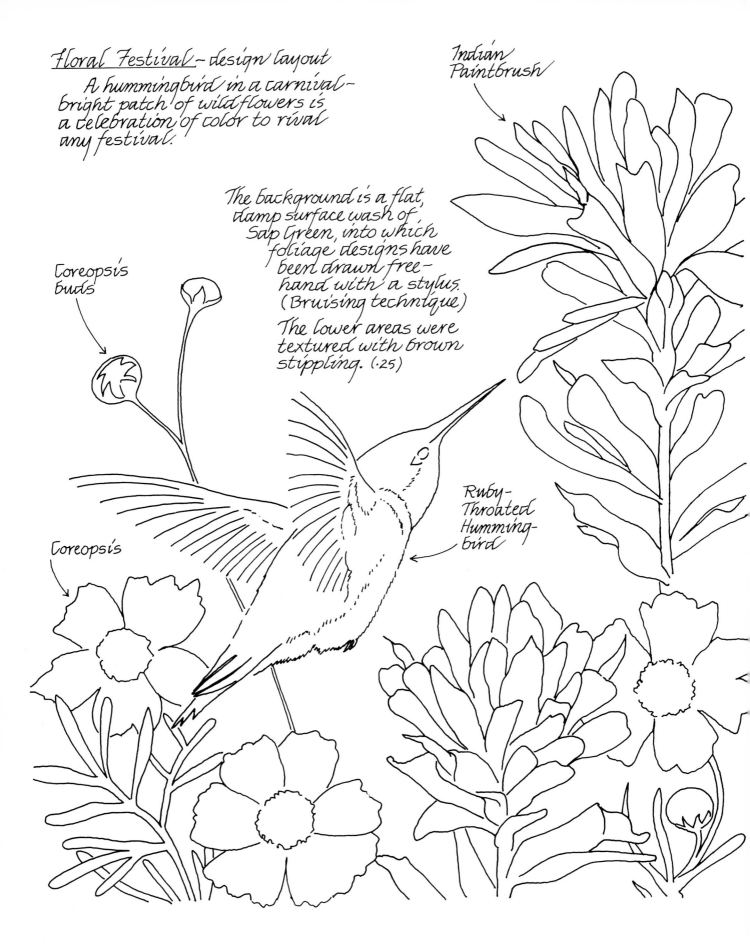

Floral Festival – design layout

A hummingbird in a carnival-bright patch of wildflowers is a celebration of color to rival any festival.

Indian Paintbrush

Coreopsis buds

The background is a flat, damp surface wash of Sap Green, into which foliage designs have been drawn free-hand with a stylus. (Bruising technique)

The lower areas were textured with brown stippling. (.25)

Coreopsis

Ruby-Throated Humming-bird

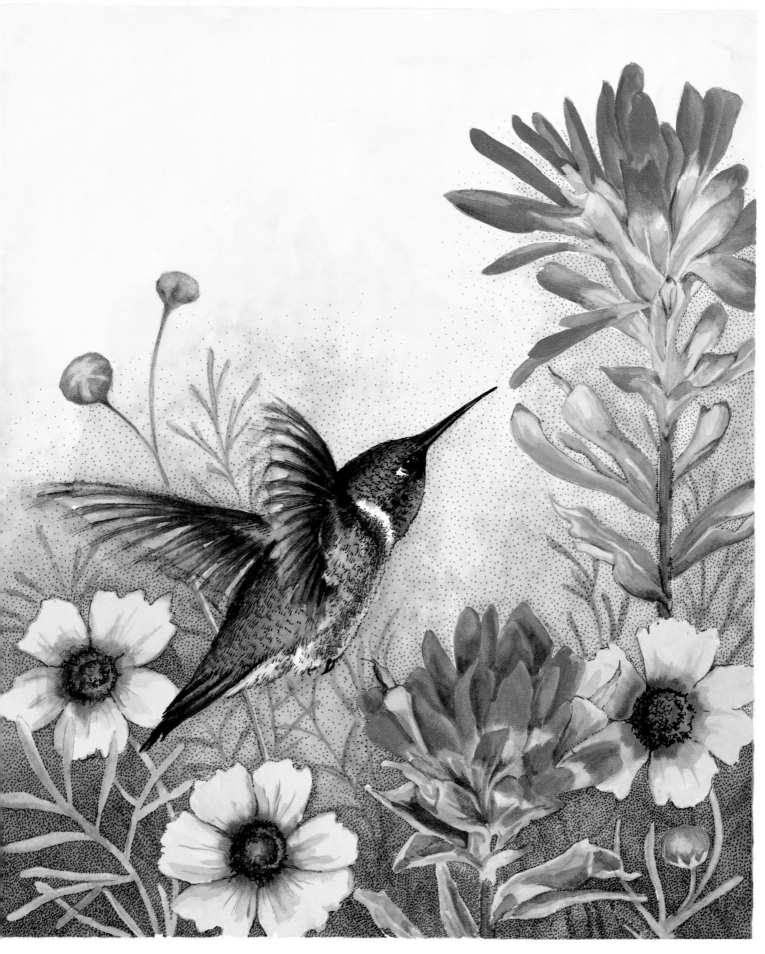

FLORAL FESTIVAL, 8″ × 10″ (20.3cm × 25.4cm), watercolor washes with colored inkwork

Ground Squirrels & Mice

The ground squirrels and prairie dogs are similar in appearance, the latter tending to be larger. Both are burrowers.

The small prairie deer mouse is at home among the grasses and flowers. Its plump, gray body would provide a nice "point of interest" to a floral study.

Pencil sketch

Black-tailed Prairie Dog →

Preliminary layered washes

Dry-brush detailing over washes of Yellow Ochre, Burnt Umber and Violet mixtures.

Fur depicted with Sepia ink in a .25 pen. (Criss-cross lines.)

Uinta Ground Squirrel, found in the sagebrush grasslands of Montana to Utah.

Earthy mixtures of Yellow Ochre, Burnt Sienna and Sepia watercolors were used.

India ink pen sketch (.25)

Prairie Deer Mouse →

This small mouse is found throughout the Midwest. Its coat varies from gray to reddish-brown above and white below.

156

Cottontail

The Eastern Cottontail is the common "little brown rabbit" of the prairie region. It nests in thickets and brush piles, hopping out among the flowers and grasses to feed.

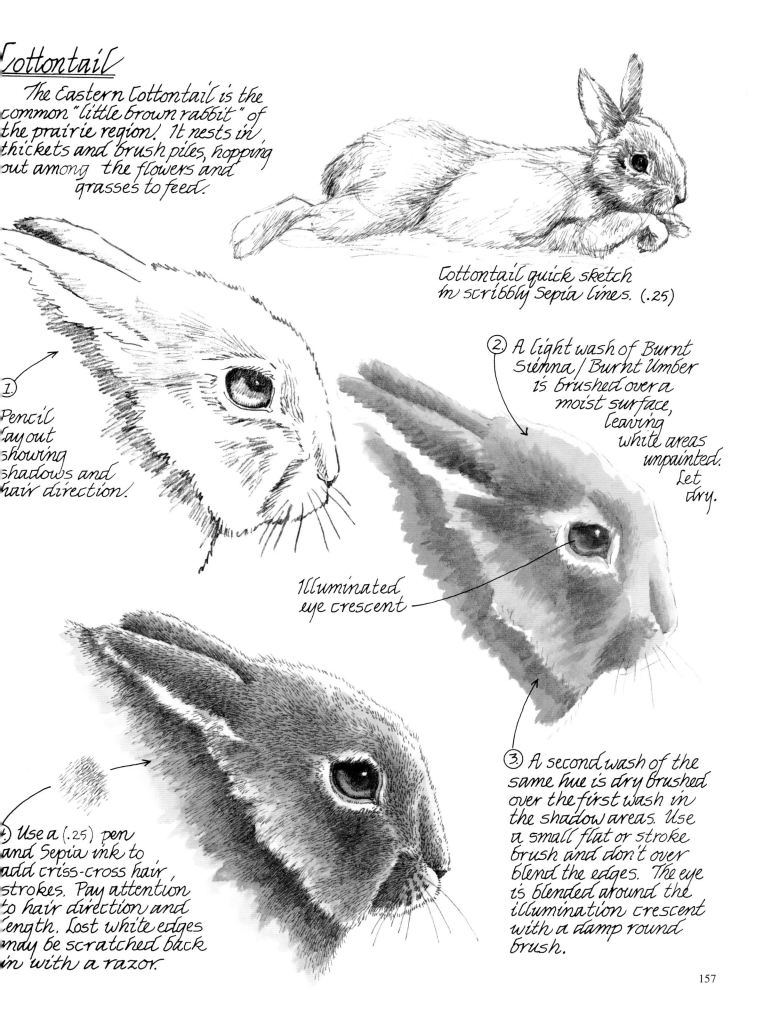

Cottontail quick sketch in scribbly Sepia lines. (.25)

① Pencil layout showing shadows and hair direction.

② A light wash of Burnt Sienna / Burnt Umber is brushed over a moist surface, leaving white areas unpainted. Let dry.

Illuminated eye crescent

③ A second wash of the same hue is dry brushed over the first wash in the shadow areas. Use a small flat or stroke brush and don't over blend the edges. The eye is blended around the illumination crescent with a damp round brush.

④ Use a (.25) pen and Sepia ink to add criss-cross hair strokes. Pay attention to hair direction and length. Lost white edges may be scratched back in with a razor.

157

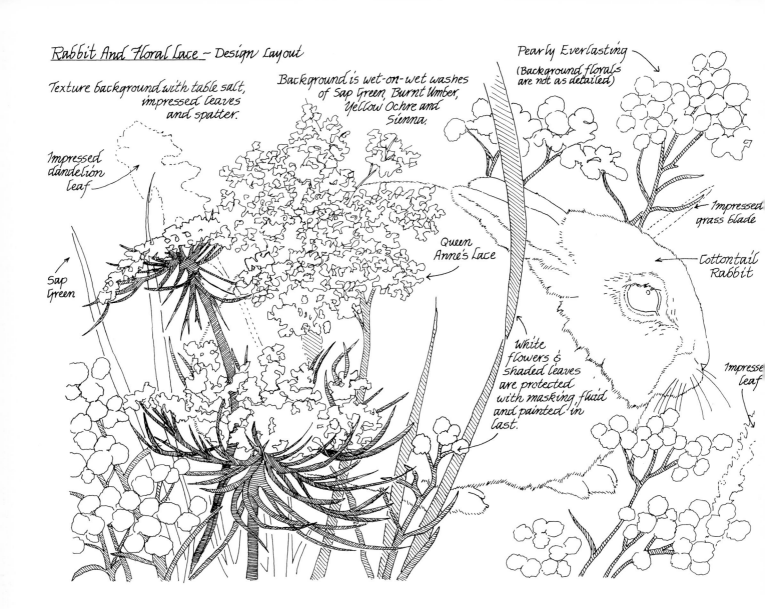

Rabbit And Floral Lace – Design Layout

Texture background with table salt,
impressed leaves
and spatter.

Background is wet-on-wet washes
of Sap Green, Burnt Umber,
Yellow Ochre and
Sienna.

Pearly Everlasting
(Background florals
are not as detailed)

Impressed
dandelion
leaf

Sap
Green

Impressed
grass blade

Queen
Anne's Lace

Cottontail
Rabbit

White
flowers &
shaded leaves
are protected
with masking fluid
and painted in
last.

Impressed
leaf

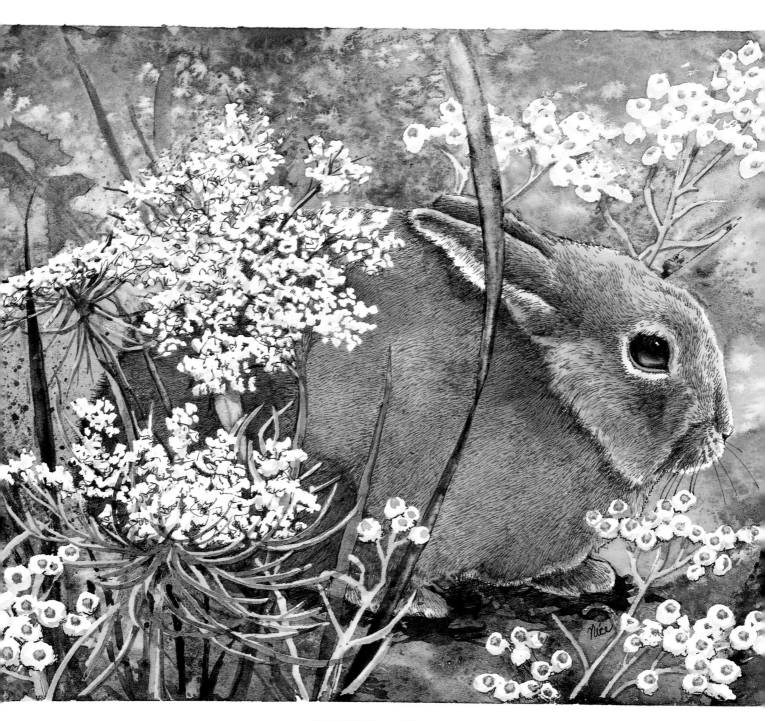

RABBIT AND FLORAL LACE, 8″×10″ (20.3cm×25.4cm),
watercolor and Sepia/Payne's Gray ink wash

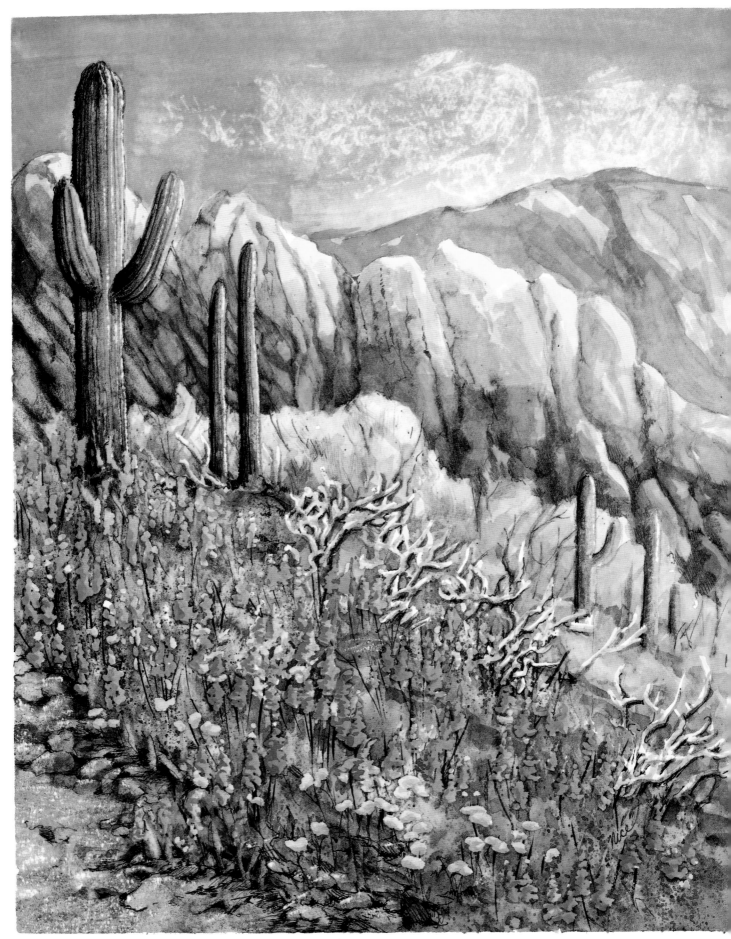

DESERT DRYLANDS

The word "desert" suggests a dry, harsh landscape of rocks, sand and thorn-covered vegetation. Yet the desert can be a place of high contrast and beauty for those who take the time to really look.

Rocks are polished to a sheen by desert sand and wind. The variety of types and colors are great. To fully appreciate a smooth desert pebble, you need to pick it up and feel the warmth of it in the palm of your hand. It may be speckled with quartz, marbled with minerals or simply tinted a delicate, pastel hue.

Raise your sights to the horizon. Study the grand rock formations, carved by the elements into statuesque shapes. The light plays over their surface, emphasizing the contours. The colors are subtle and earthy, the same mixtures that linger in the corners of a well-used watercolor palette.

Stand very still and lower your gaze. Let your eyes explore the ground, among the scattered stones and cast shadows, until you spot movement. There, staring at you from the crest of a rock, is a basking lizard. Only the rhythmic movement of its sides signals life—its camouflage is perfect! Catch him with your pen, pencil or camera, but keep your distance or he'll disappear.

The thorny bits of vegetation look shriveled and dead, but there is life within. Spring rains are all that are needed to awaken them to breathtaking splendor. The desert in bloom presents a rich contrast of austerity and delicate beauty, unsurpassed elsewhere. Orange, yellow and white poppies, blue lupines and magenta sand verbenas carpet the desert floor with color, while stark cacti put on crowns of vivid, translucent blossoms. If you can imagine the earthy, prickly cactus pads portrayed in pen and ink, and the blossoms coming to life in layered watercolor washes—the bold against the fragile—then you're ready to appreciate the artistic assets of the desert drylands.

SPRING DESERT LANDSCAPE, 10″×7½″ (25.4cm×19.1cm), watercolor washes and Sepia inkwork

Pebbles

These small stones were picked up in the desert for study. I painted them using layered washes and varied texturing techniques. Marbled streaks were added by stroking ink lines over a dampened surface. Highlights were scratched in with a razor blade.

Sandstone

Brown ink line over damp surface

Pencil sketch and preliminary washes

Damp surface wash of Payne's Gray and Thalo Green

Serpentine

Payne's Gray ink work

While wash was moist, alcohol was brushed through to lighten middle area

Agate

streaked with .25 pen and colored inks

Colored inks over damp surface

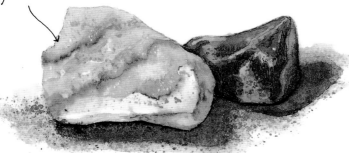

Quartz

stippled India ink

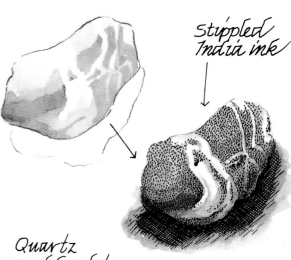

Quartz and Sandstone

Lizards

Once you've mastered the depiction of desert rocks, you can add a bit of interest with a basking lizard. They are most likely to be found out in the open during the warm morning hours or late afternoon. Pen and ink crosshatching works well to suggest their scales.

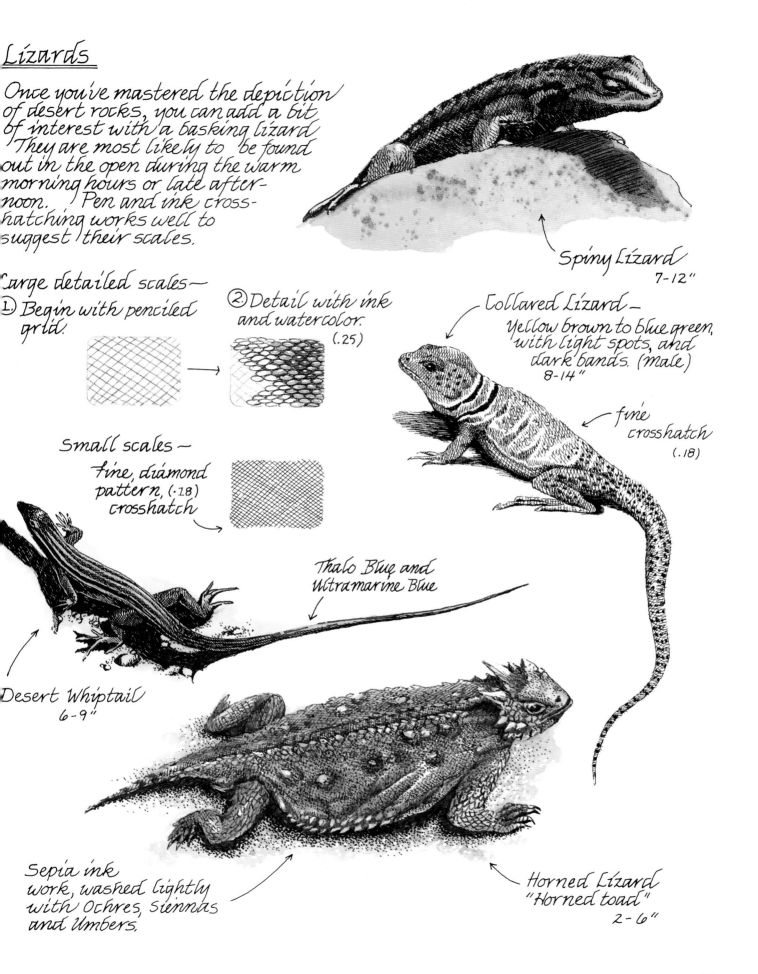

Large detailed scales—
① Begin with penciled grid.

② Detail with ink and watercolor. (.25)

Small scales—
Fine, diamond pattern, (.18) crosshatch

Spiny Lizard
7-12"

Collared Lizard —
Yellow brown to blue green, with light spots, and dark bands. (male)
8-14"

fine crosshatch
(.18)

Thalo Blue and Ultramarine Blue

Desert Whiptail
6-9"

Sepia ink work, washed lightly with Ochres, Siennas and Umbers.

Horned Lizard
"Horned toad"
2-6"

163

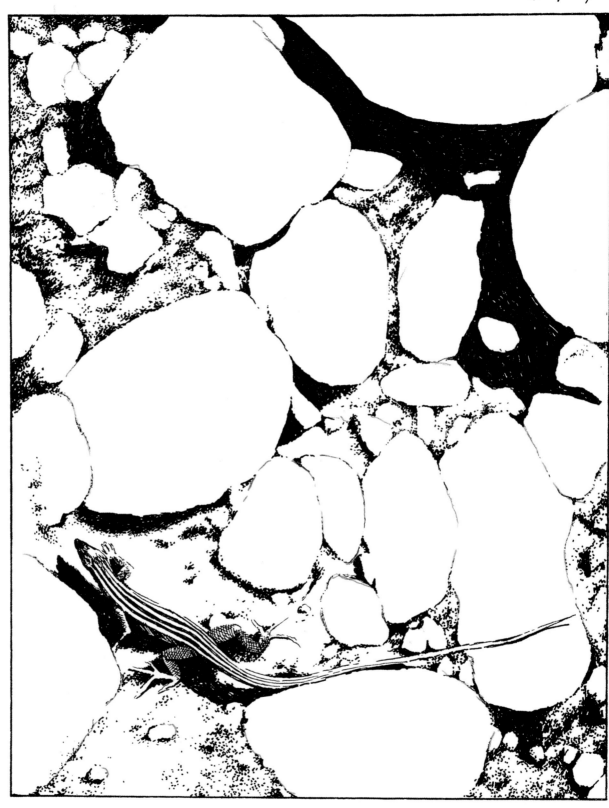

This desert floor painting began as a pen and India ink drawing to emphasize the gritty soil and lizard scales.

The sandstone pebbles were painted with layered, "dirty palette" water-color washes. Spatter was used to texture the stones.

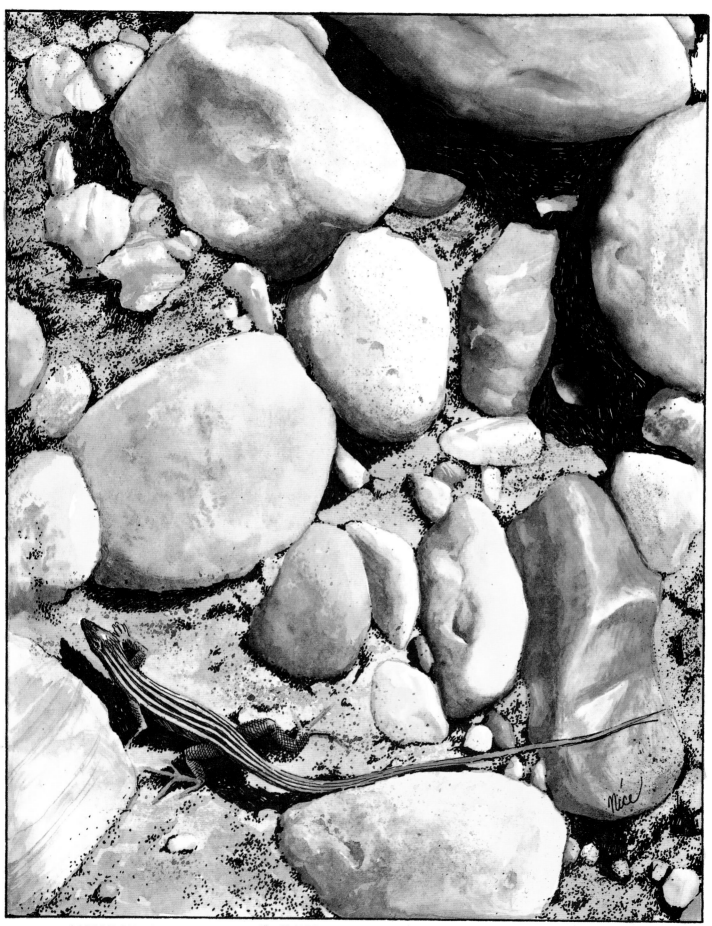

LIZARD ON ROCKY GROUND II, 6″×8″ (15.2cm×20.3cm), India ink drawing tinted with watercolor washes

Desert Birds

Birds which inhabit arid regions are often feathered in the earthy colors that surround them. Hues of ochre, umber, sienna and blue-gray provide a perfect camouflage for birds that hide among rocks and gray-green cacti.

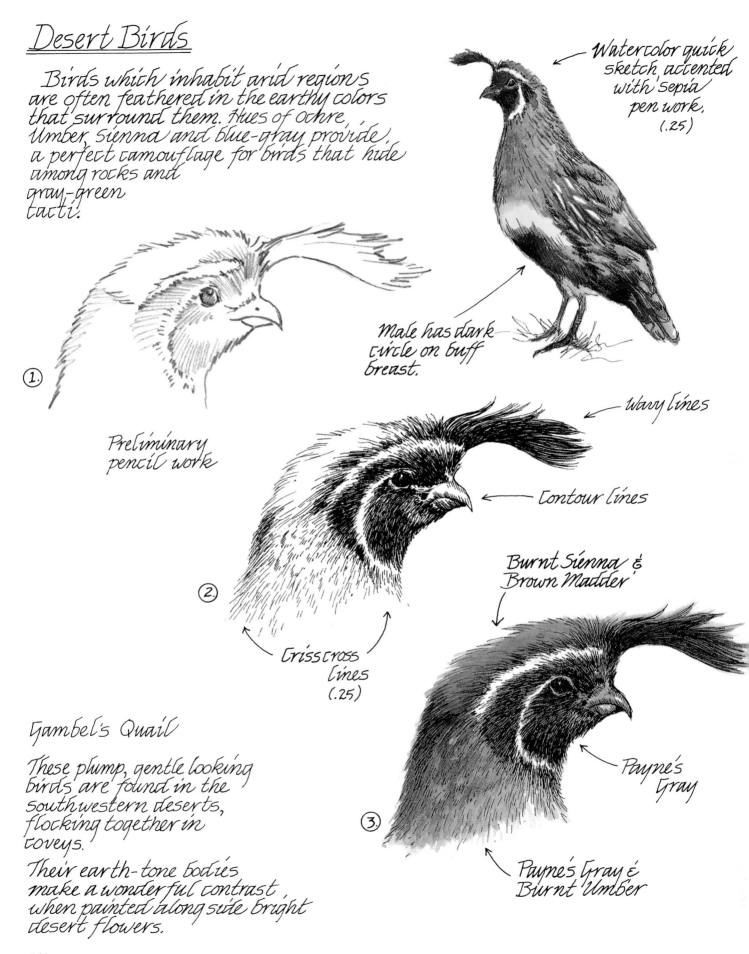

Watercolor quick sketch accented with sepia pen work. (.25)

Male has dark circle on buff breast.

① Preliminary pencil work

② Crisscross lines (.25)

Wavy lines

Contour lines

Burnt Sienna & Brown Madder

③ Payne's Gray

Payne's Gray & Burnt Umber

Gambel's Quail

These plump, gentle looking birds are found in the southwestern deserts, flocking together in coveys.

Their earth-tone bodies make a wonderful contrast when painted alongside bright desert flowers.

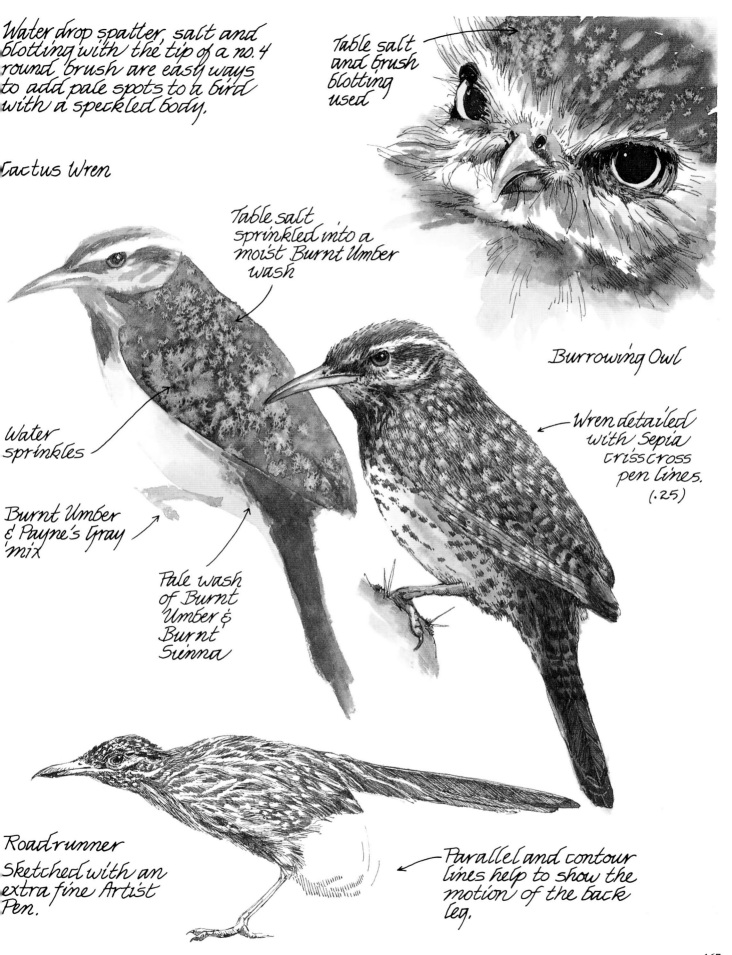

Water drop spatter, salt and blotting with the tip of a no. 4 round brush are easy ways to add pale spots to a bird with a speckled body.

Table salt and brush blotting used

Cactus Wren

Table salt sprinkled into a moist Burnt Umber wash

Burrowing Owl

Water sprinkles

Wren detailed with Sepia crisscross pen lines. (.25)

Burnt Umber & Payne's Gray mix

Pale wash of Burnt Umber & Burnt Sienna

Roadrunner
Sketched with an extra fine Artist Pen.

Parallel and contour lines help to show the motion of the back leg.

Desert Wildflowers

In the arid regions, flowers blossom and go to seed only after sufficient rain has fallen. The desert in full bloom is a rare sight, worthy of close study with camera, pen and brush.

California Poppy

① Light pencil line drawing and flat wash of Cadmium Yellow Medium.

④ Additional glazes of the orange mixture near the base of each petal will add color impact.

The center is defined with Burnt Sienna or Brown ink work.

— Base wash of Sap Green and orange mixture

— Shaded with a mixture of Sap Green /orange, Thalo Green and Payne's Gray

② Petals are shaded with a wash of Cadmium Yellow Med. and Burnt Sienna.

③ Add Grumbacher Red to above mixture and deepen petal color near center

Prickly Poppy

Textured with Payne's Gray, dry brush work

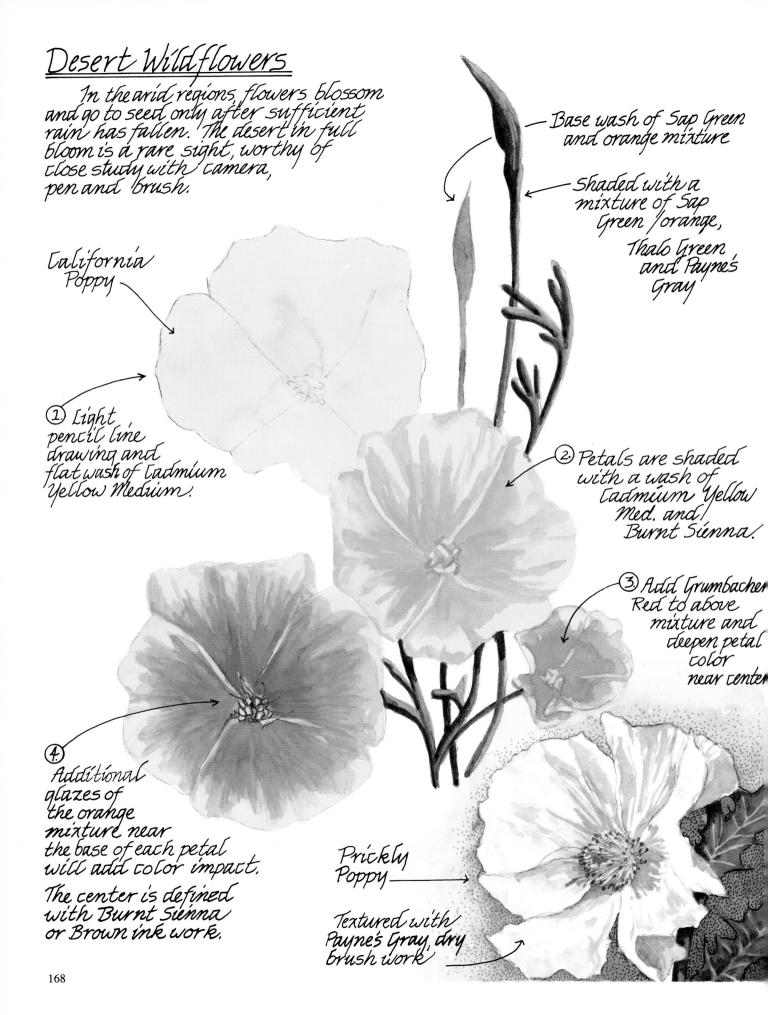

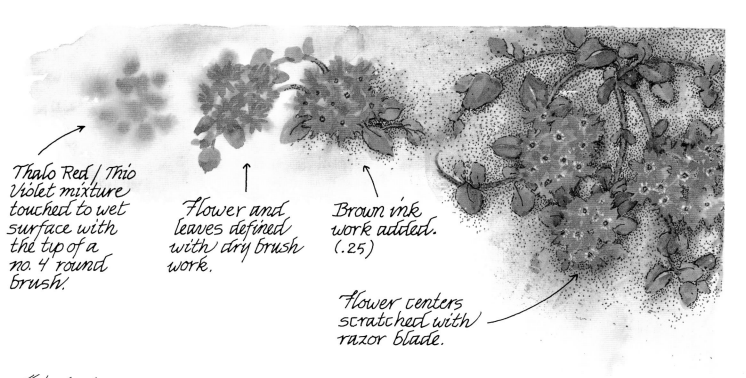

Thalo Red / Thio Violet mixture touched to wet surface with the tip of a no. 4 round brush.

Flower and leaves defined with dry brush work.

Brown ink work added. (.25)

Flower centers scratched with razor blade.

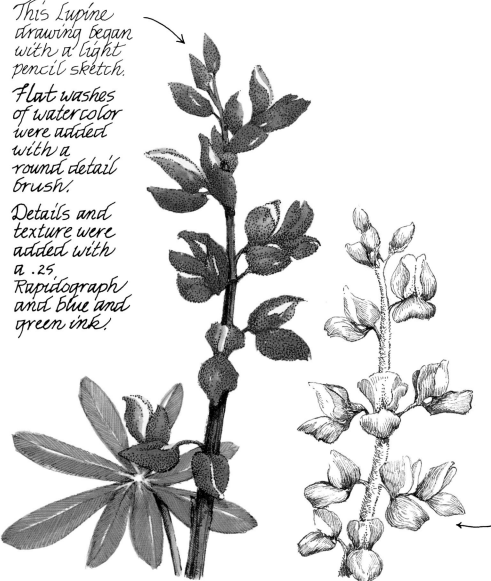

This Lupine drawing began with a light pencil sketch.

Flat washes of watercolor were added with a round detail brush.

Details and texture were added with a .25 Rapidograph and blue and green ink.

Sand Verbena (Above)

This trailing annual loves sandy soil. Its bright magenta flower clusters are wonderful additions to desert landscape paintings.

Lupine

These common perennial plants are found in many terrains and climates. In the desert, their purple-blue blossoms provide a perfect contrast to the orange poppies they grow beside.

Lupine study in brown ink. (.25)

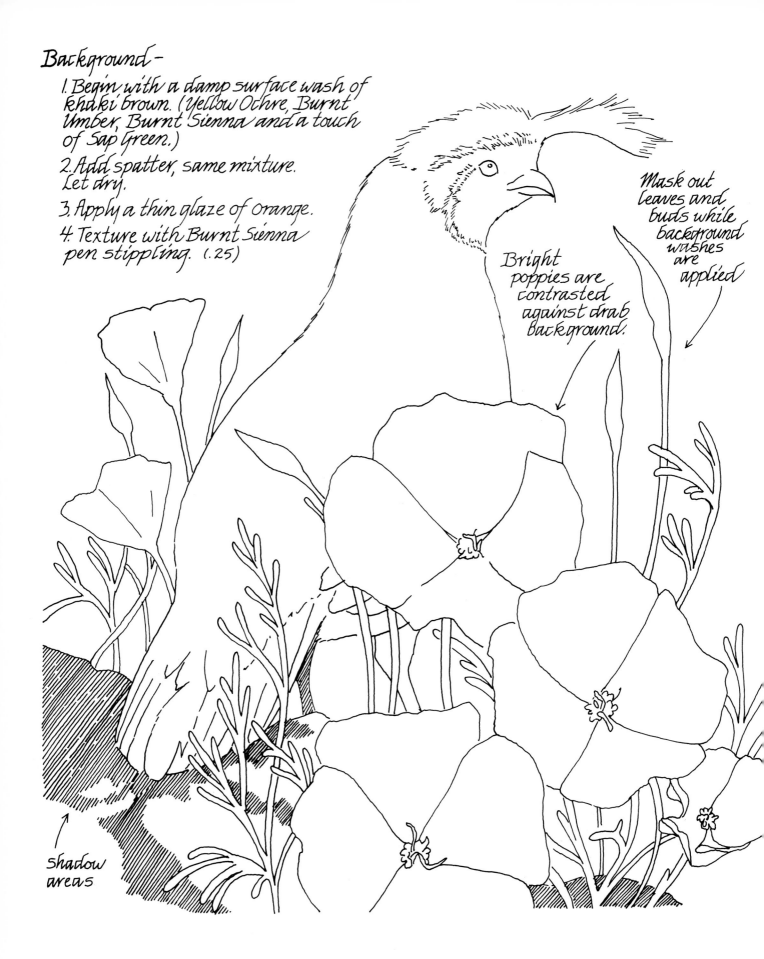

Background –

1. Begin with a damp surface wash of khaki brown. (Yellow Ochre, Burnt Umber, Burnt Sienna and a touch of Sap Green.)

2. Add spatter, same mixture. Let dry.

3. Apply a thin glaze of orange.

4. Texture with Burnt Sienna pen stippling. (.25)

Mask out leaves and buds while background washes are applied

Bright poppies are contrasted against drab background.

shadow areas

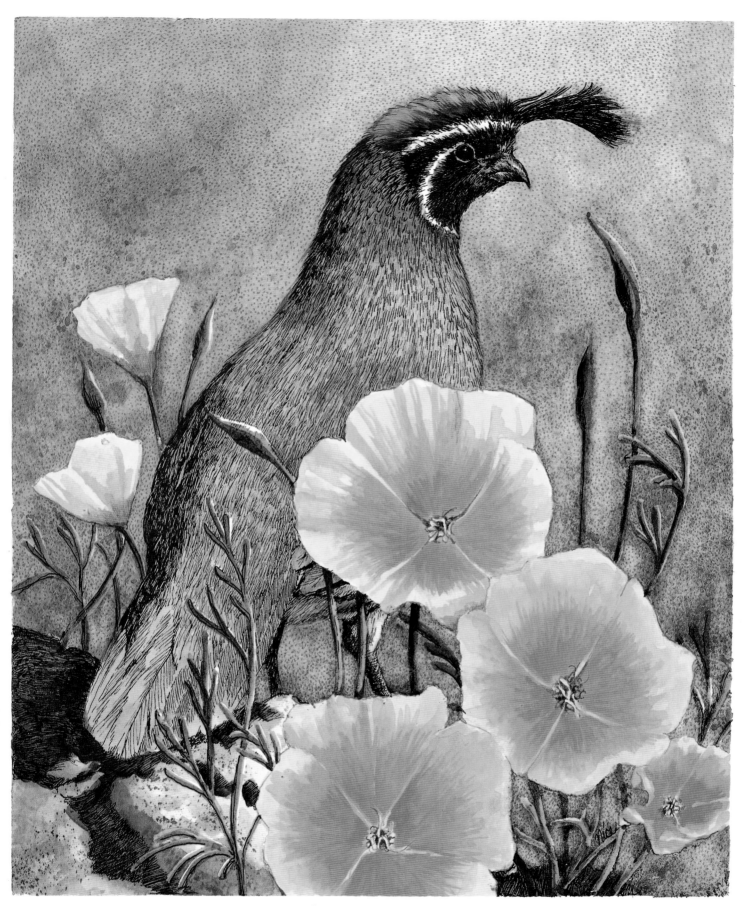

QUAIL AND POPPIES, 8″×10″ (20.3cm×25.4cm), mixed media combining India ink, layered watercolor washes and brown ink stippling

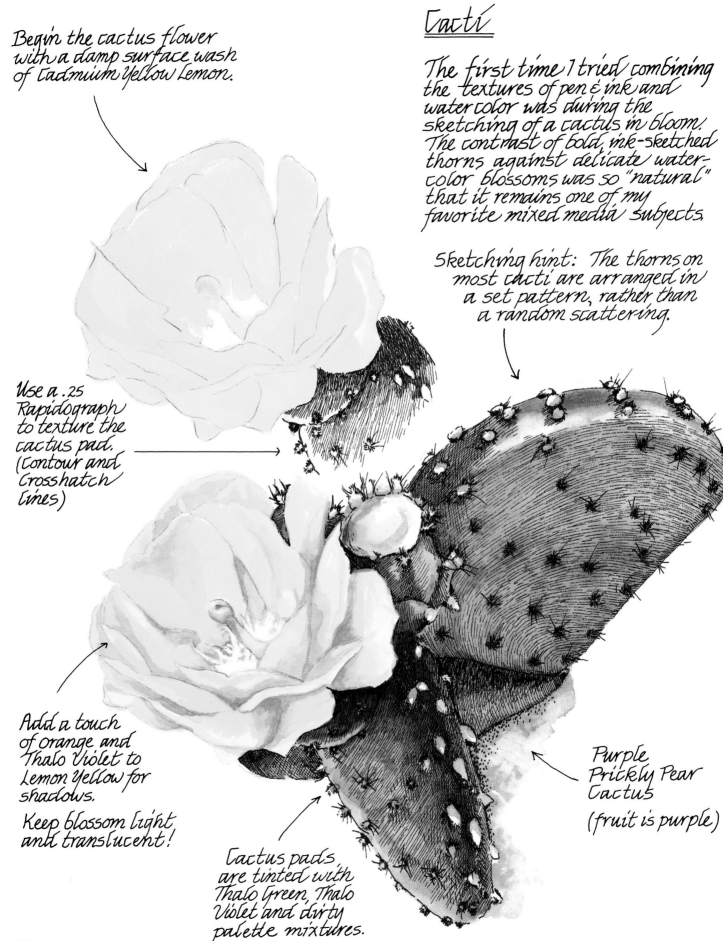

Begin the cactus flower with a damp surface wash of Cadmium Yellow Lemon.

Cacti

The first time I tried combining the textures of pen & ink and watercolor was during the sketching of a cactus in bloom. The contrast of bold, ink-sketched thorns against delicate watercolor blossoms was so "natural" that it remains one of my favorite mixed media subjects.

Sketching hint: The thorns on most cacti are arranged in a set pattern, rather than a random scattering.

Use a .25 Rapidograph to texture the cactus pad. (Contour and Crosshatch lines)

Add a touch of orange and Thalo Violet to Lemon Yellow for shadows.

Keep blossom light and translucent!

Purple Prickly Pear Cactus

(fruit is purple)

Cactus pads are tinted with Thalo Green, Thalo Violet and dirty palette mixtures.

← Cactus body and thorns rendered in India Ink, then tinted with water color washes.

← Contour lines in Burnt Sienna Ink help define the petals.

Background was textured with table salt and rock salt to suggest distant thorn clumps. The foreground thorns and flower stamens were "masked" during the painting process. Thorns are outlined in Sepia.

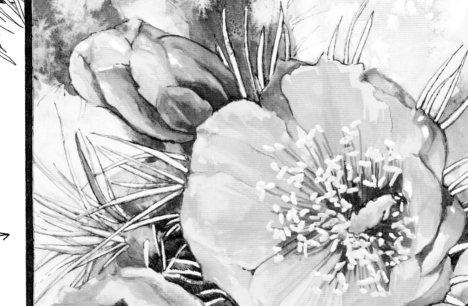

Yellow Cholla

The flowers on this cactus vary from deep yellow to reddish violet.

This color combination makes the blossoms seem to vibrate with intensity.

Sketching the cactus body—

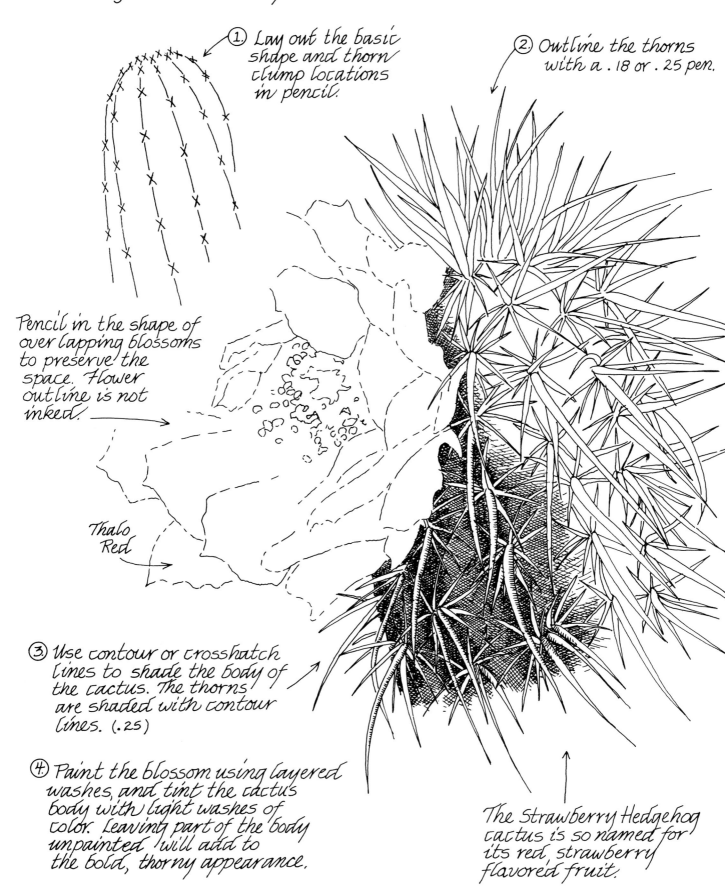

① Lay out the basic shape and thorn clump locations in pencil.

② Outline the thorns with a .18 or .25 pen.

Pencil in the shape of overlapping blossoms to preserve the space. Flower outline is not inked.

Thalo Red

③ Use contour or crosshatch lines to shade the body of the cactus. The thorns are shaded with contour lines. (.25)

④ Paint the blossom using layered washes, and tint the cactus body with light washes of color. Leaving part of the body unpainted will add to the bold, thorny appearance.

The Strawberry Hedgehog cactus is so named for its red, strawberry flavored fruit.

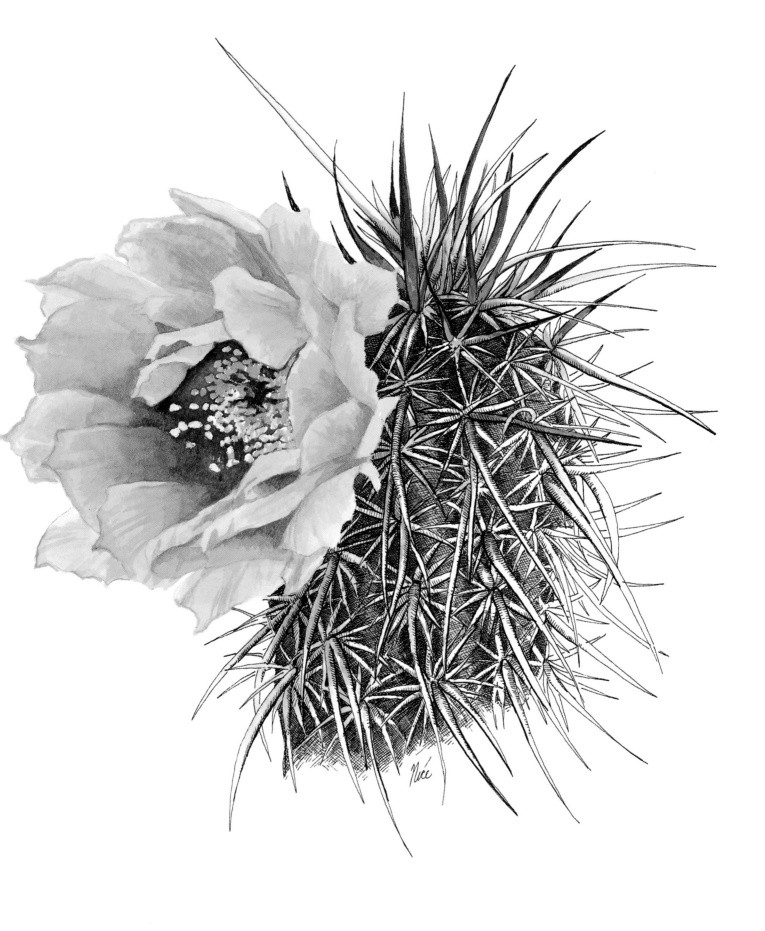

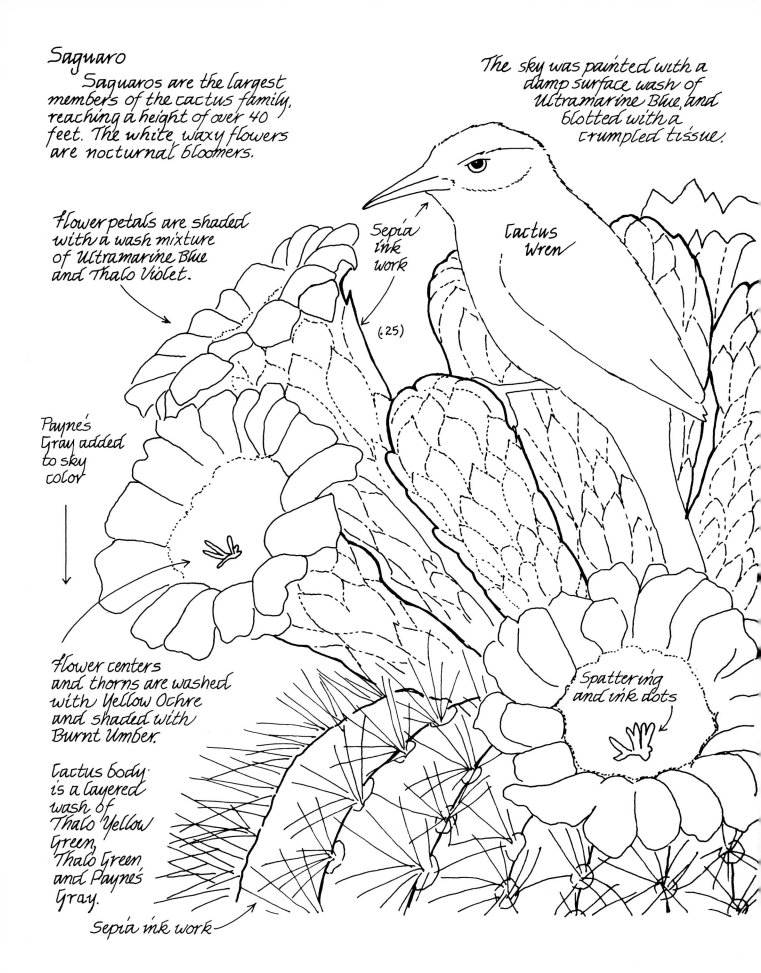

Saguaro

Saguaros are the largest members of the cactus family, reaching a height of over 40 feet. The white, waxy flowers are nocturnal bloomers.

The sky was painted with a damp surface wash of Ultramarine Blue, and blotted with a crumpled tissue.

Flower petals are shaded with a wash mixture of Ultramarine Blue and Thalo Violet.

Sepia ink work

Cactus Wren

(.25)

Payne's Gray added to sky color

Flower centers and thorns are washed with Yellow Ochre and shaded with Burnt Umber.

Cactus body is a layered wash of Thalo Yellow Green, Thalo Green, and Payne's Gray.

Spattering and ink dots

Sepia ink work

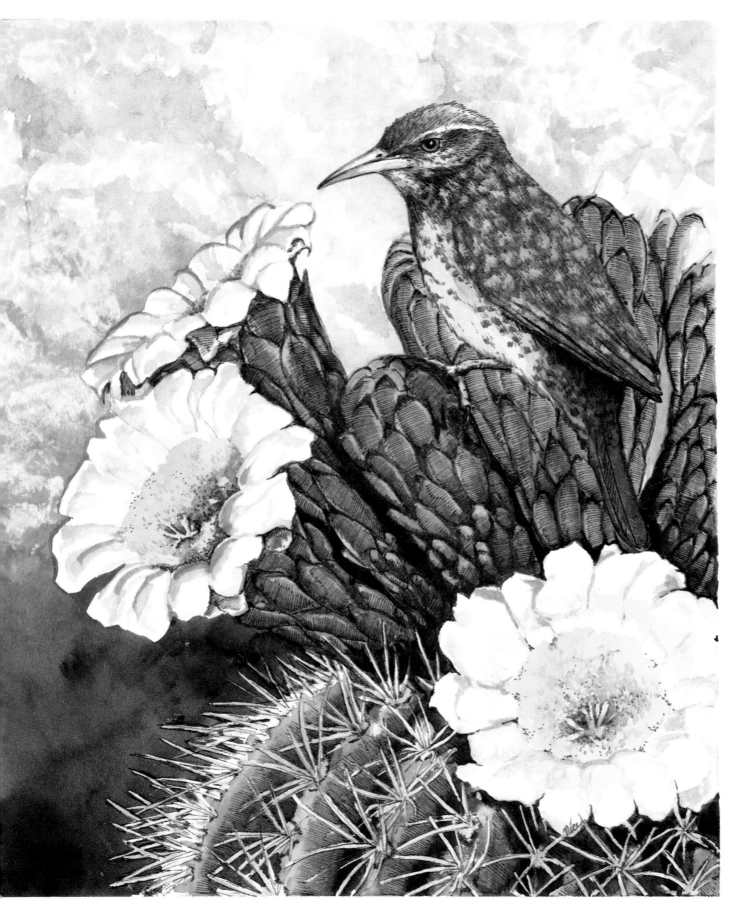

SAGUARO, 8″×10″ (20.3cm×25.4cm), layered
watercolor washes, textured with Sepia ink

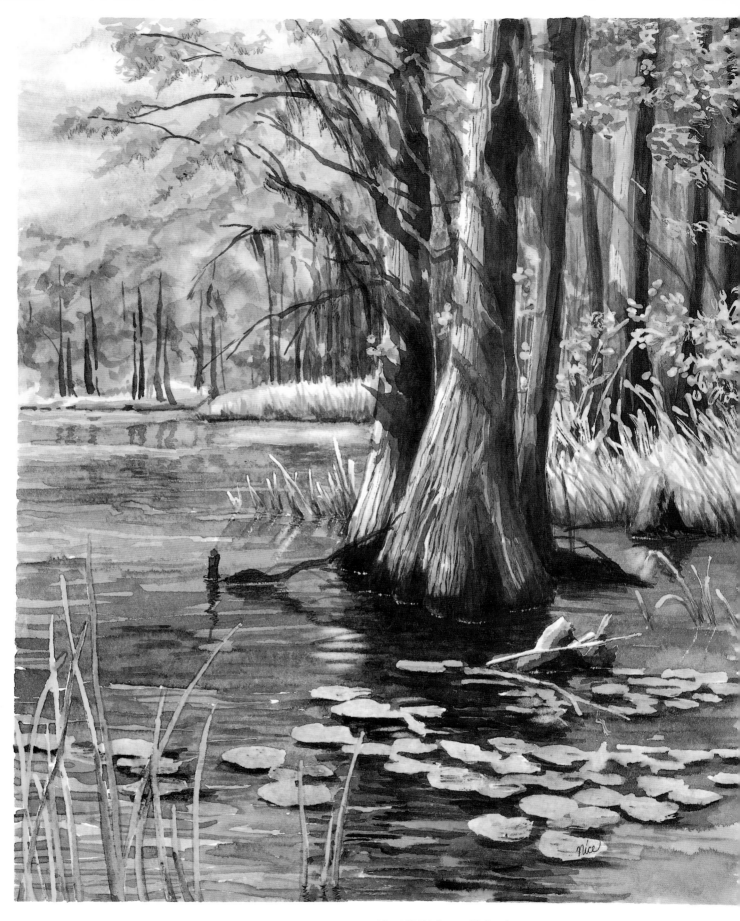

CYPRESS WETLAND, 8″×10″ (20.3cm×25.4cm),
watercolor detailed with Payne's Gray penwork

PONDS, SWAMPS AND MARSHES

Welcome to the wetlands. Here water is the main feature. If the wetland looks like a prairie with varied grasses, sedges, rushes and cattails merged with pools of water, it's considered a marsh. When bodies of still or slowly moving water intermix with forest lands, it's a swamp. In order to support themselves in the soft mud, swamp trees like the Bald Cypress and the Tupelo have buttressed trunks and vast root systems. Springing from the roots are gnarled knees that rise above the water like wooden stalagmites.

As seen in the painting on the opposite page, swamplands and marshes can be mingled. Towering Bald Cypresses yield to dense mats of rushes, which in turn give way to the deeper waters of a pond and floating rafts of lily pads.

As an artist and amateur naturalist, I am fascinated by all types of wetlands with their vast array of unique plants and animals. In the brightly lit marshes, the earthy greens and browns of the graceful rushes set off the splendor of the waterfowls to perfection. Water reflections are vivid and as varied as a kaleidoscope.

The filtered light of the swamp adds the drama of extreme highlight and shadow to a habitat already rich in intrigue. Here is a treasure chest of value contrasts, unusual shapes and diverse textures. In your mind's eye, consider sediment-stained waters lapping lazily against a rough and twisted cypress knee. Present are the rich greens of water plants, mingled with dollops of sunlight.

A dragonfly hovers above the scene, adding a dash of iridescent color. And there at the base of the cypress knee, a turtle hides in subtle camouflage. If this vision excites your artist's imagination, then it's time to put on your boots and venture into the wetlands. In this chapter, I'll introduce you to some of my favorite swampy flora and fauna and the techniques that will make sketching them easier.

A word of caution, from personal experience—the southern swamplands are not a good place for the novice to explore alone. One never knows what might swim, crawl or slither out of those deep and mysterious shadows!

All birds seem to share two basic shapes—
The head is oval or round, depending on the view, and the body is egg shaped, the narrow end of the egg pointing toward the tail.

oval

egg shaped

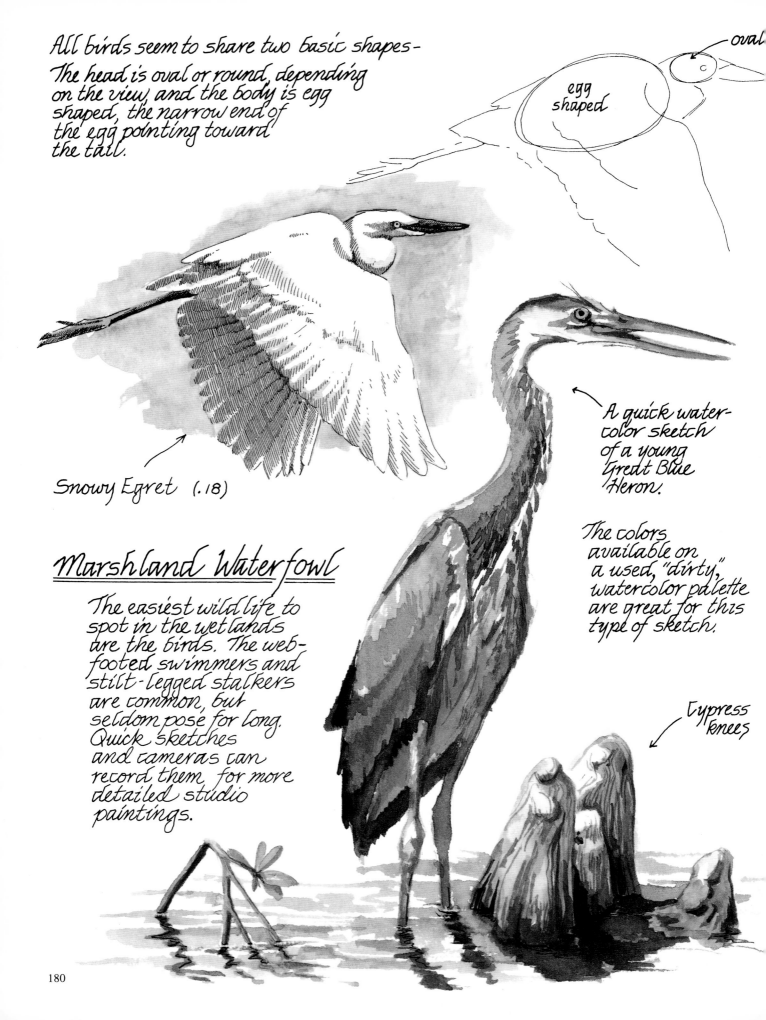

Snowy Egret (.18)

A quick water-color sketch of a young Great Blue Heron.

The colors available on a used, "dirty," watercolor palette are great for this type of sketch.

Marshland Waterfowl

The easiest wild life to spot in the wetlands are the birds. The web-footed swimmers and stilt-legged stalkers are common, but seldom pose for long. Quick sketches and cameras can record them for more detailed studio paintings.

Cypress knees

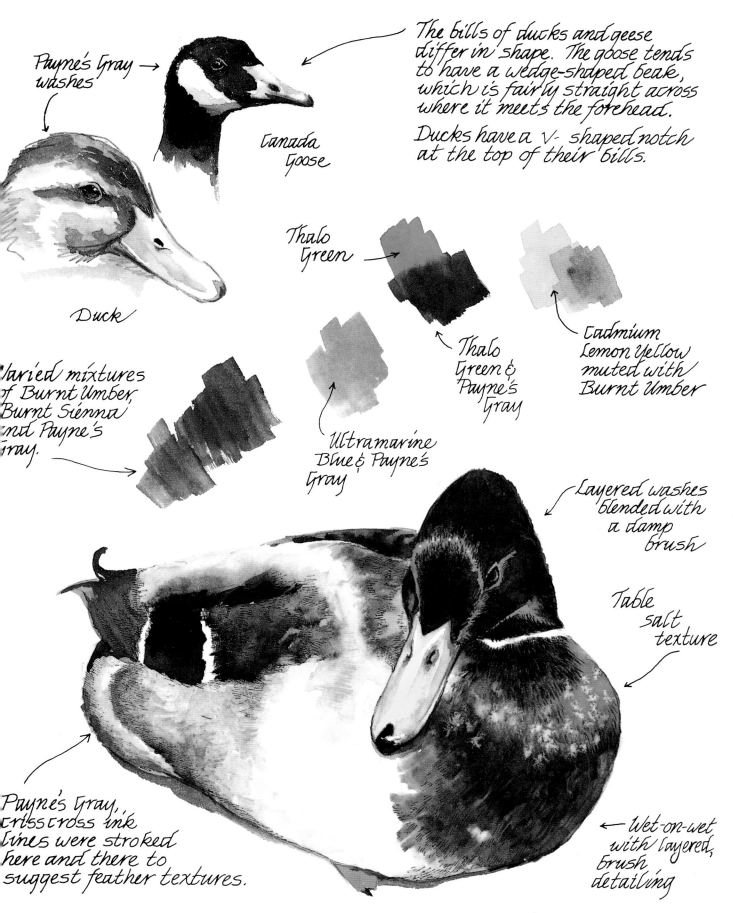

Payne's Gray washes →

The bills of ducks and geese differ in shape. The goose tends to have a wedge-shaped beak, which is fairly straight across where it meets the forehead.

Ducks have a v-shaped notch at the top of their bills.

Canada Goose

Duck

Thalo Green →

Thalo Green & Payne's Gray

Cadmium Lemon Yellow muted with Burnt Umber

Varied mixtures of Burnt Umber, Burnt Sienna and Payne's Gray.

Ultramarine Blue & Payne's Gray

Layered washes blended with a damp brush

Table salt texture

Payne's Gray, crisscross ink lines were stroked here and there to suggest feather textures.

← Wet-on-wet with layered, brush detailing

(Above) - Male Mallard Duck

181

The female Mallard is mottled brown in color, blending well into the murky pond water surrounding her.

When painting such subjects, contrast of texture becomes the key to definition— soft, fluffy feathers against smooth, glossy ripples.

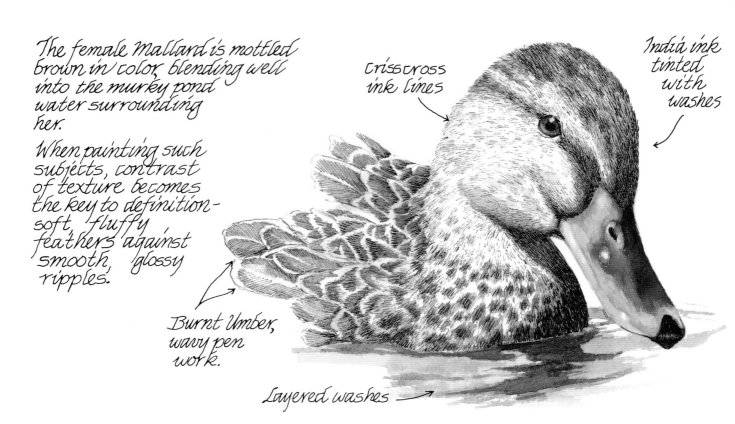

Crisscross ink lines

India ink tinted with washes

Burnt Umber, wavy pen work.

Layered washes →

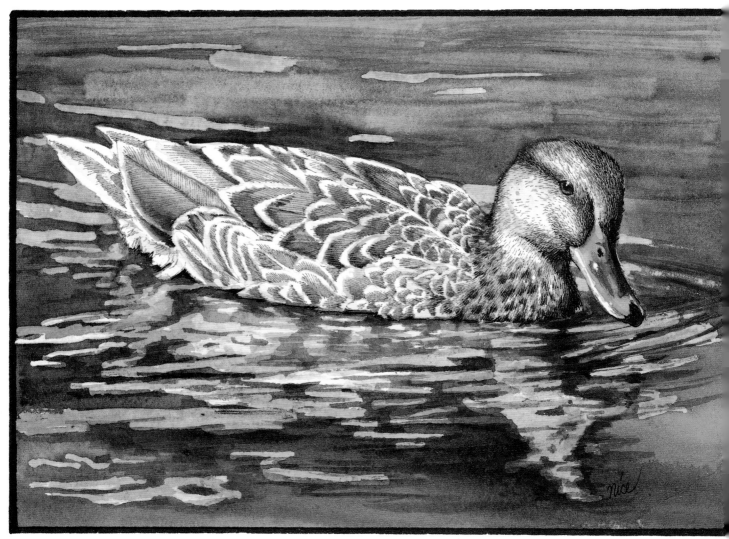

Bullfrog

① Preliminary pencil sketch

② Textured with stippled ink marks (.25)

③ Tinted over all with a wash of Lemon Yellow & Sap Green.

Spots are Burnt Sienna & Burnt Umber

④ Shaded with Sap Green / Burnt Sienna.

Frogs

A chorus of croaks and a sudden splash announces the presence of frogs in the pond, long before they are seen.

Northern Leopard Frogs can be colored either green or brown. This one was washed with layers of watercolor, then detailed with brown ink.

Cadmium Yellow, Medium with a touch of Yellow Ochre

Yellow Ochre & Burnt Umber

Burnt Umber

Front view, pen and ink study.

183

Water Lilies

These floating aquatic flowers are protected from splashing pond ripples by the round, flat lily pads that surround them.

The specialized leaves are smooth, tough and rubbery, and can be depicted quite nicely with layered watercolor washes.

① Begin with a pencil sketch to define the lilies, leaves and stems.

Stipple the pond background area with India ink and a .25 - .35 nib.

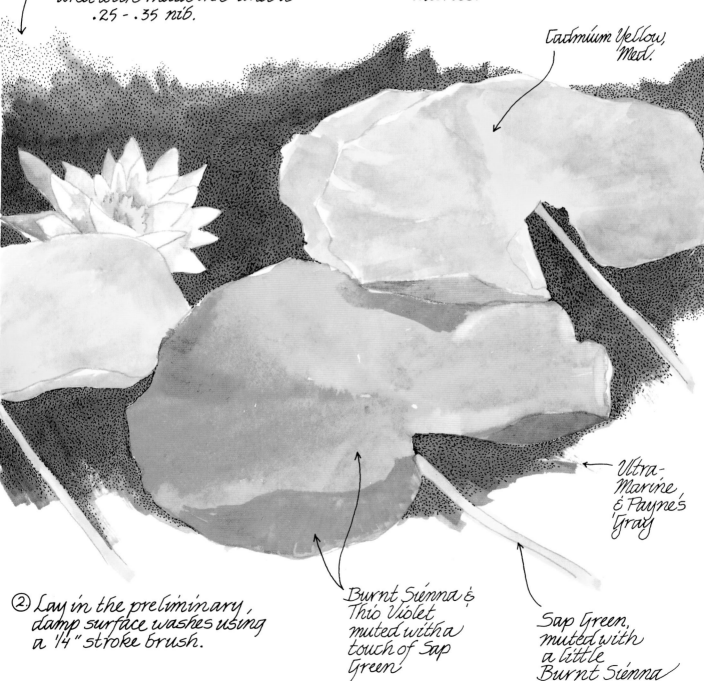

Cadmium Yellow, Med.

Ultra-Marine, & Payne's Gray

② Lay in the preliminary, damp surface washes using a ¼" stroke brush.

Burnt Sienna & Thio Violet muted with a touch of Sap Green

Sap Green, muted with a little Burnt Sienna

③ Add additional layers of water color to shade and define the painting. Let each thin layer dry before adding another.

Blend and soften edges with a clean, damp stroke or round brush.

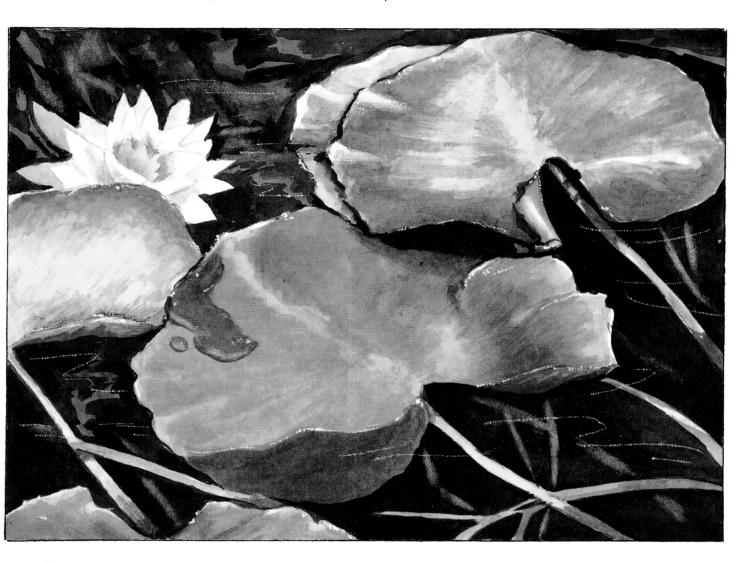

Lily pad mixture — Burnt Sienna & Thio Violet, muted slightly with Sap Green.

Use a pastel version of this mix to overlay the flower petals.

Darken the water shadows with a mixture of Payne's Gray & Burnt Umber.

Blotted with a damp stroke brush.

← Highlights scratched in with a razor blade.

Sap Green & Burnt Sienna

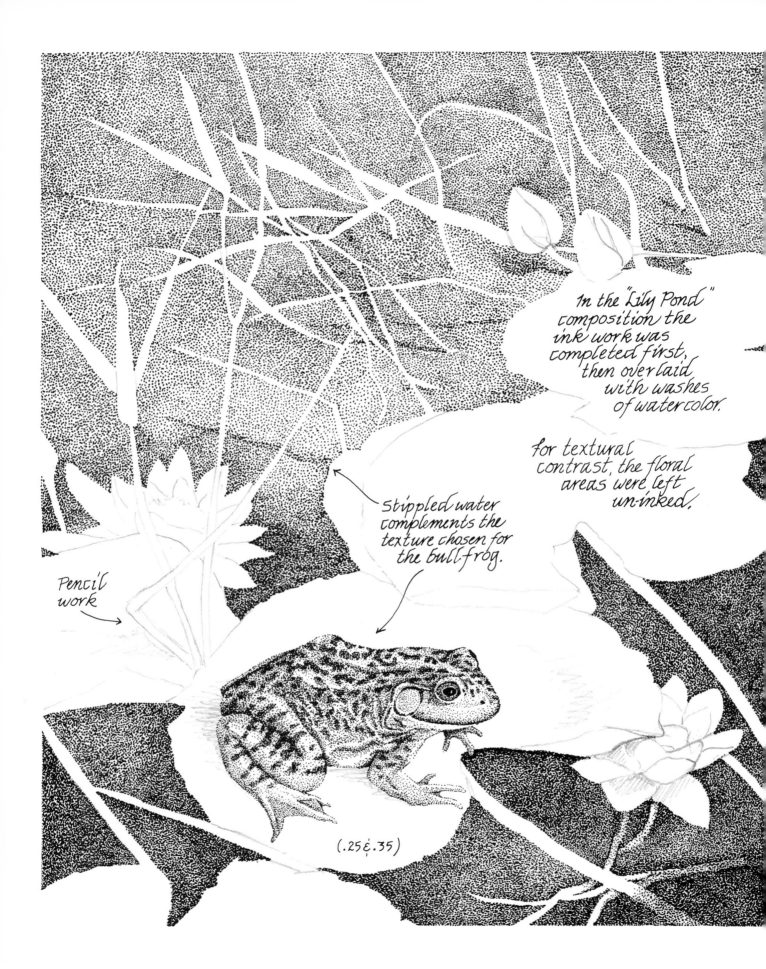

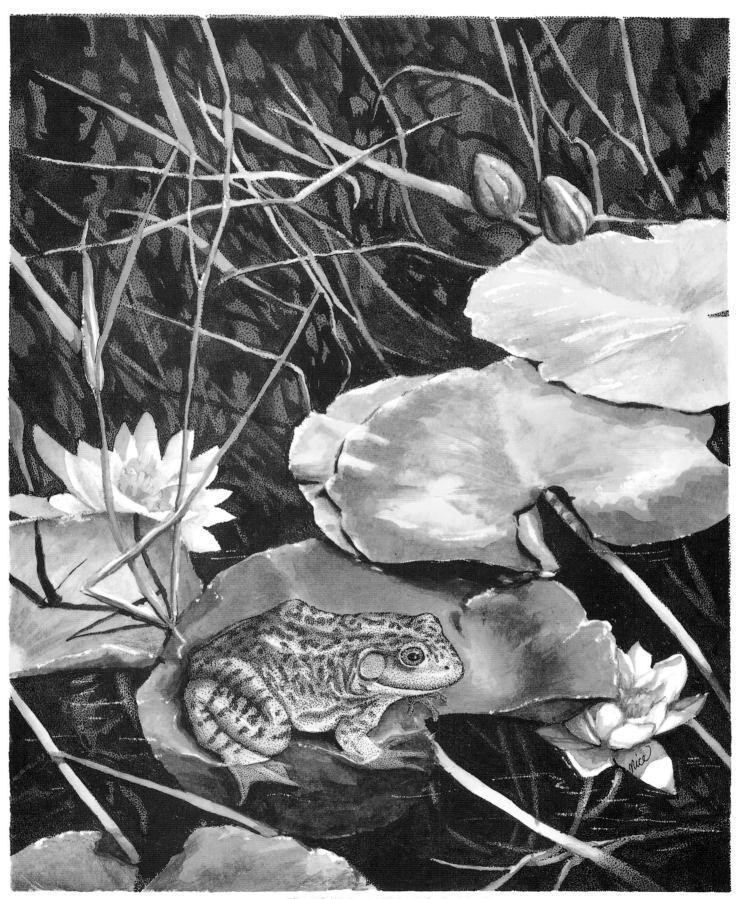

LILY POND, 8″×10″ (20.3cm×25.4cm), India ink stippled drawing, overlaid with layered watercolor washes

Dragonflies And Damselflies

These aquatic insects are a common sight in swamp lands, flitting both forward and backward above the water.

Begin with a light pencil sketch.

Wings detailed with a no. 4 round brush.

Thalo Blue plus Ultramarine Blue

Damselflies fold their wings backward while at rest.

Shade body with .25 pen and India ink.

Use light washes of background color to tint wings.

Thio Violet & Ultramarine Blue

Wing veins were bruised into the damp surface wash with a stylus.

Stippled Dragonfly

(.25)

Dragonflies spread their wings while at rest.

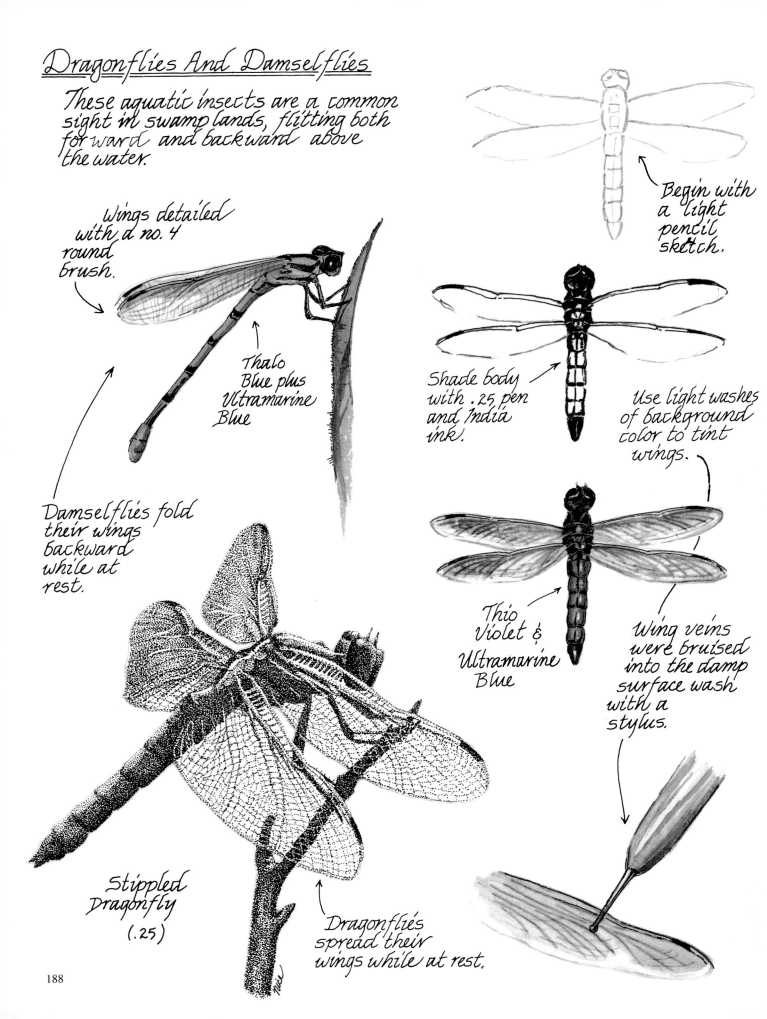

Turtles

Often found basking lazily in or near the water, turtles make excellent subjects to sketch in the wild.

Old shell was faded and weathered, so muted color mixtures were used.

Palette: Payne's Gray
Burnt Sienna
Yellow Ochre
Cadmium
Yellow, Med.

Yellow design was masked out.

Box Turtle study, painted with layered watercolor washes.

(The legs and neck were retracted in readiness to hide if I moved closer).

Underside of Box Turtle

Dark designs were applied wet-on-wet.

Sap Green & Payne's Gray

Cadmium Yellow, Med. & Thalo Red mix

Painted Pond Turtle sketch is contour line pen work tinted with watercolor.

(.25)

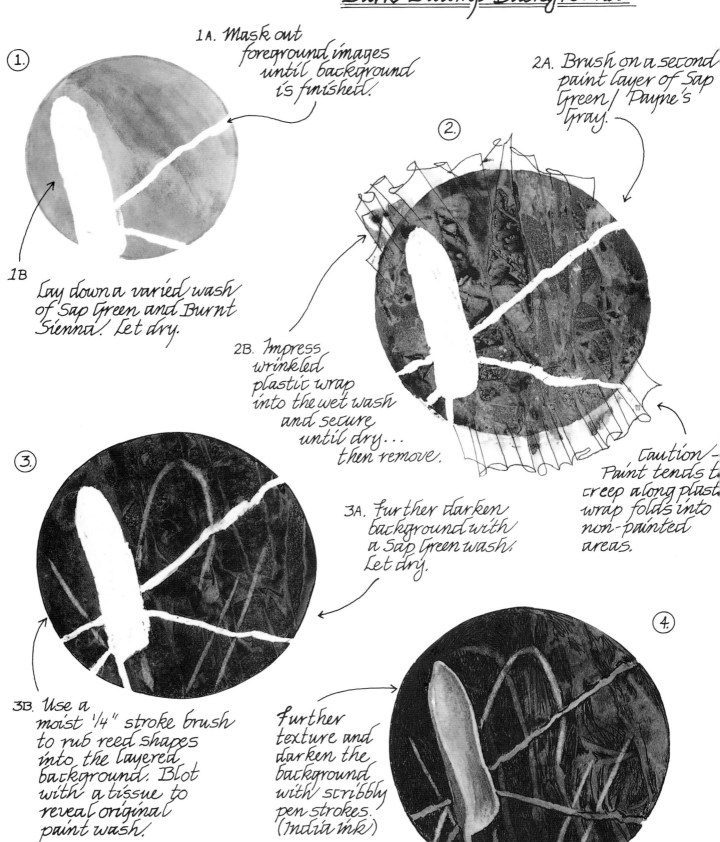

①

1A. Mask out foreground images until background is finished.

1B Lay down a varied wash of Sap Green and Burnt Sienna. Let dry.

2A. Brush on a second paint layer of Sap Green / Payne's Gray.

②

2B. Impress wrinkled plastic wrap into the wet wash and secure until dry... then remove.

Caution— Paint tends to creep along plastic wrap folds into non-painted areas.

③

3A. Further darken background with a Sap Green wash. Let dry.

3B. Use a moist 1/4" stroke brush to rub reed shapes into the layered background. Blot with a tissue to reveal original paint wash.

④

Further texture and darken the background with scribbly pen strokes. (India ink)

Remove liquid frisket with masking tape and paint foreground images.

Pickerelweed

This arrowhead-shaped plant grows in shallow water, at the edges of East Coast ponds and slow streams.

① Light watercolor washes, applied with a 1/4" stroke brush, to a damp surface.

② Shadow areas are deepened with additional paint layers.

Let each layer dry before adding the next.

Leaves are thick and glossy. White highlight areas suggest the surface sheen.

Sketched beside a Florida pond.

③ Detail the leaves and flower stalks lightly with Payne's Gray ink work.

Individual blossoms have 3 sepals and 3 petals which look alike.

Sap Green plus Cadmium Yellow med.

Sap Green

Sap Green plus Thalo Green

Sap Green plus Payne's Gray

Thio Violet plus Ultra-Marine Blue

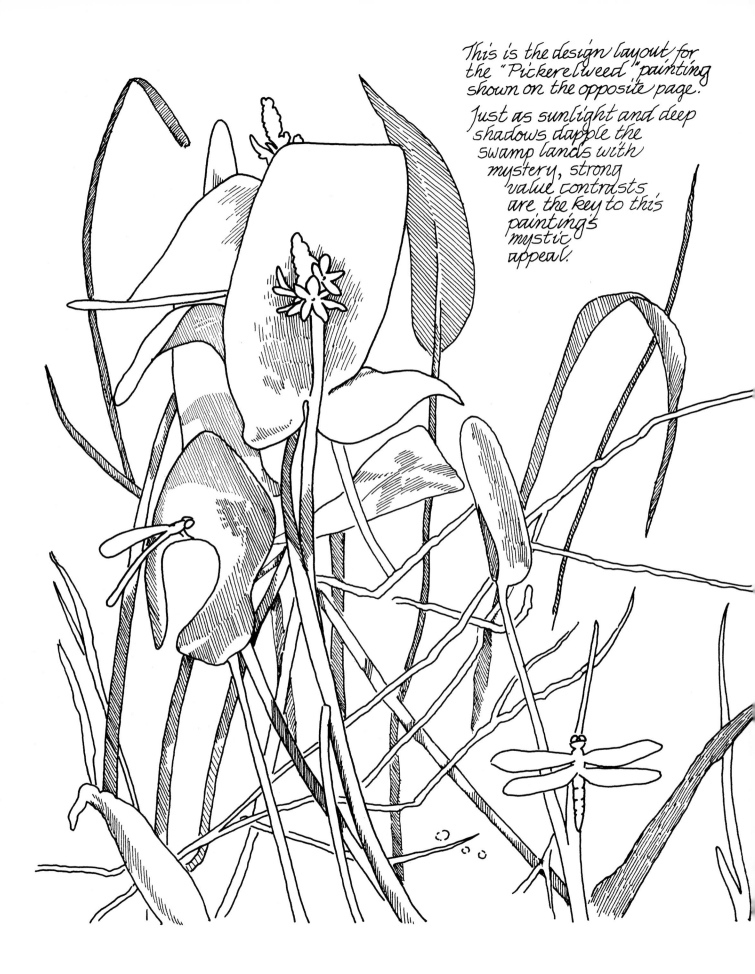

This is the design layout for the "Pickerelweed" painting shown on the opposite page.

Just as sunlight and deep shadows dapple the swamp lands with mystery, strong value contrasts are the key to this painting's mystic appeal.

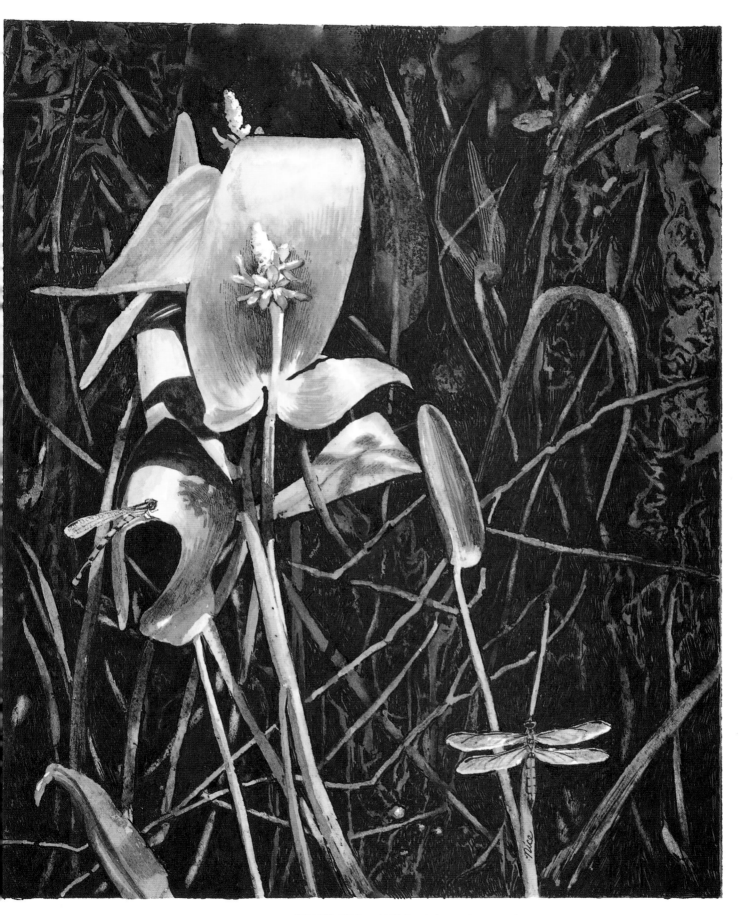

PICKERELWEED, 8″×10″ (20.3cm×25.4cm), layered watercolor
washes textured with impressed plastic wrap, blotting and penwork

Cattails

These useful fresh water reeds grow throughout North America! The starchy roots and young shoots are both edible and delicious. Craftsmen weave cattail leaves into rush seats and artists find the sausage like heads, cottony seed puffs and graceful fronds irresistible to pen and paint.

(2) Layer on a wash of Burnt Umber & Burnt Sienna.

(3) Stipple with brown ink or other dark color in a (.25 nib) Rapidograph.

Paint cattail leaves with varied mixes of Sap Green, Thalo Green, Payne's Gray and Burnt Sienna.

(1) Preliminary pencil sketch and damp surface wash of an Orange and Ultra-marine Blue mix.

Alcohol spatter

Ultramarine Blue sky was blotted with a crumpled tissue while still damp.

Pencil sketch of a cottony seed head.

wet-on-wet washes

Orange & Ultramarine Blue

Brown ink details added with pen.

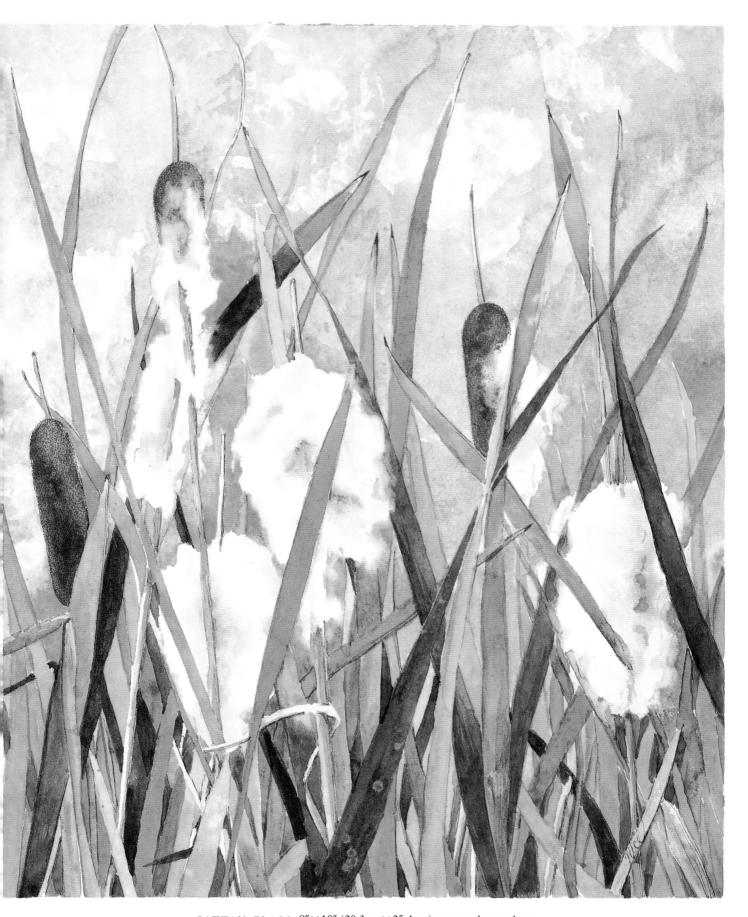

CATTAIL FLAGS, 8″×10″ (20.3cm×25.4cm), watercolor washes
textured with blotting and alcohol spatter, enhanced with brown stippled penwork

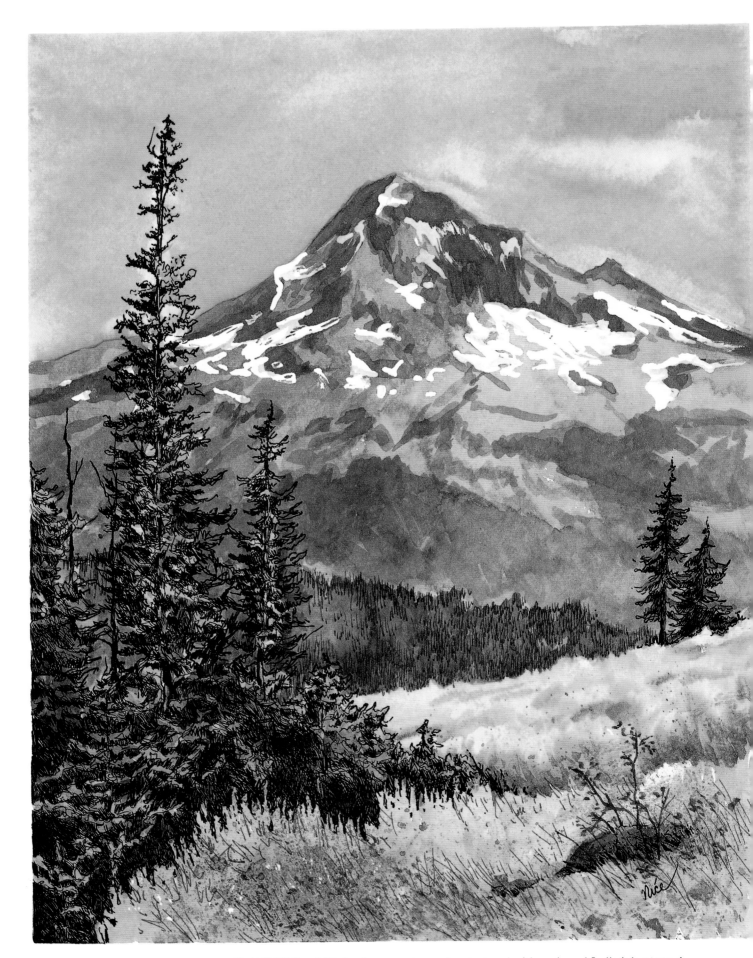

MT. HOOD IN SUMMER, 8″×10″ (20.3cm×25.4cm), watercolor washes textured with sepia and India ink penwork

CHAPTER THIRTEEN

MOUNTAINS, CRAGS AND CREVICES

High and rocky are the two words that best describe the terrain featured in this chapter. Rocks are the nature of the mountains. The higher you go, the more apparent they become. Near the top, stony cliff faces peer out from winter cloaks of snowy white. Like ancient patriarchs, the faces are seamed and weathered with age. Their children are the rock boulders that break away and romp rebelliously down the slopes, coming to rest in great congregations.

Above the rocks, eagles soar. Beneath the rocks, the creatures build their dens. Upon the rocks, alpine flora clings to life. In the mountain highlands, life is spartan and fast-paced. Plants don't waste time growing tall. Large, bright blossoms are their glory and reproduction their mission, all the while racing the time clock in a precarious climate. One can only stand in awe at the tenacity of life that flourishes amid such hardship.

As the seasons cycle, melting snow sends cascades of water dancing over the rocks in a rhythm as old as the mountains themselves. Light plays across the falling water and sparkles like the crystals of a chandelier. Is it the sound or sight of the tumbling water that catches the stride of the passerby and causes him to pause and appreciate? Be you naturalist, poet or painter, the mountains are a compellng inspiration. Linger awhile, and in the following pages we'll explore a few of the mountains, crags and crevices. Then perhaps you'll plan a trip of your own to pen and paint the delights of the alpine scene.

Stonecrop (Sedum Family)

This small succulent sprouts from crevices in cliffs, talus slopes, and rocky outcrops, forming short, dense mats of blue-green rosettes.

Gamboge

① Begin with flat water-color washes.

Thalo Red muted with green

Varied mixtures of Sap Green, Thalo Green and Thalo Blue

Lift out highlight areas from damp wash with a detail brush

Yellow Ochre

② Define shapes with additional layered washes.

③ Add dark wash background to contrast pastel flowers.

Note: Masking the Stonecrop will allow the background to be applied first. The choice is up to the whim of the artist.

India Ink stippling adds contrasting texture to the gray rock background.

Talus Rock And Lichen

Talus rocks are the old fragmented stones that break off and tumble down the mountain to form great sloping piles. These rocks become textured with a variety of lichen.

① Begin with a varied damp surface wash of Payne's Gray, Burnt Umber and violet. Add a few "dirty palette" grays and browns for variety.

A wash of blue-green is added here as a reflection of local color.

② While the wash is still damp, use alcohol to stroke in some light toned lichen spots.

③ Further texture the rocks with dark brown-grays and earthy greens applied with a sea sponge and spattering.

④ A scribbling of Payne's Gray pen work gives the lichen additional definition.

Alcohol, spatter, sponging and colored ink pen work were used to texture the lichen.

Like a tapestry of abstract design, lichens cling to the high mountain rocks where nothing else will grow.

Orange Star Lichen—A crustose (crust-like) lichen.

Foliose or leaf-like lichen with fruiting cups.

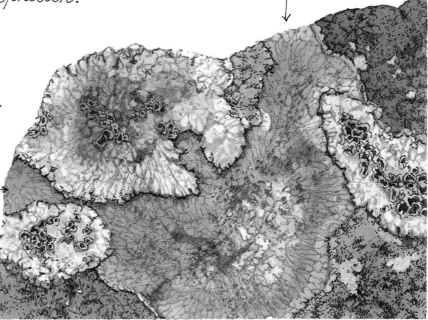

Pika

The North American Pika lives in the mountains of the Northwest, where it sun dries leaves and grasses, and stores them in rock crevices. One is more likely to hear the warning whistle of a Pika than actually see one.

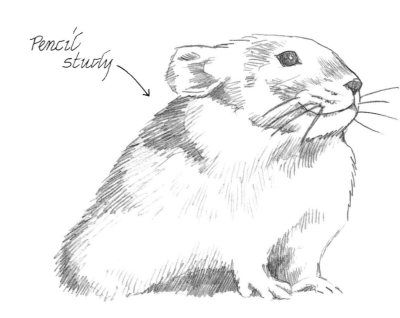

Pencil study

① Face and features are detailed using a .25 Rapidograph Pen and Payne's Gray ink. Criss cross lines are used to **suggest** hair. White hair is not inked except in the shadow areas.

② Shadow and dark hair areas are tinted with a Payne's Gray water color wash applied to a slightly damp surface.

Pen and ink scribble sketch

③ Washes of Burnt Umber are layered on to give the hair a natural brown-gray mottled appearance, which blends into the color of the mountain rocks.

Chipmunks And Ground Squirrels

Chipmunks are lively little rodents, active during the day! They have light and dark stripes on both the body and the face. The Golden-mantled Ground Squirrel illustrated below also has stripes, but not on the face. It was painted first, then textured with ink work.

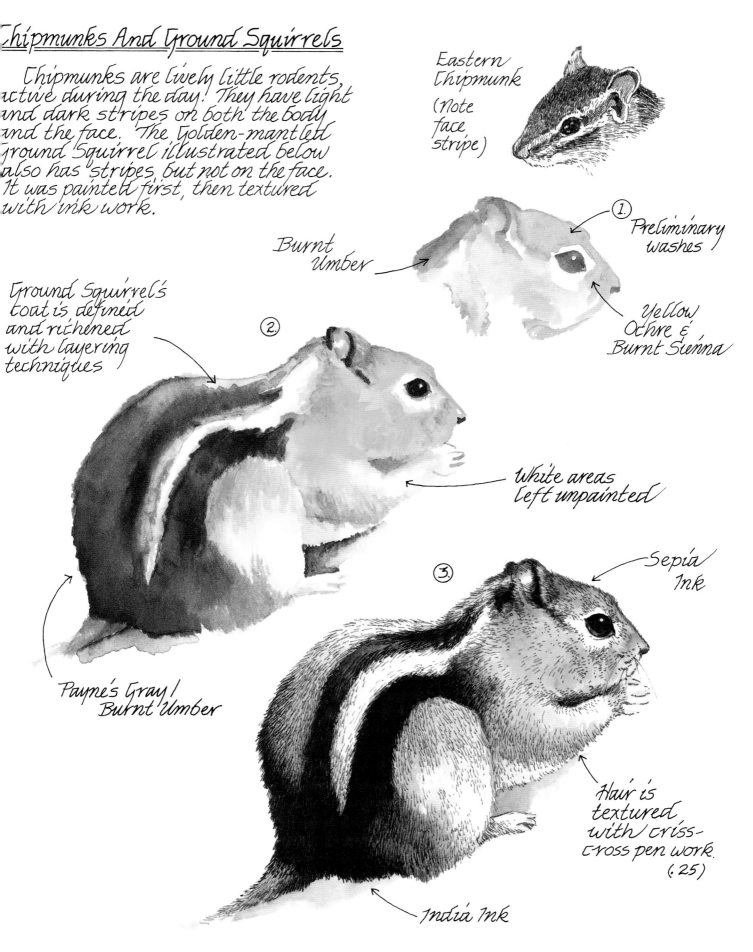

Eastern Chipmunk (Note face stripe)

Burnt Umber

① Preliminary washes

Yellow Ochre & Burnt Sienna

Ground Squirrel's coat is defined and richened with layering techniques

②

White areas left unpainted

Payne's Gray / Burnt Umber

③

Sepia Ink

Hair is textured with criss-cross pen work. (.25)

India Ink

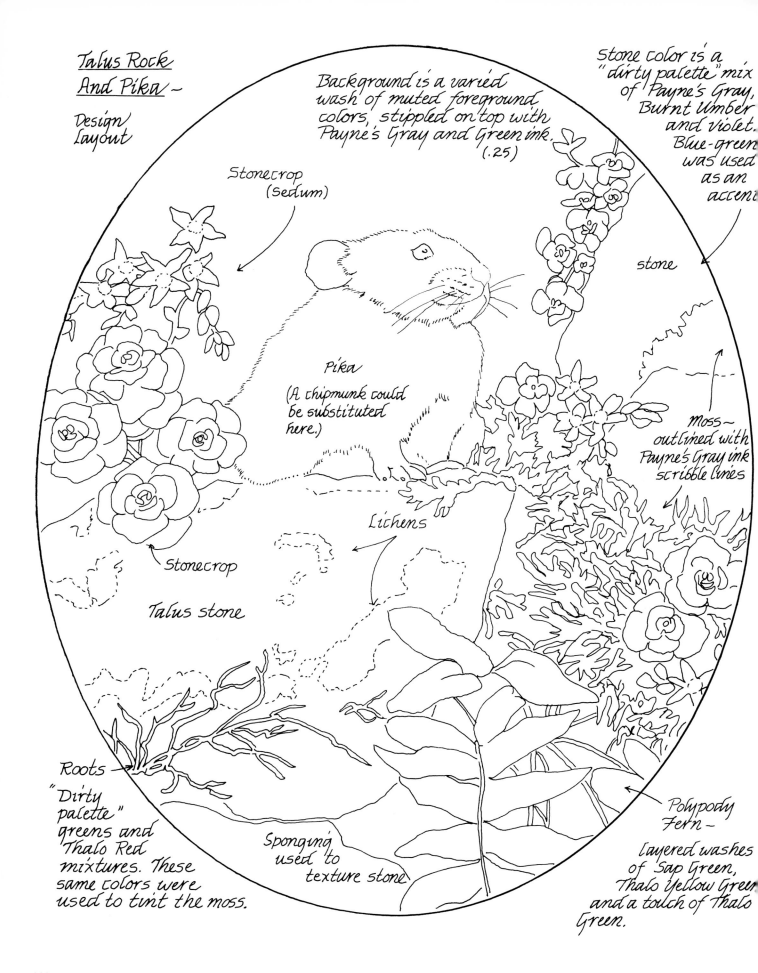

Talus Rock
And Pika ~

Design
Layout

Background is a varied wash of muted foreground colors, stippled on top with Payne's Gray and Green ink. (.25)

Stonecrop (Sedum)

Stone color is a "dirty palette" mix of Payne's Gray, Burnt Umber and violet. Blue-green was used as an accent

stone

Pika
(A chipmunk could be substituted here.)

Moss ~ outlined with Payne's Gray ink scribble lines

Stonecrop

Lichens

Talus stone

Roots →

"Dirty palette" greens and Thalo Red mixtures. These same colors were used to tint the moss.

Sponging used to texture stone

Polypody Fern ~

Layered washes of Sap Green, Thalo Yellow Green and a touch of Thalo Green.

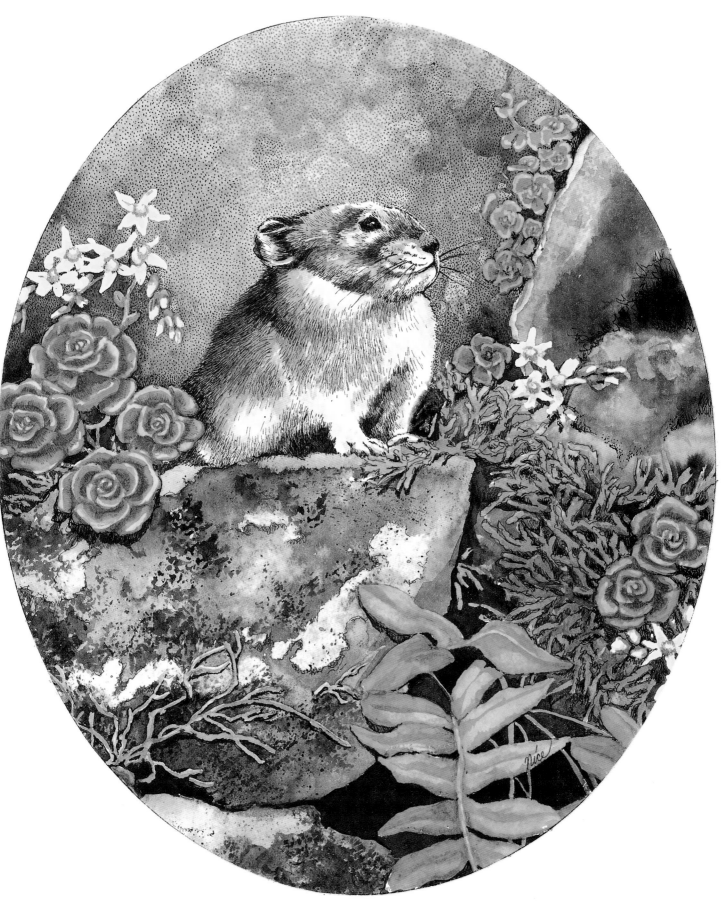

TALUS ROCK AND PIKA, 8″×10″ (20.3cm×25.4cm), watercolor
washes textured with spatter, alcohol streaks and India ink penwork

Cascading Water

Snow melt, tumbling over rocky mountain walls makes a wonderful contrast of dark, wet stone and white water. Here's one way to depict it.—

Sap Green for moss

① Thin liquid frisket with a little water so it flows easily and block out water and highlight areas. Lay in a varied wash of earthy grays & browns.

② Create spontaneous rock shapes by pressing wrinkled plastic wrap into the wet base washes. Let dry.

③ Using the rock shapes as a guide, brush in shadows and additional glazes of color. Maintain good value contrasts in the rock wall.

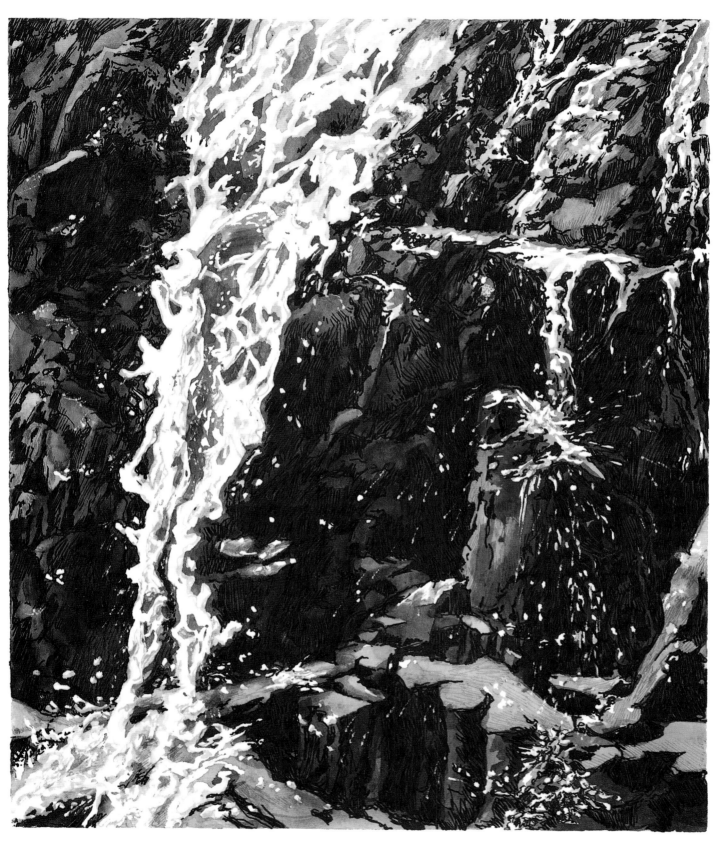

④ Further shape and texture the stone walls using black and brown inks and a Rapidograph pen. (.35) Scribbly contour lines work well.

⑤ Use a small detail brush and a pale Ultramarine Blue / Burnt Umber wash to shade the edges of the cascading water. Add drips and spatter with a razor blade.

Snow

Unless it is tinted with warm reflected color, snow is white --- unpainted paper white. Shadows give snowbanks their definition. These cast shadows are cool grays and muted blues, ranging from violet to aqua. The snow washes used in these examples are varied mixtures of Payne's Gray and Ultramarine Blue.

Snowflakes can be easily suggested by sprinkling table salt into a damp surface wash!

Unpainted areas depict sunlit snow surfaces.

Preliminary shadow areas, are brushed in wet-on-wet.

Snowbank shadows are deepened using layering and damp brush blending techniques.

Adding a touch of Burnt Umber to the water here and there suggests the presence of submerged rocks and adds a bit of warmth.

Here is a miniature scene on which to hone your snow painting skills. —

Wet-on-wet wash with table salt.

India ink pen work on branches. (.25)

Crisp, white edges were masked with liquid frisket.

Wet-on-wet wash with water drop spatter.

Water is still, in a near frozen state. There are no ripples.

Palette: Payne's Gray
Ultramarine Blue
Burnt Umber
Sap Green

Alpine Cliff Plants

These plants form thick mats on high mountain slopes and rocky ledges. The leaves are compact and the blossoms large and showy.

Layered washes were used to paint the flowers. The leaves are suggested using flow-altering techniques, with the exception of the penstemon foliage.

Alpine Collomia (Northwest Mountains)
Foliage is a varied wash, textured with crumpled plastic wrap and Brown ink work.

② Layer on additional washes to define blossom.

① Begin with flat washes.
Thalo Red

Sap Green & Thalo Green, muted with Thalo Red

③ Add complementary colors to wash mixtures and layer on shadows. Brown ink is used to detail leaves.

Note: Flowers were masked out while leafy back-grounds were painted

Cliff Penstemon →
This alpine plant, with its spectacular hot pink flowers, grows on the mountain cliffs from Northern California to Central Washington.

Purple Saxifrage —————→
(Arctic regions south to Vermont, Wyoming and Washington.)
Leaves were textured with table salt and Brown scribbled ink lines.

Bald Eagle

The Bald Eagle is a fish-eater, dwelling near large bodies of water across North America. Preferred nesting sites are in the tops of tall trees. When trees are scarce, mountain bluffs and cliffs support the large stick nests.

Brown body feathers

Preliminary wash of Yellow Ochre, Thio Violet, Burnt Umber and a touch of Payne's Gray.

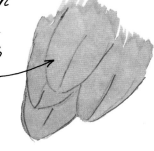

Add more Burnt Umber and Payne's Gray to the previous mix and darken the feathers, leaving the bottom edge light. Blend with a clean, damp brush.

Yellow Ochre plus Thio Violet

Yellow Ochre, Thio Violet and Burnt Umber

Eye: Yellow Ochre plus Gamboge. Add Burnt Umber for shadows.

Ultramarine Blue, Thio Violet and Payne's Gray

Burnt Umber, Thio Violet, and Payne's Gray

① Preliminary washes (Leave plenty of unpainted white areas).

② Deepen color and add shadows using a no. 4 round detail brush and layering techniques.

The eye area was further defined with Sepia pen work.

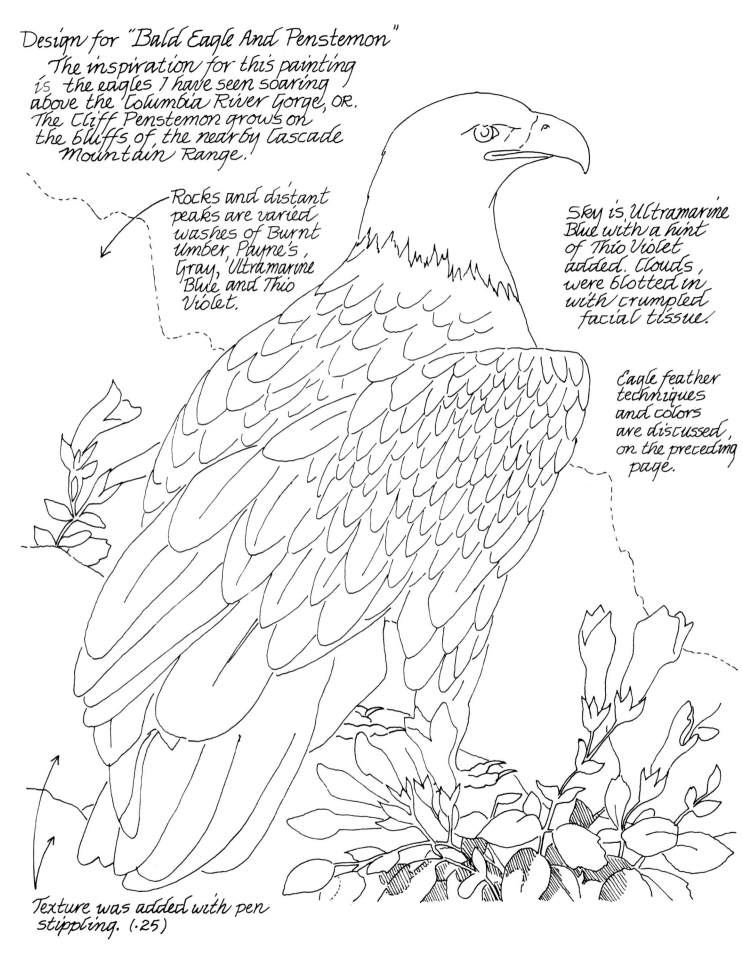

Design for "Bald Eagle And Penstemon"
 The inspiration for this painting
is the eagles I have seen soaring
above the Columbia River Gorge, OR.
The Cliff Penstemon grows on
the bluffs of the nearby Cascade
Mountain Range.

Rocks and distant
peaks are varied
washes of Burnt
Umber, Payne's
Gray, Ultramarine
Blue and Thio
Violet.

Sky is Ultramarine
Blue with a hint
of Thio Violet
added. Clouds,
were blotted in
with crumpled
facial tissue.

Eagle feather
techniques
and colors
are discussed,
on the preceding
page.

Texture was added with pen
stippling. (.25)

210

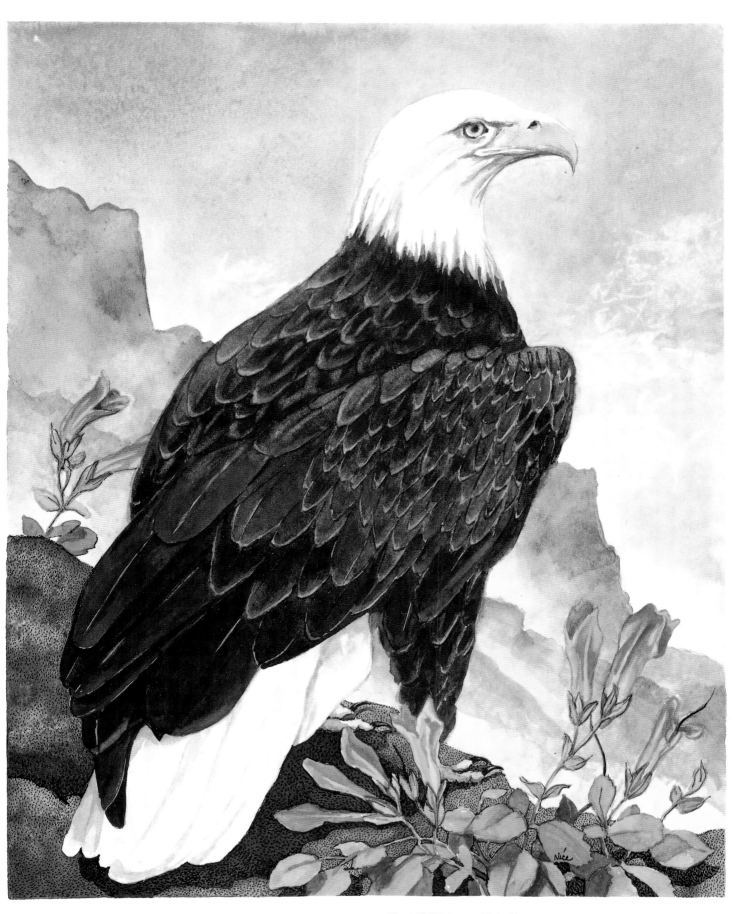

BALD EAGLE AND PENSTEMON, 8″×10″ (20.3cm×25.4cm),
layered watercolor washes and ink stippling

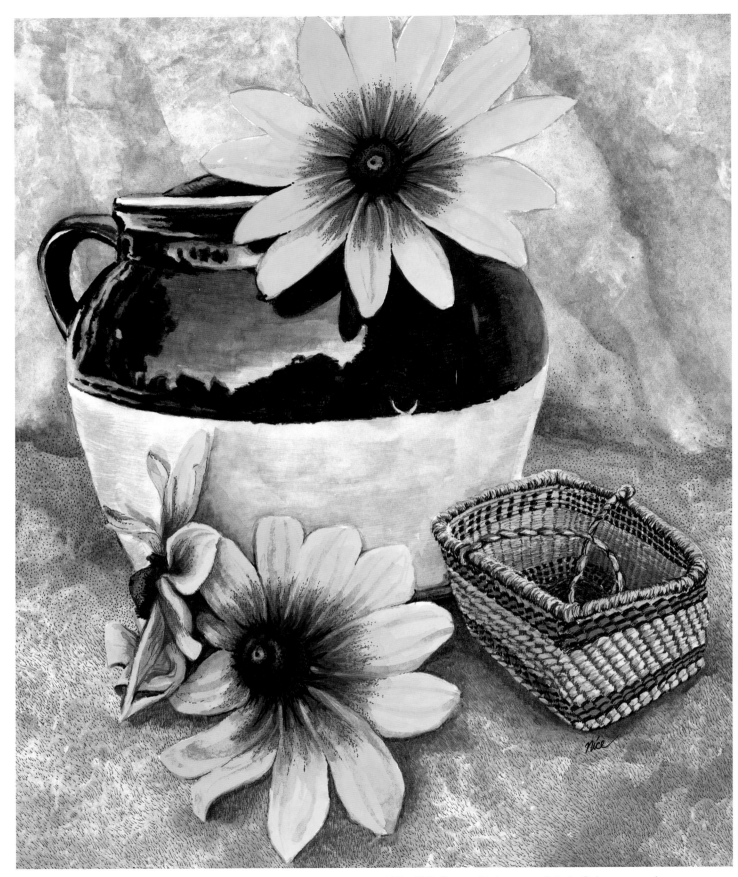

CROCK, NOOTKA BASKET, AND GLORIOSA DAISIES, 9½″×7¾″, Pen and ink, pen and ArtistColor, watercolor.

STILL LIFE STRATEGIES

When I think of a still life, visions of florals, fruits and earthy knick-knacks come to mind. Artists have arranged still lifes and painted from them for centuries, and the subject never seems to get old. However, some arrangements are definitely more exciting than others. The exceptional still life will be a well-designed composition, with a natural balance of shapes, pleasing colors and value contrasts. There will also be a variety of textures. Creative texturing can bring an ordinary inanimate arrangement to life.

Note the abundance of texture in the composition on the facing page. The highly glazed crock, the dusty, matte finished flower petals, and the tightly woven basket are set against the soft folds of crushed velvet, which was painted with Cobalt Blue, then blotted with a crumpled tissue. Take away the texture and the still life would be sadly lacking.

Most of the textures shown in this chapter began as preliminary washes, to which secondary layers and drybrush detailing were added. Pen work, with India Ink, liquid acrylic or both, was introduced as a final touch of texture. When the design pattern is the main focus of an object, as often seen in basketry, native pottery and sea shells, the bold texture of pen work is important and is laid down before the watercolor work.

I have only been able to show a few of my favorite still life objects in this chapter. Vegetables, which are handled very much like fruit, can be fun to explore. Think of the bumpy surface of an ear of corn, the layered crispness of lettuce and the rough, scarred surface of an old gourd. What textures come to your mind? Start with those and see where it leads you.

Fruit

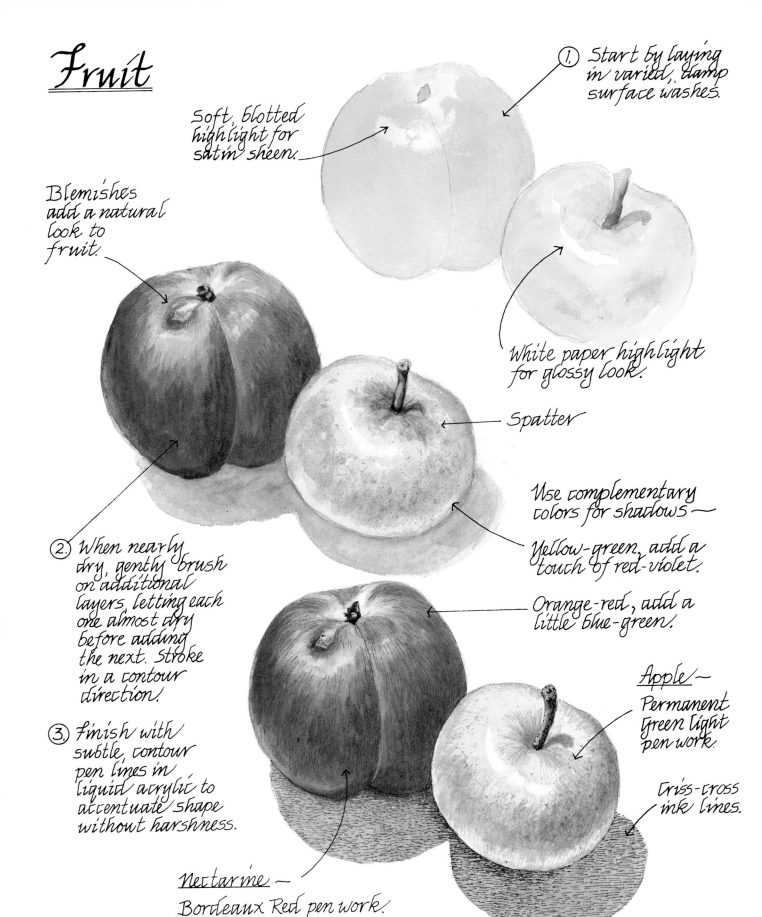

Soft, blotted highlight for satin sheen.

① Start by laying in varied, damp surface washes.

Blemishes add a natural look to fruit.

White paper highlight for glossy look.

Spatter

Use complementary colors for shadows —

② When nearly dry, gently brush on additional layers, letting each one almost dry before adding the next. Stroke in a contour direction.

Yellow-green, add a touch of red-violet.

Orange-red, add a little blue-green.

③ Finish with subtle, contour pen lines in liquid acrylic to accentuate shape without harshness.

Apple — Permanent Green light pen work.

Criss-cross ink lines.

Nectarine — Bordeaux Red pen work.

The fruit and berries on this page are layered watercolor washes, detailed with pen and ink or liquid acrylic.

Blueberries have a powdery bloom, suggested by blotted layers of paint and India ink.

Raspberries are semi-translucent with a satin sheen.

Cantaloupe Rind

ⓐ First lay down a light tan-gray wash. Let dry.

ⓑ Mask out a vein-like pattern.

ⓒ Paint with an olive green mix. Remove masking.

ⓓ Detail with brown pen work.

Mask out highlight pattern.

Blackberries are firm, with a glossy skin.

Brown, stippled pen work adds a dimpled texture to orange peels.

Wet-on-wet

Shadows give definition and placement to the fruit.

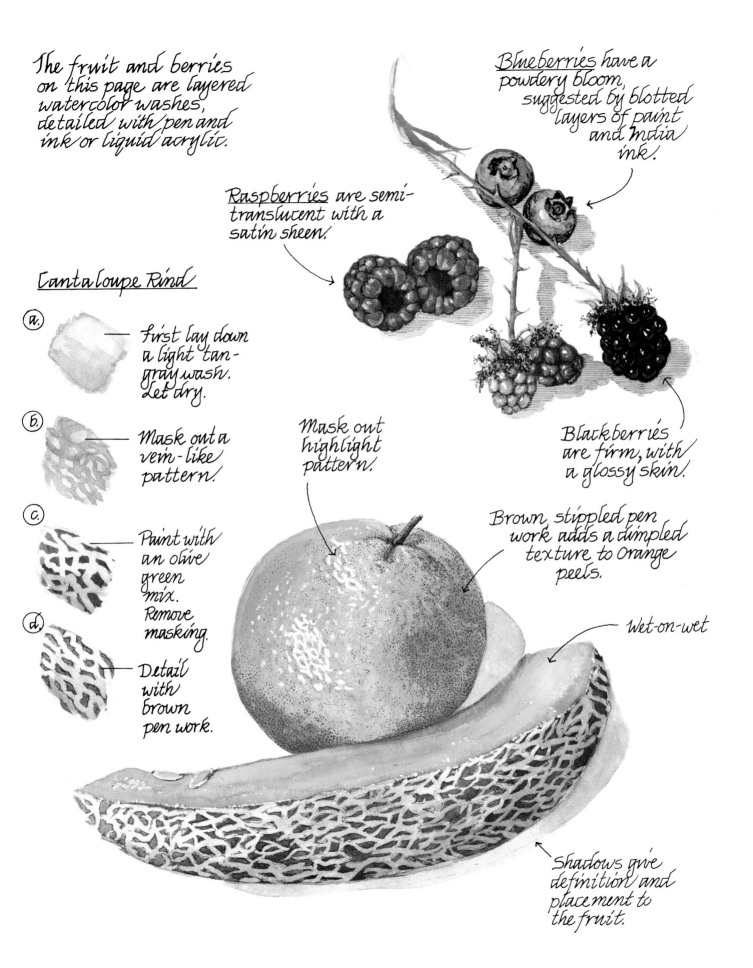

Eggs And Onions

The papery skinned onion and the porcelain-like egg share a delicate, brittle quality that provides a unique challenge to the artist. The key is soft, subtle shade work and simplicity.

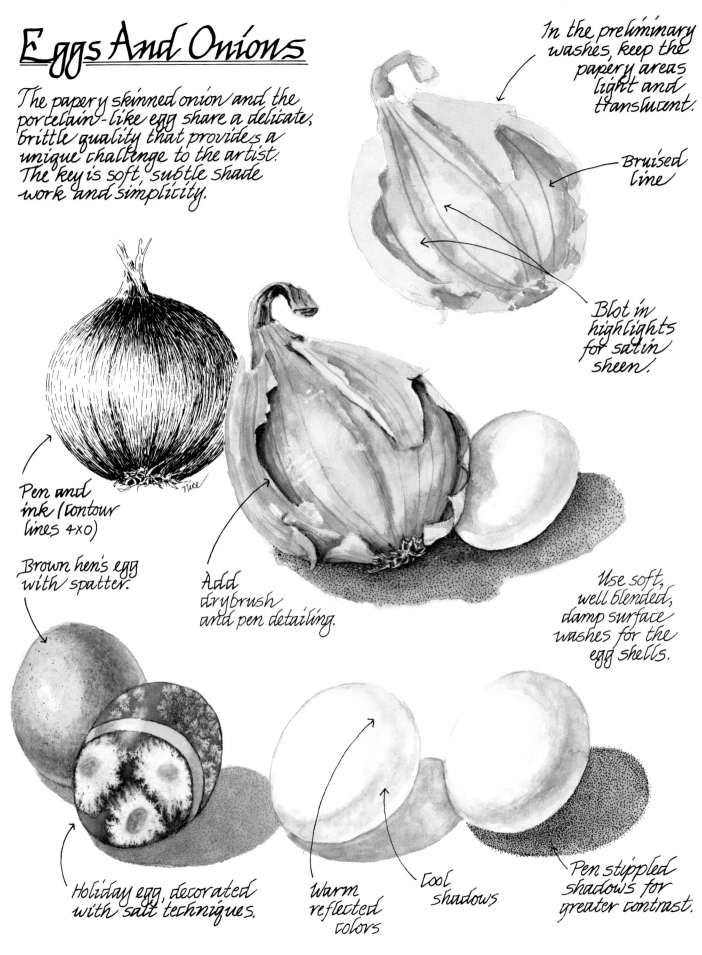

In the preliminary washes, keep the papery areas light and translucent.

Bruised line

Blot in highlights for satin sheen.

Pen and ink (Contour lines 4×0)

Brown hen's egg with spatter.

Add drybrush and pen detailing.

Use soft, well blended, damp surface washes for the egg shells.

Holiday egg, decorated with salt techniques.

Warm reflected colors

Cool shadows

Pen stippled shadows for greater contrast.

Highlight

① Lay in basic washes, maintaining white highlights to suggest a shiny surface.

② Deepen the color with additional washes and drybrush work.

③ Use scribble line pen work to further define the design pattern and texture the shadow area with stippling.

Seashells

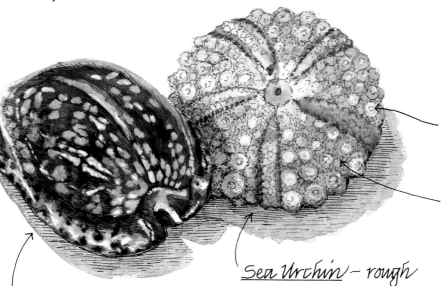

Alcohol rings laid into a wet-on-wet wash.

Stippled ink texturing

Sea Urchin – rough

Cowry Shell – highly polished

(Note multiple white paper highlight areas for glossy look.)

Ink stippling

Clam Shell – ridged, matte finish

Auger Shell – smooth, satin finish

Both shells were painted with layered washes, then detailed with Brown liquid acrylic pen work.

Textiles

Mask out stitches and paint later with ochre.

Burnt Umber / Ultramarine Blue mix.

Texture the denim with Payne's Gray or India ink, wavy line pen work.

Lay the preliminary damp surface wash on heavy, and blot with a crumpled tissue for a stone washed look.

Deepen shadows with damp surface blending techniques and Payne's Gray paint.

Mask out print design while background material is painted. Use damp surface blending techniques and blotted highlights

Worn Denim

Braided outline

Loose cross-hatching

Ribbed Knit
India ink pen work, tinted with watercolor.

Define the floral print with drybrush and pen work.

Cotton Print Fabric

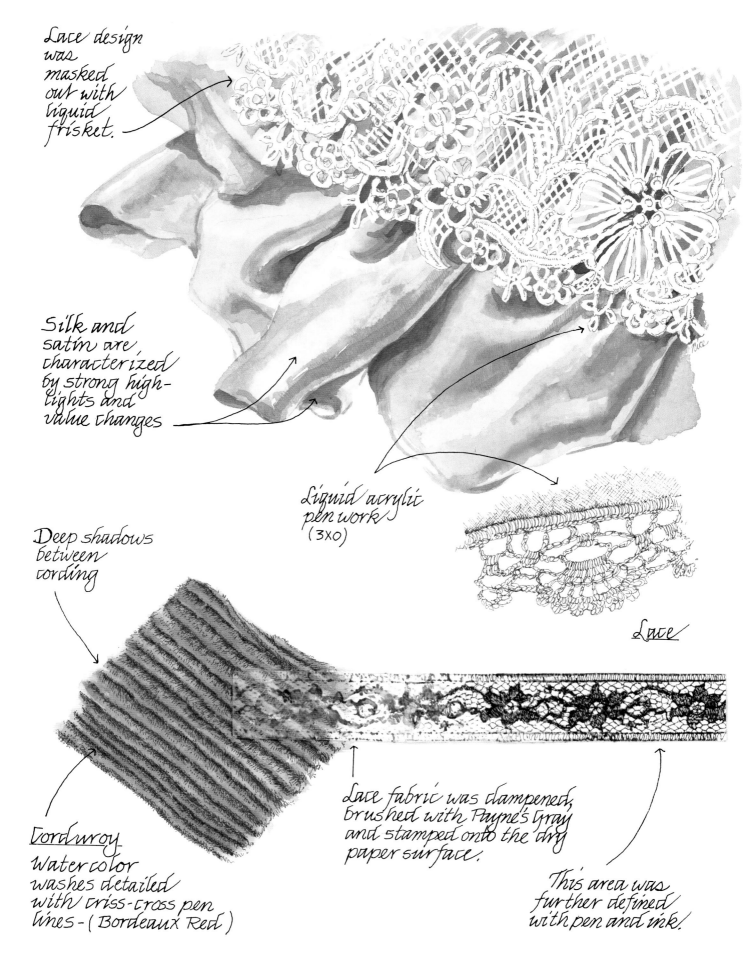

Lace design was masked out with liquid frisket.

Silk and satin are characterized by strong highlights and value changes

Liquid acrylic pen work (3x0)

Lace

Deep shadows between cording

Corduroy
Watercolor washes detailed with criss-cross pen lines - (Bordeaux Red)

Lace fabric was dampened, brushed with Payne's Gray and stamped onto the dry paper surface.

This area was further defined with pen and ink.

Basketry

1. Begin each basket sketch with a detailed pencil study. Basket weaves and materials vary greatly and can be quite complicated.

2. Detail the pencil lines with pen work. Add shadows and texture.

3. Tint with water-color washes.

4. Use additional washes and dry-brush work to add depth and dimension.

<u>Wicker</u>

Use black India ink for cool colored areas.

Use brown pen work for warm colored areas.

<u>Makah Native American Basket</u> —

Woven from grasses, cedar bark, roots and fern stems.

Note the whale design woven into this rather complex west coast basket.

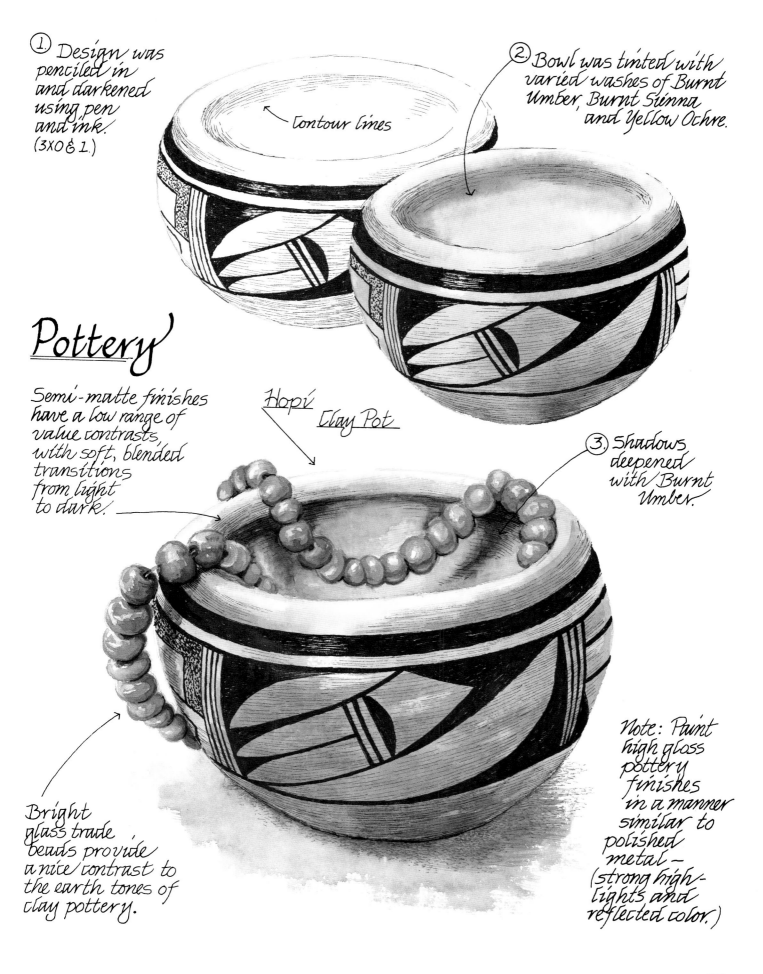

① Design was penciled in and darkened using pen and ink. (3X0 & 1.)

Contour lines

② Bowl was tinted with varied washes of Burnt Umber, Burnt Sienna and Yellow Ochre.

Pottery

Semi-matte finishes have a low range of value contrasts, with soft, blended transitions from light to dark.

Hopi Clay Pot

③ Shadows deepened with Burnt Umber.

Bright glass trade beads provide a nice contrast to the earth tones of clay pottery.

Note: Paint high gloss pottery finishes in a manner similar to polished metal — (strong highlights and reflected color.)